EVERETT SHINN

1876-1953

A Figure in His Time

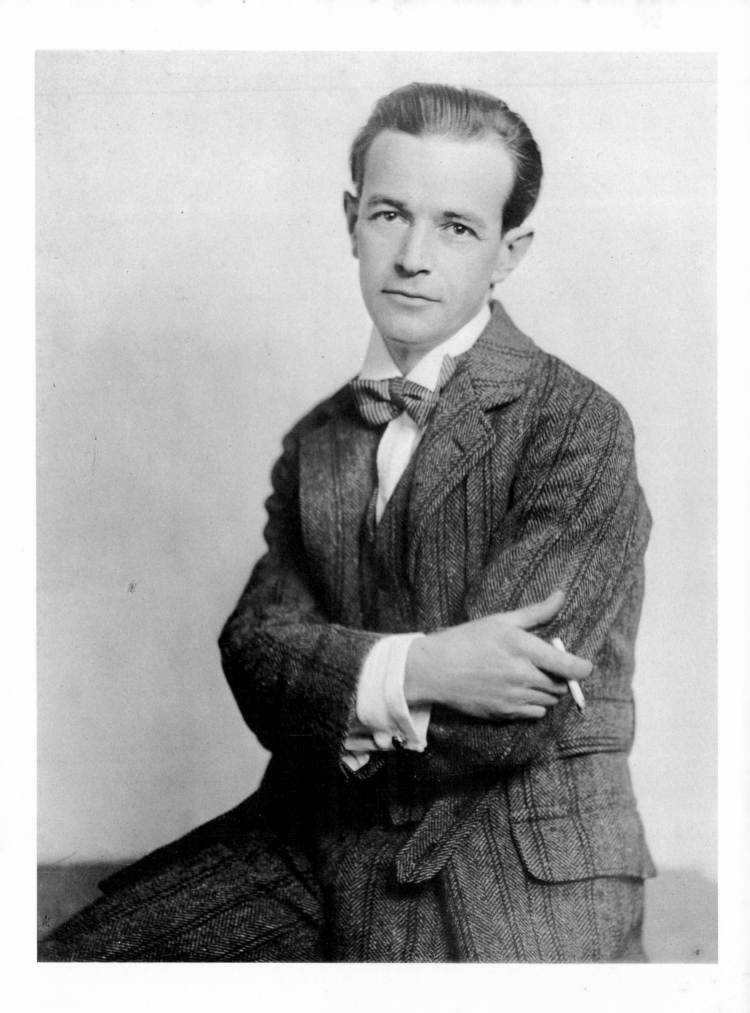

EVERETT SHINN

1876-1953

A Figure in His Time

BY EDITH DESHAZO

Research Assistant
RICHARD SHAW

Clarkson N. Potter, Inc./Publisher NEW YORK
DISTRIBUTED BY CROWN PUBLISHERS, INC.

Library of Congress Catalog Card Number: 74-77561
Published simultaneously in Canada by General Publishing
Company Limited.

First edition.

Printed in the United States of America.
Designed by Shari deMiskey

In Memory of
Ron

Contents

Foreword

EDITH DESHAZO'S INTEREST IN ART WAS KINDLED IN HER early teens. Her talents and knowledge as a self-taught art historian and collector are evident in her work as a newspaper columnist dealing with aesthetics.

Fortunately, Edith DeShazo can't resist a dare, for otherwise this book might not have been written. Shinn's dealer, who recklessly threw down the literary gauntlet before Mrs. DeShazo, was right when he told her it would be very difficult. It took her seven years, full of difficulties, but in the end she managed it and managed it very well. Because Mrs. DeShazo has a lively and vivid sense of humor, so evident in her writing, she never lost her perspective.

One meets a remarkable group of characters in this book—"The Eight," David Belasco, Stanford White, William Randolph Hearst, Theodore Dreiser, Julia Marlowe, and many other lesser lights of the period. Few, however, are as fascinating as the short, handsome, dapper ladies' man Everett Shinn, described by one of his many admirers as looking like a jockey dressed to go out on the town. Edith DeShazo has ferreted out many telling facts about Shinn which give us a lucid picture of this curious man.

Mrs. DeShazo has painstakingly reported on the life of a man, not on the life of a great artist. Shinn was a versatile painter, but, more, he was a clever, talented, and strong-willed man who escaped from the imprisonment of life through his escapades, his dabblings in the theatre, and his facile drawings and paintings. Edith DeShazo has so depicted him.

EDWARD DWIGHT
Director, Munson-Williams-Proctor Institute

Preface

I FIRST BECAME INTERESTED IN EVERETT SHINN WHILE LEC-
turing on art history at the Jewish Community Center in Cherry Hill, New
Jersey. The class was, for the most part, made up of middle-aged collectors
and would-be collectors.

I told the class that on the final day of lectures I would be glad to
treat any art subject they wanted to discuss. One of the men in the group
had a great interest in "The Eight" or "Ashcan Group." As I had only a
cursory knowledge of these men, a great deal of research was necessary in
order to produce that lecture.

In the course of my studies, I found that one of the members of this
group, Everett Shinn, had been born in Woodstown, New Jersey. At that
time, in 1966, my husband had owned a farm just outside this small town
for about five years. This immediately stimulated my interest in Shinn.
Besides, it was quite likely that he was a relative of mine through my grand-
mother who was a Shinn from Salem. Finally I found that nothing had been
written about Shinn except a few articles in magazines and catalogs and some
lurid newspaper renderings of his multimarriages and divorces.

I started to research the life of Shinn in 1966, proceeding along the

lines of investigative reportage, as art reporting for the local newspaper was one of my occupations. This research led me back and forth across New England and the Middle Atlantic states, interviewing persons in Shinn's family, talking to gallery and museum directors, collectors, and friends when they could be found.

My travels eventually led me to Mrs. John Sloan, whose husband was one of the most important members of The Eight. Mrs. Sloan and Miss Antoinette Kraushaar of Kraushaar Galleries made it possible for me to reach many people for interviews.

But it was, more than anyone else, Mr. Robert Graham of James Graham and Sons who gave me the real impetus to start work on this biography. This impetus was given without knowledge on his part of its importance. I went to his gallery and explained that I was trying to write a book on Everett Shinn. Since Graham had handled Shinn's estate, he seemed to be the logical man to contact. Mr. Graham was extremely helpful but he did say, "Very difficult, very difficult. I don't think you can do it." That was all I needed to hear. During the time I was accumulating this material, I often wished that Mr. Graham hadn't presented so strong a challenge.

The list of persons who have helped and assisted me in this book is very extensive. I have received heartwarming cooperation throughout the project. Besides Mr. Richard Shaw, who has been my research assistant for several years, Mrs. John McGinnis, Mrs. John E. Carnes, and Mrs. J. Linwood Robinson have all donated their services from time to time as research assistants.

In Woodstown, the help of Mrs. Burton Zehner and her father, the late Joseph Andrews, has been invaluable. Also in Woodstown, concerning the town at the time of Shinn's boyhood, a great deal of help was provided by Mrs. James Sherman, Mrs. Charles Biernbaum, Mr. Frank Pettit, and Mrs. Ernest Bell. J. Houston Toulson and Howard Harris, Jr., supplied a great deal of local-color information.

The family has been most cooperative. Through Shinn's son, Davidson, I acquired the family papers, and through his daughter, Janet Shinn Flemming, I received firsthand information about Shinn the man and Shinn the artist, which could not have come from any other source. Mrs. Warren Shinn, Everett's sister-in-law, granted me several important interviews, as did his niece Mrs. John Thomas. His stepson, Gäir Chase, has also been most helpful.

The library staff at the Delaware Museum of Art, and indeed the whole staff of the museum, has been cooperative above and beyond the call of duty. I wish to say a special thank you to Phyllis Nixon, Chief Librarian, and to Bruce St. John, Director of the Museum.

Ira and Nancy Glackens, the late Mr. William Bender and Mrs. Bender, and Mr. and Mrs. Meyer Potamkin have given freely of their time. Other collectors, galleries, and museums have opened their libraries and granted interviews that have been of great assistance. Mr. Robert Graham of New York and his brother-in-law, Mr. Arthur Altschul, have both granted

interviews and been extremely cooperative. Babcock, Hirschl and Adler, Wildenstein, Knoedler, and Bernard Black, to mention only a few galleries, have been very helpful. Mr. Garnett McCoy of the Archives of American Art and Mr. John Bullard of the National Gallery of Art, both in Washington, have graciously contributed to this project.

To re-create the life of a man one has never met has proved a long and fascinating journey. Research into this man who figured heavily in American art and life during his time could go on forever—things will undoubtedly continue to appear.

In writing the book, I feel I know the late Everett Shinn pretty well. I feel irritated with him at times, then proud, then exasperated, the same way I might feel about a member of my family.

It is hoped that this picture of his life will make a contribution to understanding the creative personalities of Shinn's time.

Introduction

EVERETT SHINN WAS CALLED EVE BY HIS OLDEST FRIENDS, none of whom could hold a candle to him for the diverse, protean, mercurial character of his talent. There is such a thing as being too talented, so that one's talents must be expended in many different directions in order to keep them exercised. This is the disability from which Everett Shinn suffered—too much ability. To look at his early pastels is to wonder how anyone so young could possibly have gained such sure technique so soon, for these pastels were produced when the artist was in his early thirties, and even late twenties, and are among his best work.

Our artist was stagestruck, dazzled by the glamour of the footlights and a showy fashionableness, the only one of the five original "Ashcan" painters who succumbed to that artificial life. This explains his association with David Belasco (for whom he decorated the Belasco Theatre) and with the famous decorator Elsie de Wolfe, for whom he probably designed rooms and painted screens depicting "an existence *à la* Watteau" (the lady had French leanings). I cannot imagine Henri, Luks, Sloan, or my father painting screens for Elsie de Wolfe. I am sure Shinn did so with dazzling, absolutely dazzling, *éclat*.

Everett was so vivid a person that when he was present nobody else had to make much of a social effort. He was a wonderful narrator, and highly dramatic, as well as highly undependable where facts were concerned. He had the energy of a dynamo, a lithe little figure in a checked suit, with whom nobody tried to keep up.

He jumped from job to job: he could design and build a house, construct a stage set, install plumbing, invent a puzzle. For a long period he was obliged to illustrate for *Red Book*, *Cosmopolitan*, and such magazines, to support his family. He had to please art editors who no longer let their artists do as they pleased, as in an earlier, happier day; consequently the artist who had once been a Realist began to create svelter and taller figures with longer and longer legs, until they did not greatly resemble members of the human race. Shinn's great days were over. He could not survive the magazines.

But in the meantime he had produced his astounding theatrical canvases, with their great mastery of artificial light—certainly none of his associates could approach him here, and probably did not want to. The canvases, however, after one has been sufficiently stunned by their technical brilliance, turn out to be somehow shallow. There really isn't very much under all that dazzling artificial light. Still, nobody ever did better just what Shinn did.

The murals in the Oak Room at the Plaza (which I piously visit time to time to have a drink in memory of "Uncle Eve") are perhaps his masterpieces. I never cease to marvel at them. (The ones in the small bar at the Algonquin seem to have been wantonly destroyed a few years ago). In one of the Plaza murals—I think the amazing one depicting the Plaza itself, or possibly the departed Vanderbilt mansion by moonlight—Everett placed a tipsy gentleman in evening clothes (silk hat and opera cloak) leaning against a lamppost. The manager (whose name I mercifully omit) ordered him to paint the gentleman out. Again Everett had to do what he was told to do by the ignorant holder of the purse-strings—the hardest burden of any artist's life.

In his parody melodramas he needed to please no one but himself, his actors, and his audience, and all this he did with abundant success. The three plays he wrote, designed, directed, produced, and acted in exhibit two interesting facets of the author: his genuine farcical humor, and his inability to concentrate on what came so easy. The texts of his plays read as if dashed off in an hour, without revision. His wonderful ideas are not worked out, and many a fine effect is half-realized. His good actor friends (mostly amateurs, including both my parents) had to carry his underdeveloped themes.

When he wrote articles he took more care. His description of art galleries in the early years of the century should be reprinted in histories of American art and culture, so vivid an evocation it is of the art atmosphere

of those days. (He called them "plush grottoes, where the cadavers were displayed in sumptuous coffins.")

To my father he was always fanatically loyal, both as a friend and as an admirer of his work; and Shinn was pained to discover, after my father's death, how little he was known. He wrote a perceptive article on Glackens's illustrations and wrote me that every museum should have a Glackens. How pleased he would be today to know that he and all his friends are no longer unknown and neglected, and that most American museums own their works.

It is difficult to evaluate Everett Shinn. Among all The Eight he had the easiest talent, and perhaps this is why he is less than the greatest of them. But since we should judge an artist by his finest achievements, let us value Everett Shinn for his wonderful depictions of the streets of New York, the lights of the city and the theatre, the hansom cabs and swirling traffic of a past he knew and drew so well, and accord him his deserved niche in the history of the rebirth of realistic movement in our art.

IRA GLACKENS

EVERETT SHINN

1876-1953

A Figure in His Time

Farm, Woodstown, circa 1890. WOODSTOWN PUBLIC LIBRARY.

Chapter One

EARLY YEARS

EVERETT SHINN, PAINTER OF THE ASHCAN SCHOOL, MURALIST, decorator, erstwhile playwright, was born in Woodstown, New Jersey, in 1876.

The small community of Woodstown is situated in Salem County, nestling in the very southern tip of New Jersey—facing Delaware rather than Pennsylvania. Because of the physical isolation of Salem County towns, as much from each other as from out-of-county places, the towns of Salem, Woodstown, Pennsville, and Pedricktown have strong town personalities of their own.

The Mason-Dixon line ran just north of Woodstown, and to this day Salem County is a southern community. With the river running across its southern end on its way to Delaware Bay, with its salt marshes, birds, and muskrats, the county resembles parts of the South much more than it does its closer Yankee neighbors.

Woodstown hasn't changed very much since Everett Shinn was born, as a look at the Salem County Telephone Directory will confirm. The book shows a preponderance of the names which were there and settled in when

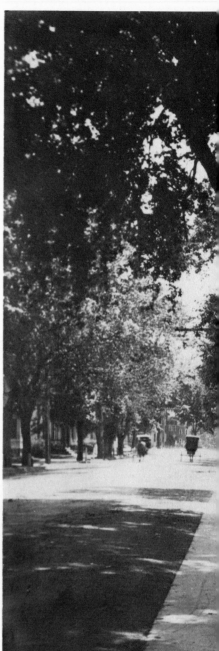

East Avenue, Woodstown, circa 1900. WOODSTOWN PUBLIC LIBRARY.

Isaiah Shinn house, 68 N. Main Street, Woodstown, circa 1895. WOODSTOWN PUBLIC LIBRARY.

Shinn was born—Andrewses, Flitcrafts, Colemans, Buzbys, Hitchners, Pettits, Wibles, and Zanes, to name a few.

Everett was the third child born to Isaiah Conklin Shinn and Josephine Ransley Shinn of Pilesgrove Township, Salem County, New Jersey. Their first child, Florence, lived only a short time. Warren was their first son, to be followed in 1876 by Everett and a few years later by a third son, Harold.

It is generally thought that Everett was the great-great-grandson of General Isaiah Shinn, one of the founders of Woodstown, and one of its first merchants, who operated a store at what is now 68 North Main Street in the village.[1]

The Main Street of Woodstown is still a countrified, sleepy village kind of street, affecting the passerby much as a trip to the late nineteenth century would. Some store facades have been slightly modernized; the pump in front of the "Old Bank" (The First National) has long since been done away with in favor of road adjustments and flower plantings; Andrews' drugstore, which was one of Shinn's favorite boyhood hangouts, has had a facelifting and is now the Lawrence Pharmacy. Gasoline stations have sneaked in to bring an unpleasantly modern note, for catering to automation has become a necessity even in Woodstown.

Main Street, Woodstown, circa 1900(?). WOODSTOWN PUBLIC LIBRARY.

Shinn House on East Avenue, circa 1900(?). WOODSTOWN PUBLIC LIBRARY.

But the general mien of the town, the farm-dominated business life of the community and the social pecking order stemming from church membership and old family ties, all these have changed very little since the late eighteen hundreds. Woodstown bows only slightly to the modern age, as compared to other South Jersey communities.

Woodstown is a Quaker-dominated community, one of the last in the country, and it was even more Quaker-dominated at the time of Everett Shinn's childhood. A quick glance at the list of bank directors in the old days, at the holders of town offices, at the *Farm Journal's* list of prosperous farmer-subscribers shows the usual names—the majority Quaker—of Lippincott, Hitchner, and Waddington. These families are still a strong presence in the town and the county.

Shinn's father was a birthright Quaker, but there is little evidence

6

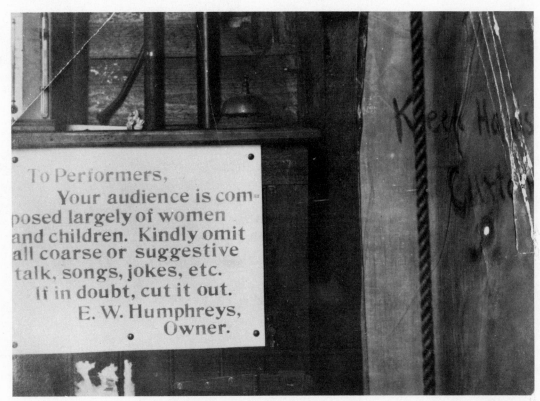

Sign posted in the Opera House, Woodstown, 1890. WOODSTOWN PUBLIC LIBRARY.

that the religious mantle weighed heavily on his shoulders, and probably the only time Everett and his brothers were expected to attend meeting was on the required Fifth Day while attending Friends' School.

At the age of four Everett was packed off to the Macaltioner sisters' kindergarten. As Shinn writes,

> True to the custom of the times, the little boy was dressed in long blond curls and a gingham pinafore. His mother pushed him forward toward one of the Misses Macaltioners and said fondly, "This is little Everett."
>
> Miss Macaltioner was delighted and leaned forward to coo words of confidence at the golden curls. Golden curls backed away from the loathsome cooing and threatened to be less of a Quaker than his mother. . . . The teacher gave him a piece of clay to work on . . . I wish

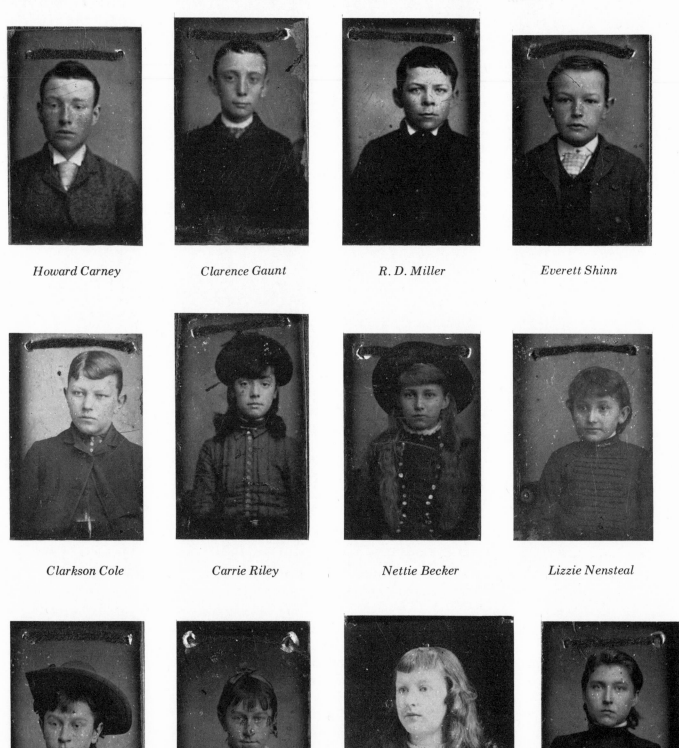

Howard Carney Clarence Gaunt R. D. Miller Everett Shinn

Clarkson Cole Carrie Riley Nettie Becker Lizzie Nensteal

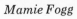

Mamie Fogg Mamie Fogg Sallie Fogg Ina P. Actley

School pictures of Everett Shinn's class, Woodstown, 1888. PHOTOGRAPH: COURTESY
HELEN ANDREWS ZEHNER, WOODSTOWN.

Bacon Academy, Woodstown, circa 1890.

I could tell you at this point that the piece of clay electrified the little boy with its creative possibilities and that was the beginning, the awakening of a great American artist.[2]

After mutually unnerving experiences for the Misses Macaltioner and himself, Everett proceeded in his school career to Bacon Academy, a Quaker school founded in Woodstown in 1844 by David Bacon, a member of the Pilesgrove Monthly Meeting, who provided the funds for the school in his will. At the time Shinn attended Bacon Academy, the school was under the sole care of the meeting and had about a hundred pupils for all grades.[3]

Everett thought school a real joke and was a terrible student, although he had some overt brilliance. Shinn himself recollects:

My earliest remembrance is closely connected with acrobatics, squirming out of my teacher's strong and disapproving hands and turning somersaults backward in hilarious retreat . . . climbing an iron column on my first day . . . and hooking myself over a cross bar, refusing the succulent bribe of an apple and the inviting gobs of clay and blocks on the table below me.[4]

His attitudes toward school did not change, as far as it is possible to ascertain, as he progressed through the grades.

Shinn's ability to draw was evident from very early childhood. His letters to his teachers always included drawings and at a very young age he made a rather good drawing of a submarine, which he also built (*See* p. 25).[5]

9

My future pardner

Dutchy the Great

10

Doodles from textbook owned by Shinn as a boy of eleven or twelve.
AUTHOR'S COLLECTION.

Shinn had a fairly happy life as a child. Isaiah, Everett's father, was born in Salem County a few miles outside of Woodstown. He had to work very hard as a child on his father's farm and so had very little formal education, but his natural interest in mathematics allowed him eventually to become expert in surveying, and he was called upon to settle a number of county boundary disputes over the years.

Isaiah was a hard worker. For a number of years he worked at Riley's store in Woodstown, which job necessitated a long walk into town and a long day at the store with a variety of duties, including the arrangement of chairs in a circle about the stove where "garrulous old men, checker sharks, domino demons and political exhorters, would gather when the sun was full up to loll, spit, grumble, and laugh and emphasize their ailments."

Isaiah Shinn had a fine reputation in Woodstown. Eventually a man who had watched his growth had him bonded and installed as teller in the First National Bank of Woodstown. He was employed at the bank for fifty years and took only a day's vacation per year. Finally, he was given a leave of two months and went abroad. This, as his son says, was "the enchanted answer to his yearly perusal of travel catalogues. . . . He had seen almost all the states but never left the bank to enjoy them."

Isaiah Shinn was a quiet man. He hated alcohol, but smoked numerous cheap cigars each day. He was an exceptionally kind man and an understanding one. He tried to be a firm disciplinarian but was not very successful because his wife's permissiveness was a constant impediment to any kind of firm hand. In any case, his heart was not in physical punishment of his sons. He was conservative but not straitlaced, pleasant but far from frivolous.

Business buildings of Woodstown, circa 1900. WOODSTOWN PUBLIC LIBRARY.

Isaiah Shinn, 1906.

Josephine Shinn.

Everett's mother, the former Josephine Ransley, was a very sociable woman and a very bad disciplinarian. She had a little money of her own and she loved to travel. She adored a good time, her moods were quixotic, and she was beautiful and interesting although a little flighty, according to acquaintances.[6]

According to her son, however, Josephine was a sweet, even-tempered woman—her tranquillity ruffled only by the fractious conduct of her three temperamental sons. She threatened them constantly but never followed through. The boys led Josephine a merry chase.

She had a well-developed imagination, and Shinn's father deplored the entrance of any newspaper into the house that might contain patent medicine advertising. The reason for this was that when he came home from the bank for lunch, Josephine would be sitting at the table unable to eat but with a clear diagnosis of her newest ailment, which fit exactly the advertisement she had read that morning. Isaiah took to cutting up the *Salem Sunbeam*, leaving in only the births and obituaries.[7]

Everett showed ability as a "decorator" rather early in life. When he was ten or eleven he decided to decorate a room on the third floor of the Shinn house on East Avenue, The rooms on this floor were all whitewashed; Everett chose a wall and marked out his drawing, the subject being a ship at sea with lightning and dark clouds, and waves washing over the deck of the vessel. After the drawing was completed, he painted the wall.

A number of his friends were present at the time. Joseph Andrews remembered hiding under one of the beds in dread fear that Mrs. Shinn would come and find the wall desecrated. When she did come, her only comment was "Isn't that just beautiful."

Everett's lack of parental discipline as a child evidently made him feel that tantrums were perfectly all right. He himself says that if he didn't get his way, he lay on the floor and screamed until everyone within earshot came around to his way of thinking.[8]

Everett Shinn had many friends as a child. His derring-do endeared him to his contemporaries and sometimes to older boys in the town. Shinn greatly admired one Oscar Reeves and his friendship with Oscar was deplored by his parents as they believed Reeves led Shinn into all sorts of dangerous, if not sinful, behavior. Shinn describes Reeves and other friends:

> The gang that Oscar controlled was a good cross-section of Woodstown. There were the smart young twins, Prof and Pruf Seagraves, keen-minded Punk Darlington, studious Ben Scott,, gentle Damon Humphries, heavy, rustic Newt Gant, and another set of twins, Squink and Fum Wibble [sic]. Squink had a speech defect which was like man's first primitive attempts to talk; and all of his teeth were missing except one in the upper front which was loose and operated on a hinge like a trapdoor. Whenever he wanted to spit out tobacco juice, his lips would part, the solitary tooth would fly out, and from under it would come a quick and expert squirt of brown liquid, after which Squink would suck

East Avenue, Woodstown, circa 1900. WOODSTOWN PUBLIC LIBRARY.

his tooth back into place. . . . And certainly Tommy Toohey deserves
mention as does Will Jaquette, son of a dentist, who once cut my mouth
to pieces trying to treat me with his father's drill.

Oscar was a force for good. His moral control over the crowd was
amazing. . . . He would never allow us to smoke anything but corn silk
. . . we did cheat him on this score with caution . . . punishments meted
out to offenders were harsh.[9]

Frank Andrews was Shinn's closest boyhood friend. His father owned
one of the local drugstores and Shinn had a notorious sweet tooth so this
must have been a very convenient friendship. Frank and Everett rang the
fire bell late one night, causing some consternation in the town.

As was usual in small American farm communities at the end of the
nineteenth century, children made their own pleasures. There was little
entertainment aside from occasional parades and visiting circuses and medi-

16

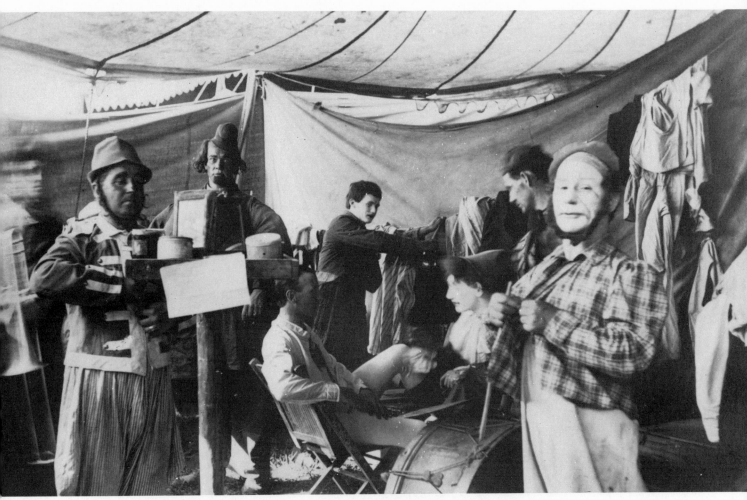

The circus comes to Woodstown, 1890. WOODSTOWN PUBLIC LIBRARY.

cine men. Shinn never missed a circus, of course. Small boys swam and explored forbidden territories. Shinn had a great interest from early childhood in acrobatics and swimming. He seems to have excelled at acrobatics from the time he was four, but the swimming was something else again.[10]

At the age of eleven Shinn announced to the family that he could swim and furthermore that his skill was not marred by "dog fashion."

My father was pleased . . . my mother drew a breath of relief. "At least," she said, "if you fall into a deep place you can splash yourself to shore."

My pride was jolted. Splashing was not the word for the demonstration I had given of a smooth breaststroke, when with sweeping arms I had planted my wrist on my older brother's chin and on the opposite side had caught my younger brother across the mouth.[11]

17

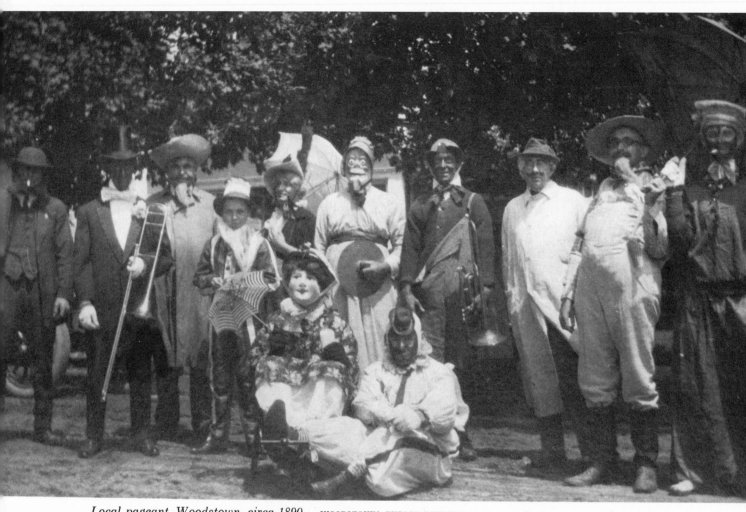

Local pageant, Woodstown, circa 1890. WOODSTOWN PUBLIC LIBRARY.

Circus performers, Woodstown, circa 1900. WOODSTOWN PUBLIC LIBRARY.

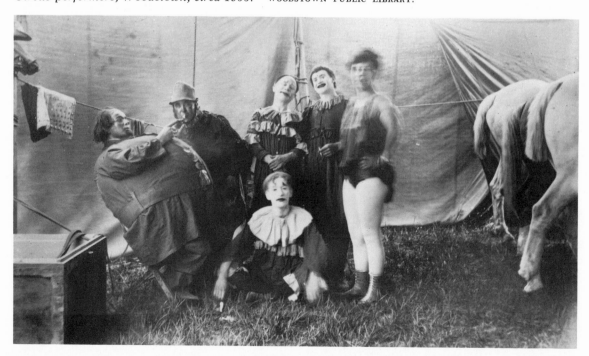

Everett's penchant for boasting caused him to swallow a great deal of water on many occasions.

Everett writes of his childhood interest in acrobatics:

> In the space between the apple trees, I strung a slack wire and improved my sense of balance and timing to meet the vibrations of the wire. I was now ready to ride my low wheeled bicycle around the gutter edge of our mansard roof. In and out around three chimneys I pedaled the solid-tired machine. My father witnessed this act at his lunch hour. The length of his heated admonition allowed him only time to eat his dessert.[12]

Shinn's interest in acrobatics applied also to his fascination with playing games on ice. Skating was a pastime loved by country children of his day and Everett and his friends were no exceptions. They played a sophisticated form of follow-the-leader, usually on ice just barely able to stand their weight. Leapfrog on skates was another dangerous winter sport.

From reading Everett Shinn's autobiographical material, one must come to the conclusion that Shinn had a rather agreeable childhood and few major problems with his family.

He has written at length about his grandmother Sayers, his mother's mother, a woman he loved dearly. For warmth, this writing would lead one to believe that his grandmother Sayers meant more to him than any other person in his young life. He loved her cooking and admired her disciplinary methods, which were original and memorable. At the time of her funeral he wrote:

> It was her utter quiet and serene placidity that shockingly thrust the word "funeral" into my childish mind. . . . At the side of her coffin gripping my mother's arm, I thought if grandma was dead then why this consideration for her hearing?
>
> Grandma would have liked the sunlight to stream in. She would have preferred cake and tea . . . and doughnuts and pie for the children, a party, a time of merriment and cherry words of remembrance for a guest that could not stay.
>
> Grandma Sayers' memory is part of my fiber as I am part of her blood and that part of my youth that could have trailed off to do small evil things, she checked, not by scolding or the switch but by her smile sitting at her little table under the canary cage.[13]

Grandmother Shinn was another matter. Everett had nothing good whatsoever to say about her, and in his writing one is able to feel the overshadowing strictures put upon the whole family by her presence.

Shinn says:

> She was a tall gaunt grey garbed Quakeress. Her plain attire was the color of granite and her mind was as inflexible as that stone . . . she was of an

Skating, circa 1890, Woodstown. WOODSTOWN PUBLIC LIBRARY.

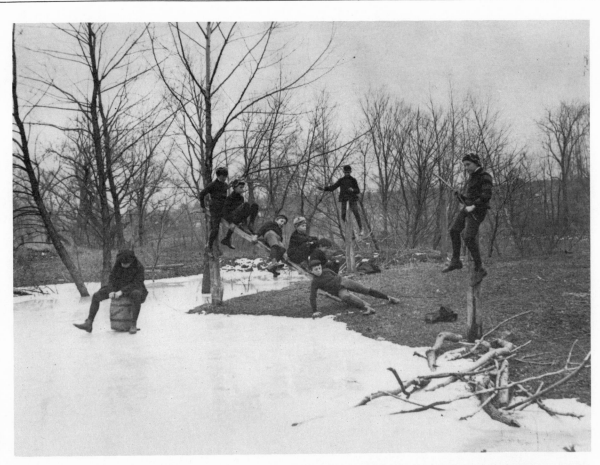

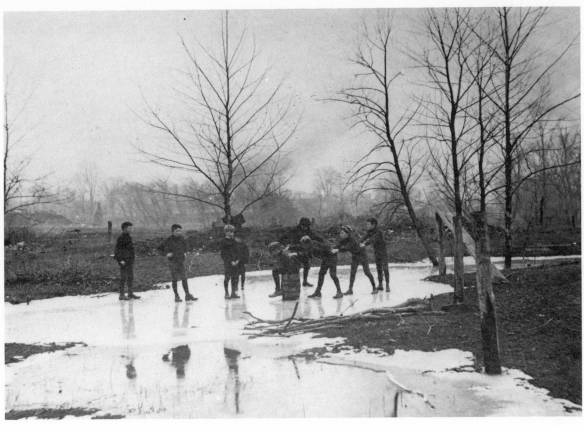

unyielding composition. The chiseled folds of her voluminous skirt did
not hang in their precise folds by the weight or texture of the fabric but
I believe were chilled to solidity by the frost of her nature. . . . All day
she remained in her room upstairs where I was sure she prepared the
gloom she brought to the table, scraping it out from deep closets, satu-
rating her aura with the gloom of the upper hallway.

Years later when my cousin Wilbur whispered a tragic happening in
our family before I was born I looked back to the tall old lady in the
Quaker clothes and felt a surging pity for her farmer husband, who, I
was told, made his way out of this troublesome world by summoning his
family to jointly witness the drawing of his razor across his throat.[14]

As for his brothers, Shinn had the usual problems connected with
sibling rivalry, albeit in his day these skirmishes were not dignified with
psychological tags. They just happened. In Everett's case, his brother
Warren was much more his antagonist than his brother Harold.

In writing of Warren from the vantage point of forty years, Everett
says,

Warren had a touch of the religious fanatic which had trailed down to
him from our ancient militant ancestors . . . my brother was as unreason-
able and cocksure as the early Shinns. He would have you walk the plank
of his tongue, and believe me it sagged precariously over a seething
brimstone sea.[15]

The influences that were to carry Shinn through his long and fas-
cinating life were all present in Woodstown, New Jersey. The peculiar sexual
mores of the town—multiple alliances were always way above the national
average there and still are; Shinn's interest in acrobatics and circuses; his
extreme willfulness and devotion to self—all these patterns were evident in
his childhood. His character was strongly set.

Chapter Two

PHILADELPHIA

IN 1888 AT THE AGE OF FIFTEEN, EVERETT SHINN LEFT WOODS-
town to go to school in Philadelphia. He was to return to Woodstown only
for visits during the remainder of his life. In Philadelphia, he enrolled at the
Spring Garden Institute, where he studied mechanical drawing and related
subjects.

Shinn once described his interest in mechanics to Bennard Perlman
and Perlman recalls the conversation in his book *The Immortal Eight:*

> *He had never intended to be an artist. His adolescent aptitude for*
> *mechanics had been awakened by an article in* The Scientific
> American *describing the invention of the submarine. Inspired by*
> *what he had read, the boy had spent a whole summer at home*
> *making a tiny model of his own. . . . When the minute-sized submarine*
> *was launched without fanfare in the kitchen sink of the Shinn*
> *home, it came to rest on the bottom of a shallow ocean. . . .*
> *Construction was begun on a larger model built to hold two boys,*
> *but this ship never reached water; it was wider than the barn*
> *door opening through which it had to pass.*[1]

Shinn did build the submarine mentioned above. There is clear evidence of this fact in a picture of the contraption, which appears on the front page of an old family album. However, his discussions with Perlman do not coincide with his own thoughts on art as a child, recollected by him later in life.[2]

In Shinn's autobiographical material, there is writing pertaining to his feelings about art as a child. He states that he felt the need to hide his interest in art and his ability as an artist for fear he would be judged a "sissy" by his peers.

Part of his memory development, according to his statements, came from going home at night after boisterous activities with his friends and reproducing on paper scenes from the day's events.

After two years at the Spring Garden Institute, Shinn was employed by the Thackeray Gas Fixture Works designing light fixtures. This occupation began to bore Everett in a very short time, and he would cover the margins of his paper with drawings of all kinds. He was fired by Thackeray, and the foreman advised him to go to the Pennsylvania Academy of the Fine Arts. This perceptive man stated: "You have the gift to draw—do it because you can and I can't."

Probably Shinn's interests when he came to Philadelphia lay in two directions—mechanics and drawing. In any case, in the fall of 1893, Shinn registered for classes at the Pennsylvania Academy of the Fine Arts and also started work as a staff artist with the *Philadelphia Press.*[3]

At the time of Shinn's matriculation, a number of his future associates in the art world already were enrolled in the Academy, although it took him a while to get to know them because of conflicting schedules. Glackens was there as well as John Sloan, who had also attended the Spring Garden Institute; and Robert Henri had been in attendance. The men studied under a number of excellent and famous instructors, especially Thomas P. Anshutz, who was a student of the great Eakins.

Shinn has described his first years at the *Press* as follows:

> In the art department of the Phila. Press on wobbling ink-stained drawing boards . . . [we] . . . went to school, a school now lamentably extinct . . . a school that trained memory and quick perception. For in those days, there was not on any newspaper the handy use of the camera, that dependable box of mechanical memory which needed only the prodding of a finger to record all and sundry of the editor's wish . . .

> The artists carried envelopes, menu cards, scraps of paper, laundry checks and rendered bills or frequently nothing to their work. Rigid requirements compelled them to observe, select and get the job done.[4]

When Shinn first went to work on the *Press* and received his first assignment, he sat up all night waiting for the paper to come out. He wanted to see if his drawing was in all the editions. "There it was, on page eight of

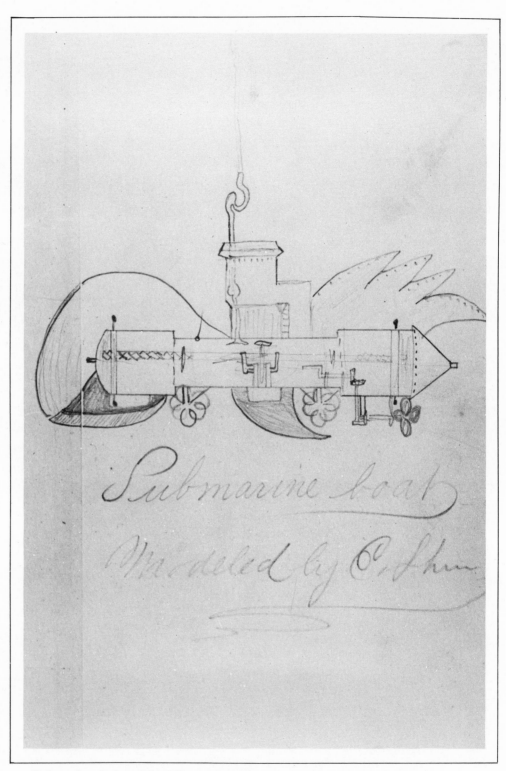

Submarine designed by Shinn at age eleven or twelve. SHINN PAPERS.

E SHINN
1905

Streetcar Scene, *pen and ink,
1905. Typical newspaper style.*
ARTHUR G. ALTSCHUL COLLECTION.

every one. Not in all my life have I had such a thrill from anything I have ever done."[5]

Shinn recalled his early newspaper experiences vividly, especially an assignment to do drawings for a story about sitting on the hat of "Billy Penn," the statue which tops City Hall in Philadelphia. Shinn and a reporter friend climbed to the top of the building to get a story:

> Our city editor had conjured up some idea that the tower of the City Hall, and further, toward Heaven, the top of William Penn's hat offered novelty. Joe Robinson craved novelty, demanded novelty . . . got novelty but never used it. His Sunday feature regularly called for some extravagant innovation but at the last minute he inserted the customary story of some resurrected revolutionary or Eighteen-Twelve War wildcat with portraits by Sully or Stewart [sic] and tied them up to the living flops of the same name but not the same character that walled themselves in Rittenhouse Square.[6]

Some of the reporters with whom Shinn worked were fascinating individuals. Many times, with a reporter named Simonds, Shinn walked the notorious "Middle Alley" in Philadelphia to its dead end, a board fence and warehouse. As Shinn says, "We walked over the bodies lying like a corduroy road along the narrow alley . . . criminals who had deserted their holes for the foul air off the trickling line of liquid filth that ran against bare feet."

The 1890s were still the days when artist and reporter covered stories together and were dependent upon each other. Many of the reporters lived up to their future prototypes in the play *Front Page*, which was yet to be written.

Tommy Moore, a reporter who worked with Shinn on a story of the *Southwark*, an iron boat for cutting ice, stayed drunk for five days while on the story. The engine went into dead center and the boat froze in, but Tommy did not realize that the ship had left port.

In Philadelphia, the reporters and artists had police cards that entitled them to a certain amount of protection. Situations were probably not nearly as dangerous then as they are today. Shinn had some interesting memories from his days as a reporter-artist. One such event he recalled in his autobiography: "Then I remembered in Philadelphia that I saw a Chinese on a roof of a burning building whom no one tried to save. 'No interfere. No touch. No interfere with fire god.' These were the admonitions of the other Chinese at the scene."[7]

When Shinn moved to Philadelphia in 1893 and joined the *Philadelphia Press*, he did not know the newspaper artists with whom he would become friendly over the next few years. He worked the night shift at the newspaper because he attended Academy classes by day. Consequently, he did not meet William Glackens or Frederick Gruger who were at that time working on the *Ledger* or John Sloan who was working on the *Inquirer*.

28

Shinn found a place to live at Eighth and Chestnut streets, moving later to Girard Avenue. Everett was joined at the *Press* at about the end of his first year of employment by the irrepressible George Benjamin Luks.[8] Shinn describes Luks:

In those days at the *Philadelphia Press* Art Department, Luks' clothes were shadow plaids of huge dimensions, the latest word in suburban realty maps. Vests were featured, cream-colored corduroy, like doormats laid out . . . like bark-stripped logs on a frontier fort stockade. A flowing black tie like a soot-dyed palm tree splayed out under his high and immaculately clean minstrel collar. A (black) bowler tilted in a cocky slant over his blond hair.[9]

George Luks was a very entertaining, though boisterous man. He would awaken Shinn out of a sound sleep so he could watch Luks perform at the shaving mirror, which he used as a kind of painting exercise each morning.

Luks was an excessive drinker even in those days, and Shinn noted "his rumbling advance along a bar rail was like a tank rolling on with a child at the wheel and all guns popping cork."

After much transferring back and forth by Glackens and Shinn between the *Press*, the *Ledger*, and the *Inquirer*, Glackens, Shinn, and Luks all wound up on the staff of the *Press* by mid-1895. Sloan was still at the *Inquirer* until December 1895, when he also joined the group. The artists became friends, however, and the *Press* art department became a meeting place for men both on the staff and off with similar artistic and literary interests.[10]

The memories of these artist-reporters were fine honed by the necessity of taking a few notes and coming back to the office to draw what they had seen in the field. Shinn never lost this talent. When he was sixtyish and living with his fourth wife, Paula Downing, in Westport, Connecticut, they used to pass an old house while out driving in the car.

Paula Shinn was very enamored of this house and asked Everett to make a drawing of it. He returned home from a ride one afternoon and did a beautiful pastel of the house which he presented to his wife, saying, "If you can find a detail which is wrong in the drawing, I'll buy you a new dress." Shinn and Paula and a friend, Charlie Henry, motored back to the house the next morning to have a look. Shinn had missed nothing.[11]

A great deal has been written about the early meetings of the Philadelphia Four. To repeat this history would seem to be redundant. Shinn had associations with all of them at one time or another and was especially fond of Luks and Glackens. Luks's overindulgence in alcohol caused him to be very pugnacious at times, however; and he was given to excessive boasting. George used to say that the world never had but two artists, Frans Hals and little old George Luks.

Of all the men Shinn knew in those days, his most lasting association

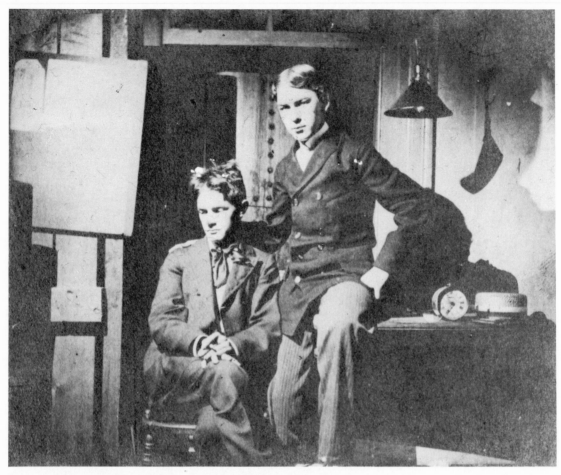

Everett Shinn and Hugh Kelly, Philadelphia Inquirer *office.*
DELAWARE ART MUSEUM. JOHN SLOAN PAPERS.

⟶

Everett Shinn, *by William Glackens, sanguine drawing on brown paper, circa 1900.* AMHERST COLLEGE COLLECTION, AMHERST, MASS.

was made with William Glackens, whom he admired all his life. The artists and reporters on the newspapers used to spend the time waiting for story assignments in getting Glack to go into a room and come out and draw what was in there from memory. He seldom, if ever, made a mistake.[12]

Robert Henri's studio was the center for a great many social activities of this group and there were many high-level discussions there. There were also boisterous stag parties in which Henri and others staged amateur theatricals and burlesques. There is no doubt that Shinn developed his natural taste for dramatics through his Philadelphia associations. Among the farces produced at Henri's studio was one called *Twillbe*, a takeoff on Du Maurier's *Trilby* which was a very fashionable play at that time.[13] The play dealt with Svengali and hypnotism.

30

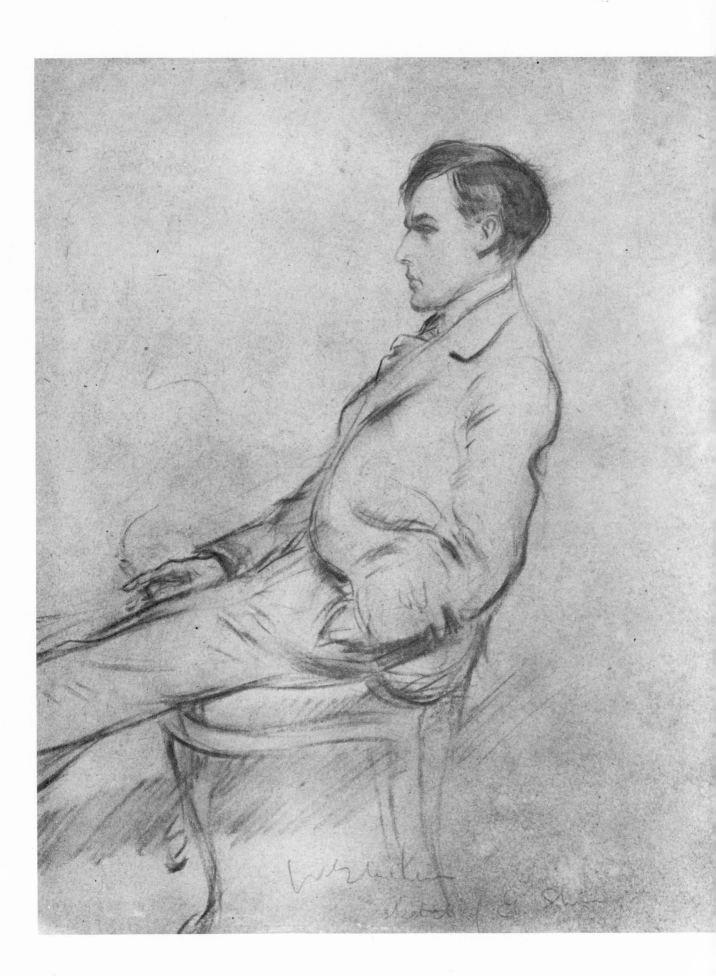

The Philadelphia Four—Glackens, Shinn, Luks, and Sloan—were greatly influenced by Robert Henri—more by Robert Henri the man than Robert Henri the artist. He was a source of inspiration and intellectual stimulation and the means by which they came together and exchanged ideas. Sloan once said, "Henri could make anyone want to be an artist." Henri had a deep commitment to the artistic spirit of Thomas Eakins, feeling that honesty of subject matter and rendition were all-important. And his influence was felt by the artists, just slightly younger than he was, who socialized with him in Philadelphia during the 1890s.

Chapter Three

NEW YORK

IN 1897, EVERETT SHINN STARTED WORKING FOR THE *New York World*. Other members of the Philadelphia group, Luks and Glackens, succumbed to the lure of New York and joined him there shortly. John Sloan was the only holdout, not answering the call of Manhattan until 1904.

Shinn was delighted with New York. He was fascinated by the people, the noise, the activity, the garishness. The whole situation was very different from staid, proper, stuffy Philadelphia.

A year after arriving in New York, Shinn began contributing to magazines as an illustrator. As Bennard Perlman tells us in *The Immortal Eight:*

> Shinn had a gluttonous taste for achievement. In the fall of 1898, after only one year on the art staff of the New York World, he set his sights on the center spread of Harper's Weekly. This prize plum was the hallowed domain of Gibson, E. A. Abbey, and Charles Stanley Reinhart. The artwork of these established illustrators alternately occupied the two most desirable pages of the magazine.

*Shinn planned a . . . campaign. Armed with a . . . portfolio of
drawings, he haunted* Harper's *at regular intervals. . . . After fifty-
two weeks of this ritual, even an aggressive Shinn was near defeat.
As a last resort, he humbly left his drawings one bleak December
day with the request that the proper persons glance at his wares.*

*Upon his return the following week, the door of a hitherto
forbidden sanctuary was opened. . . . Colonel George Harvey, editor
and publisher of* Harper's Weekly, *was shuffling through Everett
Shinn's sketches.*

*"You have here such a variety of New York street scenes," the
editor began, "that I was wondering if you have in your collection
a large color drawing of the Metropolitan Opera House and Broadway
in a snowstorm." Shinn glanced out of the window at the falling
snow which would soon create the desired effect. "I think I have,"
he replied. "Good," snapped Harvey, "have it here at ten tomorrow
morning."*

*Shinn had his evening's work cut out for him. On his way home
he purchased a fifty-cent box of pastels, then hurried to the
Metropolitan Opera House to observe the architectural detail of its
facade. Once home, he began to toy with the pastels . . . a medium
he had not employed since his student days at the Pennsylvania
Academy.*

*Shinn worked through the early hours of the morning. Shaky
and pale he delivered the finished drawing at the appointed deadline.
Colonel Harvey stared at the artwork in silence. He scrutinized
the lights twinkling dimly through the swirling snow, the dashing
hansom cabs, the scurrying ladies hoisting their voluminous skirts.
"We have to decide on a price," Harvey finally announced. "How
about four hundred dollars and you own the original?"*

*When Shinn opened an advanced copy of the February 17, 1900,
issue of* Harper's Weekly, *he thrilled at his achievement. He was
confident that he had arrived.*

Beginning at this time and continuing for many years, in fact for
most of the rest of his life, Everett Shinn's drawings and pastels appeared
in many major magazines. Besides *Harper's*, magazines using his material
were *Vanity Fair, Judge, Life, Look*, and so on.

In 1898, Everett Shinn married Florence Scovel of Philadelphia.
Flossie Shinn was distantly related to the Biddle family and, when Shinn
became engaged to Florence, he was taken to meet with a number of Scovel
relatives, including these ancient and proper Biddles who sported their blue
blood in the way only old Philadelphia families can. They really did not
approve of Shinn or his looks. Shinn was to put it mildly a very snappy

Everett Shinn meets his future wife's Philadelphia relatives. "An Artist! But what do you do, *Mr. Shinns?"* DRAWING BY WALLACE MORGAN.

dresser. His wardrobe ran to wild plaids and checks but he was always immaculately turned out.[1] John Sloan always described Shinn in his diaries as very well dressed.

Flossie was a witty talented woman, an illustrator in her own right, and her company was much sought after by Shinn's associates—possibly more than his own. In the early years of twentieth-century New York, Flossie and Edith Glackens, William's wife, became fast friends. And it is through their lively correspondence that we come across wonderful descriptions of the activities of this talented group of artists.

At this time of his life, between 1897 and 1903, the lower-class life in New York was very fascinating to Shinn as a painter. From January 16 through February 25 of 1899, Shinn exhibited at the Pennsylvania Academy of the Fine Arts. In this exhibition was one of his best pastels, entitled *The Docks*, now owned by Munson-Williams-Proctor Institute of Utica, New York. This picture is still possibly the finest piece of work ever done by Shinn. In it, his qualities as a reporter-observer and his great gift of line are combined in the most felicitous fashion. From this exhibition at the Academy, William Merritt Chase, famous artist of his time, purchased a painting entitled *Street Scene*.

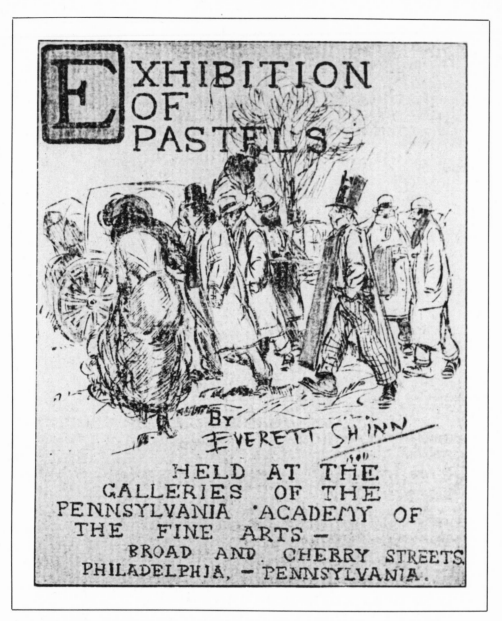

Cover of catalog of Pennsylvania Academy exhibition of Shinn's pastels, January through February, 1899.

LIST OF PASTELS

1. Madison Square (thaw)
2. House-tops (rainy day)
3. Mentropolitan Annex
4. House-tops (snow storm)
5. Broadway and Twenty-third Street
6. Dewey Arch
7. Salem Creek
8. Madison Square (cabs)
9. Rag-picker
10. Down-town Shop
11. The Docks
12. The Storm (No. 1.)
13. The Foundry
14. Fifth Avenue Stage Coach
15. Washington Square
16. Unloading at the Docks
17. Blockade at the Ferry-slip
18. Fifth Avenue (snow-storm)
19. A Rainy Night
20. The Theatre
21. Fourteenth Street Theatre
22. Cooper Union Fountain
23. The Lime-kiln
24. The Geese.
25. Along the Creek
26. The Lime-light
27. Fifth Avenue. Loaned by Miss Gilder
28. Cutting a Road in the Suburbs
29. Union Square
30. During the Biograph
31. The Storm (No. 2.)
32. The Storm (No. 3.)
33. River Front
34. Street Scene. Loaned by Mr. Wm. M. Chase.
35. Park Row
36. Shoppers (Twenty-third Street)
37. Dewey Arch (No. 2.)
38. Down Town Music Hall
39. The Rail-road Bridge
40. The Plaza
41. House-tops, (moonlight)
42. Gramercy Park
43. Across the Medows
44. In the Suburbs
45. East Twenty-first Street
46. Snow-balling. Madison Square
47. East Side
48. The Curtain Call

PORTRAITS

1. Miss Elsie de Wolfe. Loaned by Miss de Wolfe.
2. Miss Julia Marlowe Loaned by Miss Marlowe
3. Portrait of Miss Marlowe (Violia) Loaned by Miss Marlowe
4. Portrait of Miss Marlowe (Barbara Frietchie) Loaned by Miss Marlowe
5. Portrait of Mr. Clyde Fitch

List of pastels exhibited in Pennsylvania Academy show, 1899.

In 1899, Shinn submitted nine pastels to the Society of American Artists for an exhibition. All these were rejected by the society, and this experience was repeated at the National Academy of Design, also in 1899.[2] However, he did have the one-man show at the Pennsylvania Academy mentioned above.

The year 1900 was especially important for Everett Shinn. Among other things, he drew his now famous elongated portrait of Mark Twain for *The Critic*. As he said, this portrait just kept getting longer and longer and turned out to be a semigrotesque portrayal of the famous author. But in the meantime, Shinn did some absolutely beautiful sketches of Samuel Clemens as preliminaries to the drawing for *The Critic*.[3] Later, in the 1950s, he did an excellent portrait of Mr. Clemens, now in Detroit.

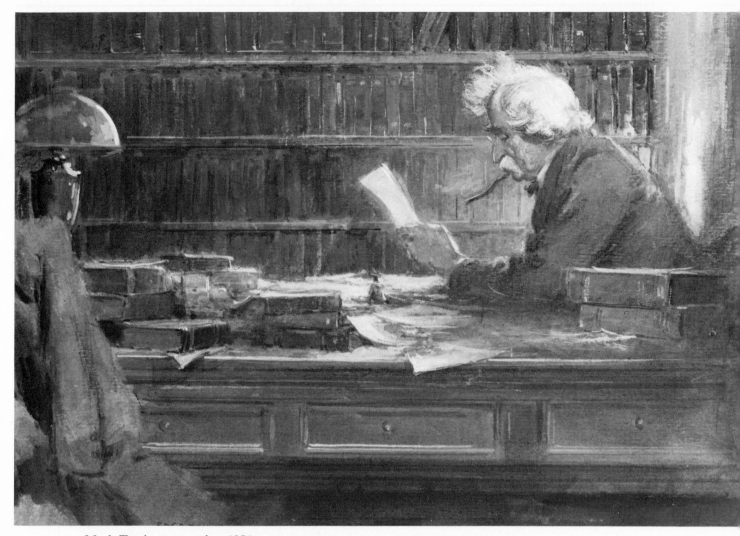

Mark Twain, *watercolor, 1951.* THE DETROIT INSTITUTE OF ARTS. GIFT OF MR. AND
MRS. LAWRENCE R. FLEISHMAN.

In February 1900, Everett Shinn had his first large one-man show,
which took place at Boussod, Valadon and Company, 303 Fifth Avenue,
New York. This exhibition opened February 26 and ran through April 4.
All in all, Shinn showed forty-three paintings and drawings in this exhibition,
the major portion being pastels. (The catalog lists only forty-one, but Shinn
claims it was forty-three.) It is interesting to note that there were no "theat-
rical" pictures in the exhibition except for three portraits of Julia Marlowe—
and two exteriors of theatres. Portraits of Clyde Fitch and Elsie de Wolfe
appear in this exhibition, showing that, in 1899, he had already made the
acquaintance of the people with whom he would function as a decorator
of furniture and a muralist for the next decade or more.

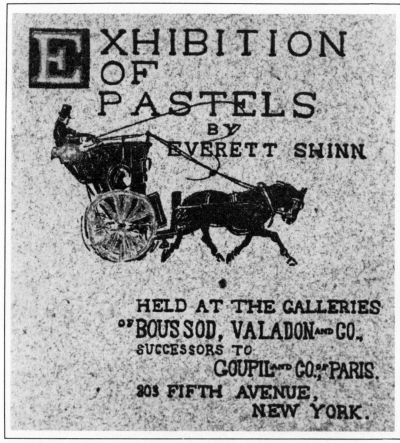

Catalog of Shinn's first large one-man show of pastels, at Boussod,
Valadon, New York City, February 1900. SHINN PAPERS.

LIST OF PASTELS

1. Madison Square (thaw)
2. House-tops (rainy day)
3. Metropolitan Annex
4. Housetops (snow storm)
5. Broadway and Twenty-third Street
6. Dewey Arch
7. Salem Creek
8. Madison Square (cabs)
9. Rag-picker
10. Down-town Shop
11. The Docks
12. The Storm (No. 1)
13. The Foundry
14. Fifth Avenue Stage Coach
15. Washington Square
16. Unloading at the Docks
17. Blockade at the Ferry-slip
18. Fifth Avenue (snow storm)
19. A Rainy Night
20. The Theatre
21. Fourteenth Street Theatre
22. Cooper Union Fountain
23. The Lime-kiln
24. The Geese

25. Along the Creek
26. The Lime-light
27. Fifth Avenue. Loaned by Miss Gilder
28. Cutting a Road in the Suburbs
29. Union Square
30. During the Biograph
31. The Storm (No. 2)
32. The Storm (No. 3)
33. River Front
34. Street Scene Loaned by Mr. Wm. M. Chase
35. Park Row
36. Shoppers (Twenty-third Street)

PORTRAITS

1. Miss Elsie de Wolfe. Loaned by Miss de Wolfe
2. Miss Julia Marlowe. Loaned by Miss Marlowe
3. Portrait of Miss Marlowe (Viola). Loaned by Miss Marlowe
4. Portrait of Miss Marlowe (Barbara Frietchie) Loaned by Miss Marlowe
5. Portrait of Mr. Clyde Fitch

Charles M. Tweed bought *The Docks* out of this exhibition, and altogether Shinn sold ten pictures out of the forty-three.[4]

The critics had a lot to say about Shinn's first one-man exhibition at Boussod, Valadon. In a review in the *Commercial Advertiser* of New York on February 26, 1900, the critic says, "clever and unconvincing, perhaps an unfortunate slovenliness . . . hope he will escape from some of his mannerisms."

Shinn was reviewed in thirteen papers in New York, Philadelphia, and Pittsburgh. The *New York Times* said, "may be called an American Raffaello when he shall have learned to draw better."

Most reviews were very favorable, however. Shinn was still interested in his New York studies at that time, but he was clearly becoming more and more interested in the theatre as he went along.

Shortly after the Boussod, Valadon exhibition closed, Everett and Flossie went to Europe. Interestingly, Shinn never wrote down, in all the thousands of words he wrote, one single impression of his trip to Europe. He must have gone to both England and France, because his paintings, for years afterward, reflect the trip. Paris scenes and once in a while an English one were seen periodically as late as 1920. His impressions seem to have been completely visual: no scrap of paper exists complaining of water or food problems, no irritations about language, not one word.

However, from evidence in his notebooks, Shinn exhibited in Paris on July 3, 1900, at Goupil's. In this exhibition, pastels shown were *The Wrestlers*, *Merry-go-round*, *Monkey Cart*, and *Luxembourg Gardens—Punch and Judy*.[5]

After this trip to Paris, he never again seemed to take note of the seamy side of New York until he did his famous New York at Night series later.

It must be assumed that Shinn returned from Europe in late August or early September because by November he exhibited again in the United States, this time at the New York Gallery, in New York. The painting exhibited was called *Metropolitan Annex*. And on the seventeenth of that month, his portrait of Clyde Fitch appeared in *The Critic*.

In January 1901, he had his second large one-man show at Boussod, Valadon. In this show there were forty-six pastels and oils as well as some thirty-odd drawings. These pictures were all related to Paris or London with the exception of a few drawings. J. P. Morgan bought two paintings, but on the whole very few pieces were sold.

The period from 1900 through 1911 was a time of great productivity for Shinn as a painter. His great love of and interest in the theatre had begun to show up very strongly in his paintings, and his exhibitions reflect this growing interest. In 1901–2 Shinn's work appeared in thirteen shows including another large show in November 1901 at Boussod, Valadon, an exhibition at Kraushaar Galleries and, in March of 1903, his famous show at M. Knoedler and Company on Fifth Avenue. Finally, there was a show at Durand Ruel Galleries in March 1904.[6]

Green Park, London, *pastel, 1908.* COLLECTION MR. BERNARD BLACK.

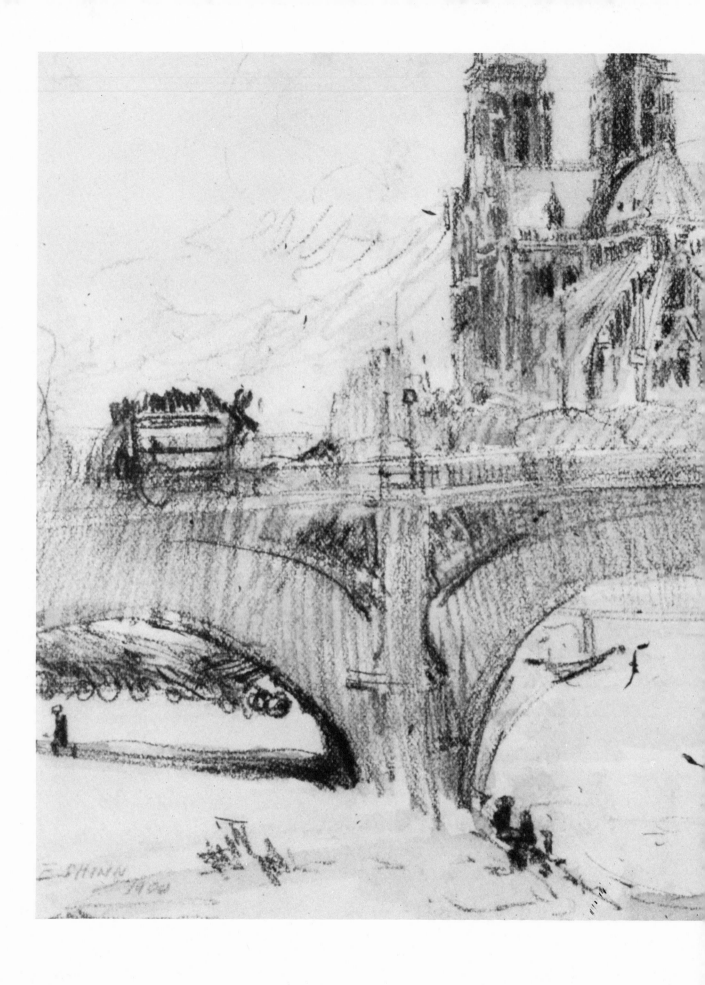

Bridge over Seine, Paris,
black chalk and watercolor,
1900. COLLECTION MR. AND
MRS. ROBERT C. GRAHAM.

43

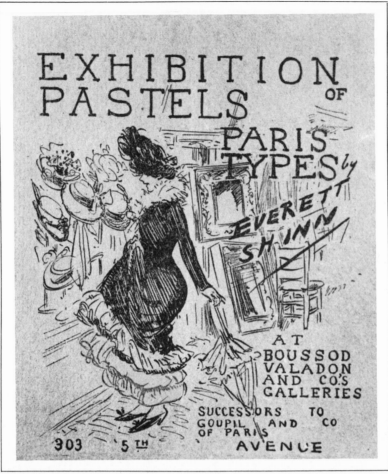

Catalog of Shinn's second large one-man show of pastels, at Boussod, Valadon, January 1901. SHINN PAPERS.

LIST OF PASTELS

1. Green Park (London)
2. Rue de Paris (Exposition)
3. News-stand
4. Grand Ballet
5. The "Bal Bullier"
6. Back Row, "Folies Bergerès"
7. La Blanchisseuse
8. Cafe Lelas
9. On the Boulevard
10. Merry-Go-Round (Luxembourg Gardens)
11. Along the Seine
12. Les Chiffonniers
13. Off the Rue de Rennes
14. At Versailles
15. Storm in the Luxembourg Gardens
16. The Milliner's Shop
17. The Trained Monkeys
18. Near Pont Neuf
19. The Wrestlers
20. Notre Dame
21. Fourteenth of July
22. London Street (Chelsea)
23. Behind the Scenes
24. Ballet Dance
25. The Milliner's Girl (Luxembourg Gardens)
26. The Flower Stall
27. Ville d'Avray
28. The Gaieté Montparnasse
29. Madame L—— of the "Chatelet"
30. Madame L—— of the "Chatelet"
31. Madame L—— of the "Chatelet"
32. Madame L—— of the "Chatelet"
33. Punch and Judy Show (Luxembourg Gardens)
34. Sunset (Luxembourg Gardens)
35. The Funeral
36. Outside the City Walls
37. The Theatre
38. Capucin Monk
39. In Front of the Pantheon
40. Paris Street
41. At the Convent Door
42. Montmartre
43. Before the Mirror
44. In the Fontainebleau Forests
45. A Sudden Shower (Luxembourg Gardens)
46. Resting

The Orchestra Pit, Old Proctor's Fifth Avenue Theatre, *oil, circa 1906–7.*
ARTHUR G. ALTSCHUL COLLECTION.

Curtain Call, *oil, n.d.* IRA AND NANCY GLACKENS
COLLECTION.

46

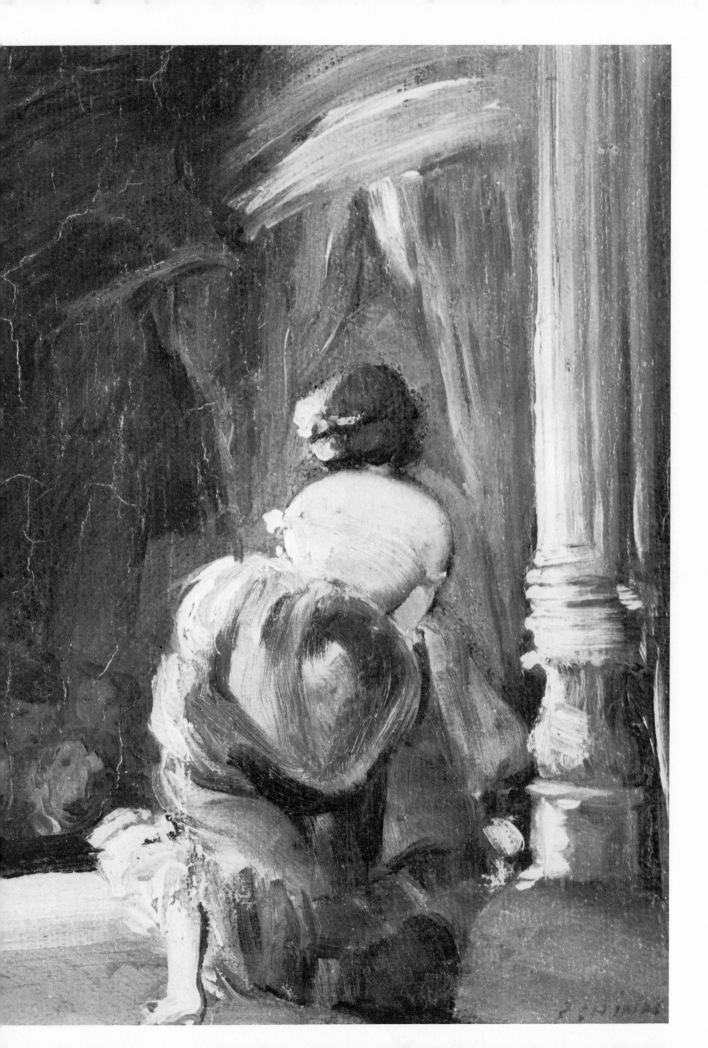

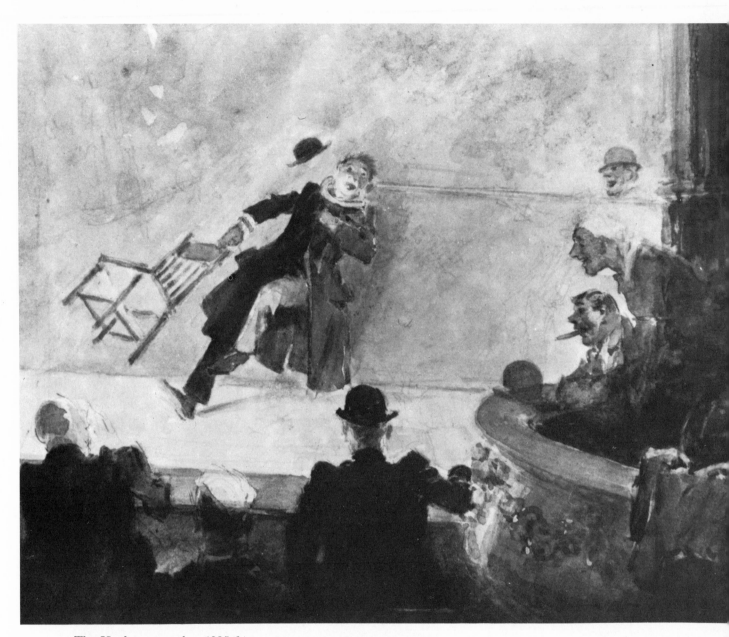

The Hook, *watercolor, 1935(?).* ARTHUR G. ALTSCHUL COLLECTION.

The Magician, *red chalk, 1906.*

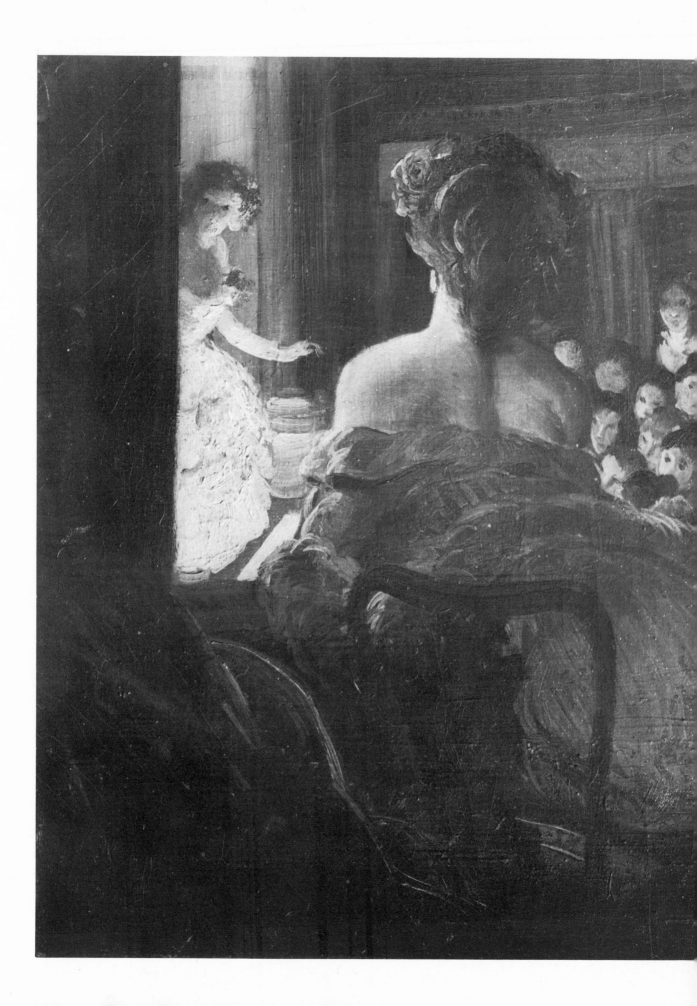

Theater Box, *oil on canvas, 1906.* ALBRIGHT-KNOX
ART GALLERY, BUFFALO, NEW YORK. GIFT OF T. EDWARD
HANLEY.

51

EVERETT SHINN

Olympic Theatre
14th St + 3rd av.
N.Y. City
1916

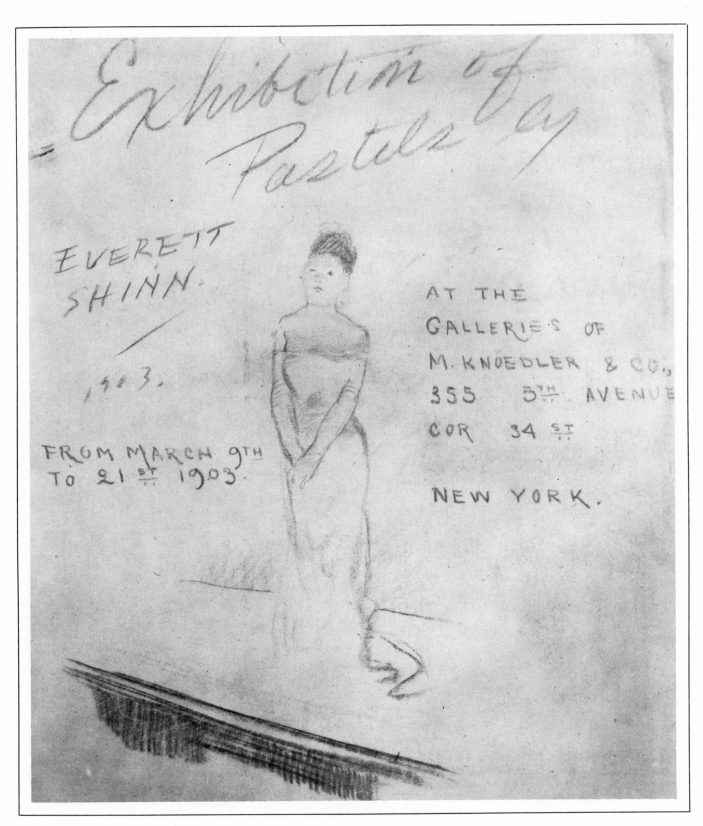

Poster *for Knoedler Exhibition, March 1903, pastel.* ARTHUR G. ALTSCHUL COLLECTION.

←

Study of Heads, *Olympic Theatre at Fourteenth Street and Third Avenue, New York City, 1906.* CHAPELLIER GALLERIES, NEW YORK.

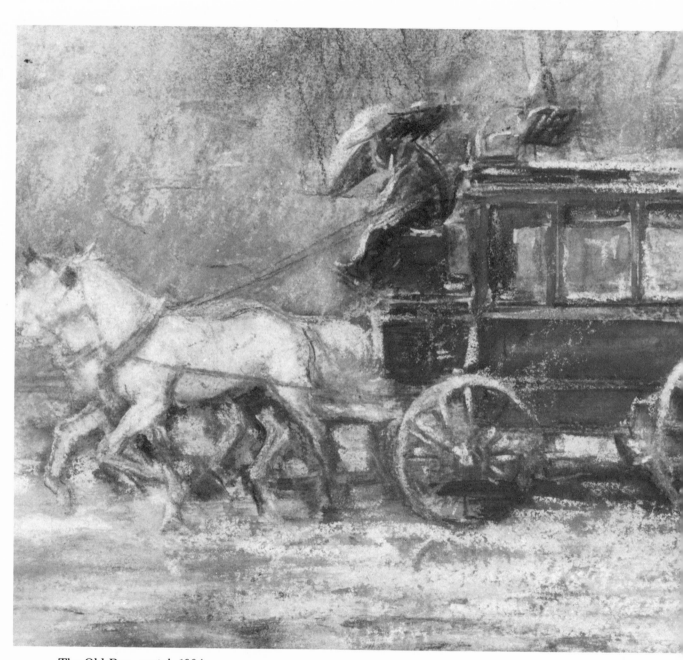

The Old Bus, *pastel, 1904.* R. H. FARBER COLLECTION, CEDARHURST, NEW YORK.

54

Exhibition of Pastels
by EVERETT SHINN
From the 2nd to the 16th of March, 1904
DURAND-RUEL GALLERIES
389 FIFTH AVENUE
Cor. Thirty-sixth Street NEW YORK CITY

Cover of catalog and list of pastels exhibited in the Durand-Ruel show, March 1904.

LIST OF PASTELS

1 Canal—La Villette	32 Across the Bridge—Paris
2 Paris—Early Morning	33 Tight Rope—Balancing Act
3 The Dance—From Back of Stage	34 Madison Square Tower
4 Bridge Over the Seine—Autumn	35 The Prize Fighters
5 The Ballet	36 Matinee Crowd—Broadway
6 Bridge Over the Seine—Winter	37 The Cemetery Wall
7 Girl in Pink	38 The Tired City
8 The Dance	39 Wash Day
9 The Prompter's Box	40 Lights on the River
10 The Funny Man	41 The Love Song
11 French Comedian	42 A Song of 1863
12 The "Trapeze Artist"	43 Bill Posters—Paris
13 Open-air Stage at Robinson	
14 Election Banner—23d Street and Broadway	SMALL PASTELS
15 Fire in Sky-scraper	
16 In a Box—French Theatre	44 Near the Greek Church—Paris
17 The Pool Players	45 The Acrobats
18 Café Chantant	46 Bridge Over the Seine
19 Show-window—Rainy Night	47 Sailing Boats—Long Island
20 The Frozen Seine	48 Before the Foot-lights
21 Japanese Juggler	49 The Gaieté Montparnasse
22 The Red Lantern	50 By-path in Central Park
23 Steps Between Houses—Paris Street	51 Skating
24 Empty Street—Paris	52 Slack-wire Walker
25 "Follow the Leader"—Jersey Meadows	53 Ghost Dance
26 Street Fight	54 Ballet Dancer—Paris Fête
27 Fête-Day—Paris	55 The Empty Fiacre
28 The Red Theatre	56 The Old-fashioned Pink Dress
29 Skating—Near the Palisades	57 The Yellow Light
30 When Paris Sleeps	58 A Spanish Song
31 Washing—French Canal	59 A French Type

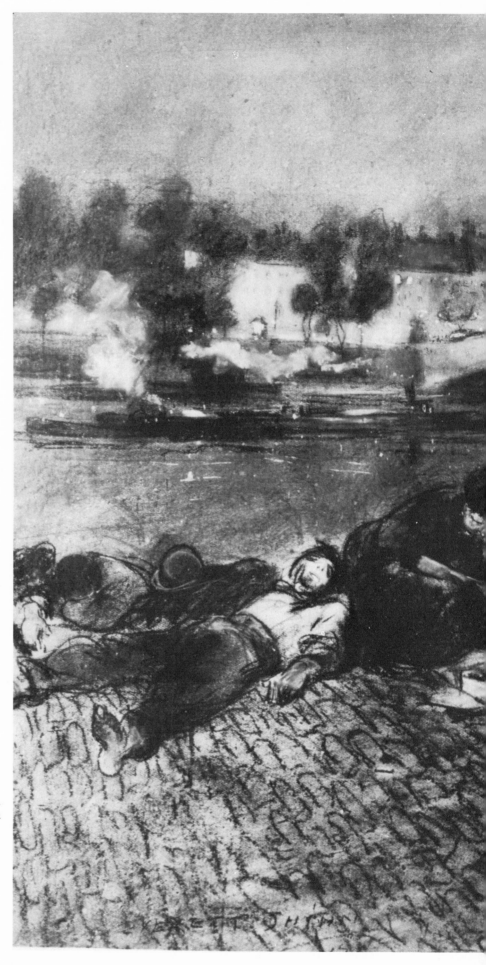

Seine Embankment, *pastel, 1903.*
WHITNEY MUSEUM. GIFT OF ARTHUR
G. ALTSCHUL.

56

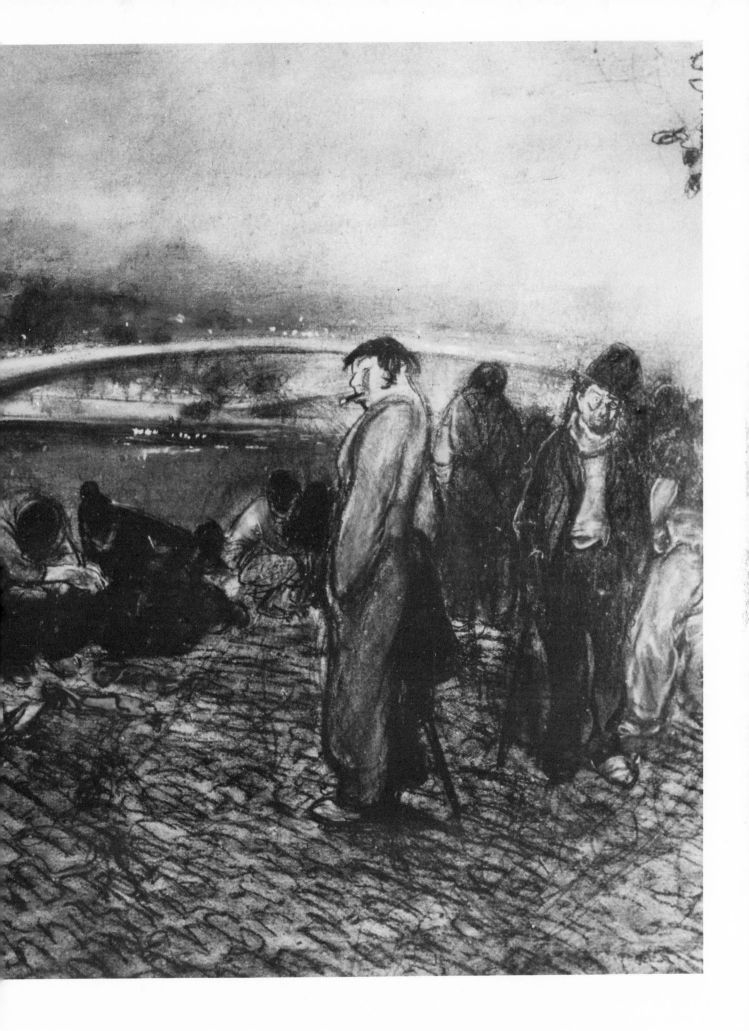

At this time he seemed to be getting along with his dealers quite well. He was not selling many paintings, but certainly more than any of his fellow painters—those who were painting at the time in the realistic style that came to be known as the "Ashcan School."

In the exhibition at Knoedler's his famous pastel of Mouquin's old restaurant was for sale for $300. This painting is now at the Newark Museum. *Gaieté Montparnasse* was also on sale—the price $250.

During the period 1904–11, Shinn continued to show in a wide variety of exhibitions including another show at Knoedler's in June of 1904, one at E. Gimpel and Wildenstein in 1905 which was peppered with French pictures and a number of ballet and theatre pieces. There were several at the Pennsylvania Academy, the Chicago Art Institute, one at the Carnegie Institute in Pittsburgh, the Corcoran Gallery in Washington, D.C., and at the Lewis and Clark Centennial Exposition in Portland, Oregon. He also loaned paintings to Stanford White frequently.

During this prolific ten years, Shinn was reviewed widely. For the most part, the reviewers were very kind to him. The *New York Times* said that he "has only to go forward to fill the full measure of success in the art of making the life of the day and pavement interpret and express the emotion and observation of the time." This was in February 1900. However, in the Union League Club Show in April 1911, one member was heard to remark, "If this is art, I guess I'm not up to it."

Henri Pène du Bois writing in 1905 called Shinn "a Fragonard of the present time," while the *Sun*, in 1901, felt he was a little too facile, expressing this opinion in a review of his second exhibition at Boussod, Valadon. The *Sun* actually reviewed Shinn twice, on both the fifteenth and sixteenth of January, in connection with the second Boussod, Valadon exhibition. One reviewer stated: "The danger of a brilliant talent such as Mr. Shinn exhibits is that it will fall too readily into ready-made forms."

Other reviews of the period were in the same vein: "his capacity for conveying emotions good (*Evening Post*, January 10, 1911); "rather weak but talented" (*Philadelphia Item*, November 19, 1901); "clever, too clever, but well worth seeing (*Brooklyn Eagle*, March 13, 1903); "not dull . . . lacks substance and truth but always brilliant" (*New York Press*, March 16, 1904).

At this time, Shinn was working mostly in pastels and red chalk, while doing some oils. In *Studio Talk* for November and December 1906, A. E. Gallatin states the following regarding Shinn's techniques with pastels:

Shinn is a master of the pastel; he knows thoroughly both the possibilities and the limitations of his medium. The material is never strained in endeavoring to get too much out of it; and if technically his pastels are great achievements, pictorially they are also. . . .
the artist is still rather new to oils and in consequence his paintings

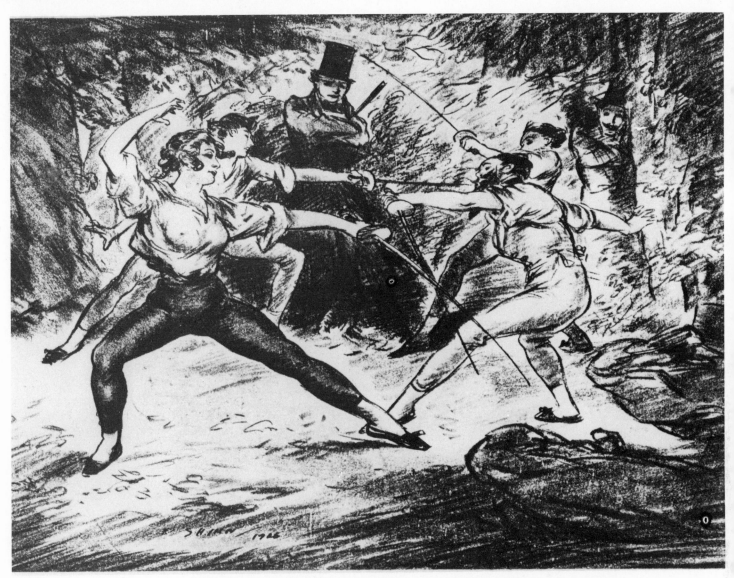

Drawing for Frederique *by DeKock.* DELAWARE ART MUSEUM. SLOAN PAPERS.
PHOTOGRAPH BY NICK HENKY.

are occasionally somewhat raw . . . as vigorously executed as the
pastels they have the same daring color schemes, painted with a full
and rapidly manipulated brush. . . . Shinn possesses a great contempt
for everything academic and does not believe in art schools. He
studied at the Pennsylvania Academy of the Fine Arts for five years,
but would never take criticism from an instructor. This disregard
for precedent and academic law has resulted in a decided freshness
of vision.

In 1906, he did a series of illustrations for *Frédérique* by Paul
DeKock, a project upon which both Glackens and Sloan had been working
from time to time. In his notebook he lists the illustrations expected of him.
He did some fourteen illustrations for which he seems to have been paid $700.

The Works of

CHARLES PAUL DeKOCK

With a General Introduction by
JULES CLARETIE

Frederique

Translated into English by
EDITH MARY NORRIS

VOLUME II

THE FREDERICK J. QUINBY COMPANY
NEW YORK LONDON PARIS

John Sloan, in his notes, reports as follows on this project:

> *There were to be fifty volumes of the DeKock publication,
> illustrated by Glackens, Luks, Preston, myself and others. One
> edition was printed on vellum at a thousand dollars per volume. . . .
> However, when about thirty volumes were off the press a court
> ruling was issued which released buyers of the whole set from their
> contracts on the grounds that the purchaser was not liable. This
> broke the limited edition business . . . we artists had a lot of trouble
> collecting part of the money owing for our work.*[8]

In 1907, Robert Henri became extremely vexed at the fact that his
paintings, Sloan's, Glackens's, and those of other artists whose work he
found excellent were being turned down in show after show at the National

60

Copyright 1906 by The Frederick J. Quinby Company

Academy. Consequently on April 4, 1907, a meeting was held at Henri's home. At this meeting, the regular Philadelphia crowd assembled and Ernest Lawson came, too. These men: Henri, Sloan, Glackens, Luks, Shinn, and Lawson were joined later by Arthur B. Davies and Maurice Prendergast to discuss the idea of exhibiting together.[9]

These men were innovative painters for their time. Their work today, however, seems very mild indeed. But, in 1907, when compared to the Victorian prudery of academicians, their work was an enormous departure, dealing as most of it did with life in the street as the artist actually saw it. These men would eventually be known as "The Ashcan School" or "The Eight." At the original meeting at Henri's it was decided that they would all band together and exhibit, but the location (eventually William Macbeth Galleries) was not decided upon immediately.

61

Night Life (Accident),
pastel, 1908. COLLECTION
MR. AND MRS. ROBERT C. GRAHAM.

62

EVERETT SHINN

For the recapitulation of the exhibition of The Eight held at the Brooklyn Museum in January 1944, Shinn himself wrote, in his usual purple prose, concerning the situation existing then in the art world and of each man concerned in The Eight's first exhibition.

> . . . Art in America of that era was merely an adjunct of plush and cut glass.
>
> It [was in] a state of staggering decrepitude. . . . It was disciplined in an order of sameness, effete, delicate, and supinely refined. It revealed its pale countenance with the elegance of plush-lined shadow boxes in shrines and gilt grottos. Art galleries of that time were more like funeral parlors wherein the cadavers were displayed in their sumptuous coffins.
>
> One day an incredulous stare came into its imported plate-glass eye which had for a decade mirrored only lorgnettes and fawning patrons. For there on its velvet lawn stood a bedraggled group of invaders. The Eight had wandered in. The interlopers paused and removed their hats. The solemnity of death had caught at their scant respect. The Eight had journeyed out to see life and found themselves in a morgue.

Of course, Shinn is referring here to the academicians. He discusses the men involved in the original exhibition of The Eight at Macbeth Galleries as follows:

> *Robert Henri*: As a goading whip against any compromise that might soften The Eight. . . . Out of his utter disgust for an institution that had rejected pictures by Luks, Sloan, and Glackens, he, Henri, withdrew his own from the show.
>
> *Arthur B. Davies*: . . . he gloated in the controversy. Over the tonal beauty of Arthur Davies' pictures he smeared a verbal mystery, never content to let them voice themselves.
>
> *George B. Luks*: Only his great ability as a painter could excuse his weaknesses. Chief among them was his bombastic boasting. . . . Luks worked equally well with both hands.
>
> *Ernest Lawson*: [his] first picture was a tattoed design of an anchor and star on his forearm of his own making . . . a rich ability and an amazing interpretation of scenes . . .
>
> *William Glackens*: All things within the range of Glackens' vision were taken up into flexible walled granaries, unconsciously absorbed and catalogued in orderly fashion for any immediate usage. His eyes were veritable harvesters of the total limits of his sight.
>
> *John Sloan*: Sloan will make no concessions to art's overlords. He is a sacrificial crusader in quest of the crown of Heaven on an ideal, equipped with the zeal to carry his banner aloft . . . America's master etcher . . . there he walks alone.
>
> *Maurice Prendergast*: . . . always his eye was diverted toward the street where human activity animated the colorful patterns . . . in Paris he toiled under the critical eye of a master that did not understand his novel approach to picture making.

And again:

> *Robert Henri*: He kept open house in his heart and all were welcome to his bountiful supply of encouragement and fighting enthusiasm to lift art out of the rut it had bogged in.[10]

And with the above cast of characters including Everett Shinn, the die was cast. The exhibition at William Macbeth's opened on February 3, 1908. John Sloan has this to say about it in his diary:

> *They report a great crowd at the gallery and young DuBois [Guy Pène], the artist and critic of the* American, *came in most enthusiastic over the show. . . . On February 5th . . . I went to Macbeth's, found the rooms well crowded. More than fifty people were there and coming and going. Pictures look well. The* Tribune *has a sermon for us in this morning's edition. Advised us to go and take an academic course, then come out and paint pictures . . . It is regrettable that these art writers, armed with little knowledge (which is, granted, a dangerous thing) can command attention in the newspapers. I'd rather have the opinion of a newsboy. . . . February 17 . . . We've made a success—Davies says an epoch. The sales at the exhibition amount to near $4000 [Shinn sold* Blue Girl*]. . . . Trask wants the show for the Pennsylvania Academy.[11]*

In Shinn's journal he lists the paintings sent to the exhibition by him. They were: *Gaieté Montparnasse; Rehearsal of the Ballet; White Ballet; Leader of the Orchestra; The Gingerbread Man; Trapeze Artist; Girl in Blue* (sold out of the show to Mrs. Harry Payne Whitney); and *London Hippodrome*. It is interesting to note that Shinn was asking $500 for this last painting (now at the Art Institute of Chicago). This has come to be his most famous work.

When the exhibition of The Eight went on to the Academy in Philadelphia, from March 7 to 28, Shinn sent these same pictures, substituting *La Première Danseuse* for the *Girl in Blue*. At this time Mrs. Whitney also purchased four red chalk drawings and one monotype from Shinn.

In October of 1908, the exhibition of The Eight resumed its travels and was exhibited in Chicago, Buffalo, and Toledo. Shinn sent an almost entirely different group of paintings on the traveling exhibition. But after the notoriety of the exhibition at Macbeth's it is interesting that *The Leader of the Orchestra* was sent to be exhibited at the Corcoran Gallery in Washington, D.C., with a price tag of $600 more than when it hung at Macbeth's. He now was asking $1000 instead of the original $400.[12]

The men of The Eight were considered very avant garde and their exhibition had great impact on the art world of their time.

During the time of the exhibition and in fact, during most of the

group's residence in New York, they frequented a cafe called Chez Mouquin. Shinn drifted away from his friends as he became interested in theatrical personalities. He says of Mouquin's: "It was there that the crowd really became intimate." Shinn did not frequent Chez Mouquin very much because he was a teetotaler and never did learn to enjoy drinking.[13]

Another place frequented by the group of artists and critics in Shinn's New York circle was William Moore's Café Francis. There was a small bar downstairs in this cafe about which John Sloan wrote to Henri in March 1906:

> *Last night Dolly and I went to the Francis for dinner. Prestons and Glackens went down to the "Lair beyond the Moat" and had a right good evening. Glackens, Shinn, or somebody who don't care particularly for the credit has painted a big panel in the cellar, showing J. M. [Moore] in high hat and ladies lingerie playing "frog" with unmentionable accessories, others of the crowd grotesquely disarrayed standing and seated around. James says it is too bad it will have to be painted out. I hope this don't happen before you return for it is a funny thing. The mural sounds like the sort of thing Shinn would have relished doing.*[14]

During the period immediately following the exhibition of The Eight at Macbeth's, Everett Shinn apparently grew quite restive. Shinn always enjoyed the prospect of quick-money projects, and he launched himself into what has become known as "The Great Puzzle Scandal." This incident can best be told by quotations from *William Glackens and the Ashcan Group* by Ira Glackens:

> *Everett Shinn, during this time, was a very busy man. He had invented what he called a "political puzzle," and now was the moment to launch it. The year 1908 was among other things a political year. Teddy Roosevelt was finishing his second term, and there was great interest in whether he would break precedent and run again. He very much desired to do so—a trait that ran in the family—and here was where Everett came in. His puzzle consisted of the well-known face of T.R. in the form of a round flat box with a celluloid cover. The pupils of the presidential eyeballs, in the form of two BB shots, rolled about within. The trick was to get them simultaneously into their sockets to answer the question, "CAN HE SEE A THIRD TERM?" The invention had just the mixture of the absurd and the amusing to stamp it a product of Everett Shinn's bizarre imagination.*

> *W. G. had considerable to say about this puzzle, which rapidly became a* cause célèbre *in the art world.*

66

The Greatest POLITICAL PUZZLE Ever put on the Market ✍ ✍ ✍ ✍ ✍ ✍

ITS A WORLD BEATER

This Game Sells Itself and Everybody Buys Them

BRYAN, Puzzle Size, 7x5 Inches
TAFT, Puzzle Size, 5 Inches

"BILL" TAFT "BILLY" BRYAN

These Games are made of heavy plate tin, beautifully lithographed in highest colors, Bright Red Faces. Something a customer will see a Block off. Eyes, block tin discs painted white. Pupils are turned steel ¼ inch balls which run about the eyes so readily that it makes the puzzle as hard as the devil to do. Eyes are covered with transparent celluloid.

THE POLITICAL CAMPAIGNS are now on and these two games will find millions of buyers in every town of the United States between now and election

A WINDOW OF THESE PUZZLES MAKE A CORKING DISPLAY
They are BULLY SOUVENIRS for LIVE MERCHANTS to Give away to Customers
They Will Draw Buyers to a News or Novelty Stand

We put out the Teddy Puzzle. It was a big success and it was not half as good as our **Taft and Bryan Puzzles**

HERE ARE A FEW COMMENTS ON IT

Senator BEVERAGE says: "It's very interesting indeed."
N. Y. TIMES says: "Third Term Puzzles will be distributed freely about the country."
Senator CLAPP says: "Life is too short to try to solve that puzzle."
N. Y. PRESS says: "More power to Roosevelt."
Senator BULKELEY says: "It has afforded much amusement to myself."

Vice-President FAIRBANKS says: "Your Third Term Puzzle has been received."
N. Y. HERALD says: "Cords of Third Term Puzzles for voters all over the country."
Senator WARREN Says: "The game is dead easy."
N. Y. SUN says "The Third Term Puzzle is bully."
Senator McLAUREN says: "It will be considered."

CHILDREN GO BUGHOUSE FOR THEM. THEY SELL LIKE WILDFIRE ON SIGHT.

They Put the New York Stock Exchange out of Business for a Day

EVERYBODY BUYS WHO SEES THEM **AGENTS WANTED**
$1.50 for 2 Dozen $9.00 per Gross 2 Doz. in Carton
DISCOUNT ON LARGE ORDERS WE WILL NOT ACCEPT CHECKS UNLESS CERTIFIED

THEODORE III CLUB
112 WAVERLY PLACE, NEW YORK

Flier for the Theodore III Club, 1907. SHINN PAPERS. DONATED BY IRA GLACKENS.

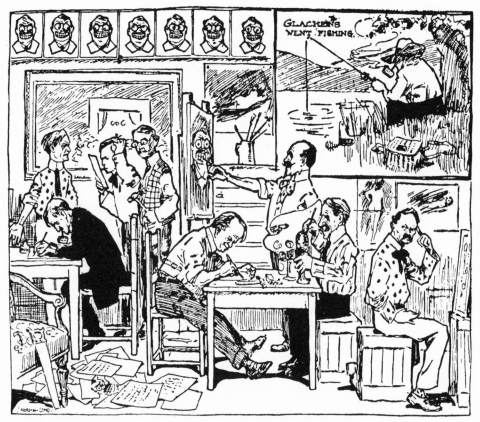

Cartoon showing The Eight's Theodore III Club, *by J. Norman Lynd in the New* York *Herald, May 17, 1908.*

May 9:
Shinn is up in the air about his puzzle. I saw one last night. It looks quite an object d'art. . . . We are all going to be interviewed about our views on Teddy as a third termer. I think that is what he intends. He has a press agent camping out in his studio turning out ideas to advertise the puzzle. . . .

May 10:
. . . Tonight we go over to the Shinns to be interviewed on the political outlook for advertising purposes.
 The plan for launching the puzzle had seemed ready-made to Everett Shinn. He and his seven colleagues were at the moment riding on the crest of a wave of publicity, and it struck him that this was a wonderful opportunity for the puzzle business. He formed (entirely in his mind) the "Theodore III Club," ostensibly created

by The Eight, all of whom appeared to be Republicans that year. Actually it was a publicity stunt to benefit Everett Shinn's little business enterprise. The enterprise was so ridiculous that nobody at first took it seriously.

May 14:
Shinn's puzzle is out and the stories published in the papers about it make first class idiots of the whole lot of us. Everett has certainly taken advantage of his friends for advertising purposes.
Shinn promised the papers speeches by Glackens when he returned from his fishing trip—the publicity man on this project was George Calvert with whom Everett was associated for the next twenty years in get-rich-quick schemes which never quite got off the ground.

Glackens writes again on the seventeenth of May:

I saw Flossie and Everett last night. Eve is absolutely crazy over this puzzle business. He has gotten [it] into his head that he is a captain of industry *and purposes to do things with strictly business methods, with modern means of advertising. It sounds all right but you should see the results.*

A letter from Flossie Shinn to Edith Glackens sums up the matter well:

You ask in your last, "How is the Puzzle?" It is quite well thank you but it has brought on a social war which makes the Battle of Bull Run look like a game of bridge. It seems that Lawson didn't like being brought into the political part though he gave his consent when Ev asked him. Instead of coming to Ev and kicking, which he had a perfect right to do, his old friend Aunt Sallie Gregg [Frederick James Gregg] publishes in the paper [the Evening Sun] as an appendix to Henri's marriage notice [such good taste] that E. Shinn was running a political club to sell a "mechanical device" which he said the Eight belonged to, but that every member of the Eight indignantly denied having any knowledge of such an organization . . .[15]

After this item got into the paper, Shinn threatened to sue the *Sun* and Gregg.

As a side play to the great puzzle issue, Flossie sent Edith Glackens a postal card with a picture of the Shinn doorway at 112 Waverly Place under which she wrote: "Historic Doorway Series, #36. Many battles have been fought here."

The years 1901 through 1912 were by far the most productive period artistically in Shinn's life. By the end of 1912, he was so busy decorating

buildings, painting murals, and the like that he seemed to have lost interest in painting. In fact, when invited to participate in the famous Armory Show in 1913, Shinn did not even answer the invitation.[16]

In 1912 a major change occurred in Shinn's life. His wife, Flossie, divorced him in August of that year, naming him for three counts of adultery with women whose names were withheld. Mrs. Shinn was awarded $4,800 in alimony and allowed to take back her maiden name.[17]

On March 30, 1913, Shinn remarried. His second wife was Corinne Baldwin, who was to be the mother of his two children, David and Janet.[18]

Chapter Four

THE THEATRE

EVERETT SHINN'S INTEREST IN THEATRICAL SUBJECTS DATED
back to his boyhood in Woodstown when he made posters for his brother
Warren, who ran the dances at the Opera House. It was evident in the fact
that he never missed a carnival or parade that came to town, and also ap-
parent in his constant desire to put on a show.[1]

In the days in Philadelphia, the group that gathered at Henri's
studio put on plays every once in a while—such at the famous *Twillbe*, a
takeoff on *Trilby* by George du Maurier. In this production, Robert Henri
played Svengali and Everett Shinn made his acting debut. He was cast as
the expatriate painter, James McNails Whiskers.[2]

In New York, while he was married to Flossie Scovel, Shinn built a
small theatre in his home at 112 Waverly Place. This theatre was very com-
plete with proscenium, stage, and crimson curtains which parted in the
middle. The house capacity was fifty-five.

Shinn did everything: he was the playwright, director, and producer.
He made the scenery, did the casting. He formed a group called "The
Waverly Street Players." In this company were the Glackenses, Jimmy

Party at the Shinns', 112 Waverly Place. DELAWARE ART MUSEUM. SLOAN PAPERS.

Postcard showing the doorway to 112 Waverly Place; from Everett Shinn to William Glackens, a month before the famous first exhibition of The Eight. →

Preston, and Wilfred Buckland, assistant to David Belasco, as well as Flossie and Everett. A few of the early titles were: *Ethel Clayton, or Wronged from the Start* (a Civil War drama), *Hazel Weston, or More Sinned Against than Usual,* and *Lucy Moore, or the Prune Hater's Daughter.*[3]

The *New York Times* reviewed *The Prune Hater's Daughter* with almost a full column in its edition of March 21, 1912. The headline was "Artists as Actors Give Prune Drama."

The reviewer, no slouch at flowery rhetoric himself, said:

After picking your way through the vine hung and mysterious area which passes for a back yard in Waverly Place, you would have landed at last in Mr. Shinn's studio and there have joined the chosen few that witnessed the first performance on any stage in this country or in Europe, the dress rehearsal, of Mr. Shinn's twelve act drama in four acts, "Lucy Moore, or the Prune Hater's Daughter."[4]

Ben Ali Haggin played Old Edgar Moore, Lucy's pa. Lucy herself was played by Flossie Shinn, while Everett played the part of a slick villain, Glu Melch, and Buckland was the heavy, Doc Allen. In an old mill, the two gamble for Lucy, the Prune Hater's Daughter. Lucy's father, old Edgar, detests prunes and he has invented a machine for pitting them on the theory that if all prune pits could be destroyed the fruit would disappear from the face of the earth. The whole thing gets completely out of hand, involving a spider who makes decisions. A second production of this farce at a later date featured Pearl White and Marc Connelly.

Shinn's plays were full of deathless prose and a few examples follow: In *Lucy Moore, or the Prune Hater's Daughter*, Zack Freeman (Lucy's uncle, a miller) is speaking:

"I just come from the doctors. . . . Lucy, yer father haint no better . . . he's even worse . . . gettin his idees confused. He says he's sowed his wild prunes . . . also he claims that the prune was the original forbidden fruit . . . outside of that he's safe as any padded cell can make him."[5]

In *Hazel Weston, or More Sinned Against than Usual*, Ben Ali Haggin played the part of Hazel and Everett Shinn the part of Luke Prentice, a well-to-do Vermont farmer. Edith Glackens was Mrs. Prentice with Harold Shinn, Everett's brother, playing Jonas Prentice, their son. Jimmy Preston played the part of Boob Jordan, a not too bright chore boy, while the sheriff was played by Alden Scovel, Flossie's brother. Flugeon Smith, the owner of the quarries, was played by William Glackens. Costumes were by the George L. Ragbag Company. A notice at the bottom of the program read, "Any incivility on the part of the attendant should be overlooked."[6]

74

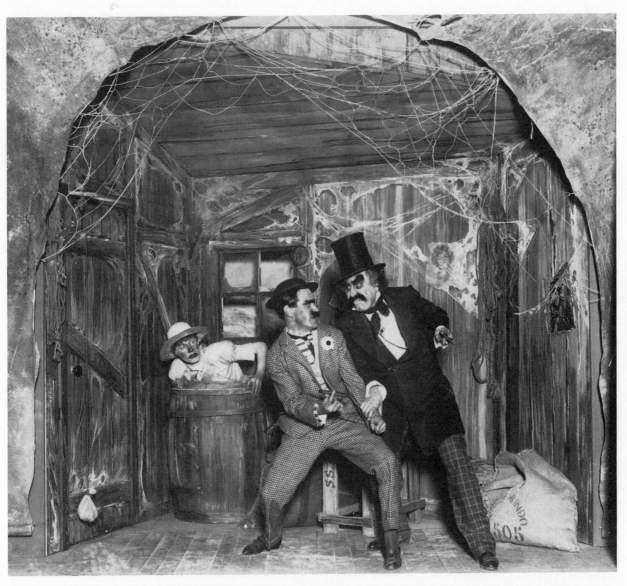

Left to right: *James Preston as Sammy the village simpleton, Everett Shinn as Glucose Melch, and Wilfred Buckland as Doc Allen in* The Prune-Hater's Daughter. SHINN PAPERS.

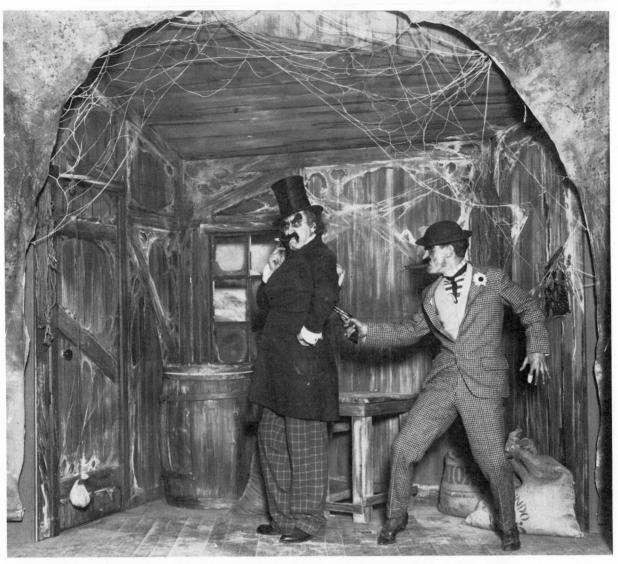

Left to right: *Wilfred Buckland and Everett Shinn in* The Prune-Hater's Daughter.

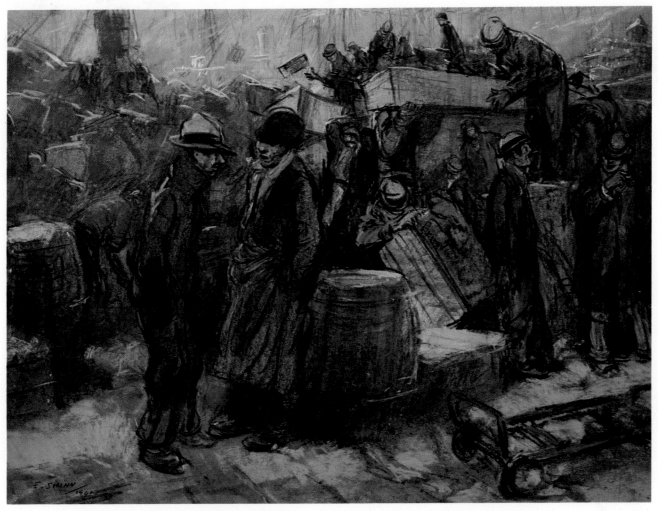

The Docks, New York City, *pastel, 1901.* MUNSON-WILLIAMS-PROCTOR INSTITUTE, UTICA, NEW YORK.

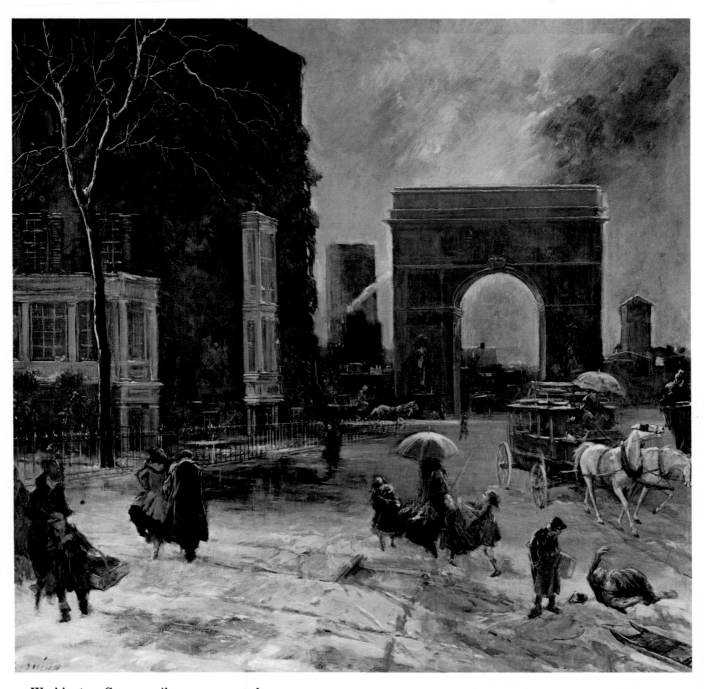

Washington Square, *oil on canvas, n.d.* ADDISON GALLERY OF AMERICAN ART, PHILLIPS ACADEMY, ANDOVER, MASSACHUSETTS.

Backstage Scene, *pastel and watercolor, 1900.* DELAWARE ART MUSEUM.

Canfield Gambling House, *gouache, n.d.* COLLECTION MR. AND MRS. ROBERT C. GRAHAM.

Spring Shower in Luxembourg Park, Paris, *pastel, 1902.* COLLECTION MR. AND MRS. ROBERT C. GRAHAM.

Sketches for Decorations for the Hotel Plaza Bar, *pen and watercolor, 1945.* COLLECTION MR. AND MRS. ROBERT C. GRAHAM.

Paris Cabaret, *pastel, 1917.* MUNSON-WILLIAMS-PROCTOR INSTITUTE, UTICA, NEW YORK. EDWARD W. ROOT BEQUEST.

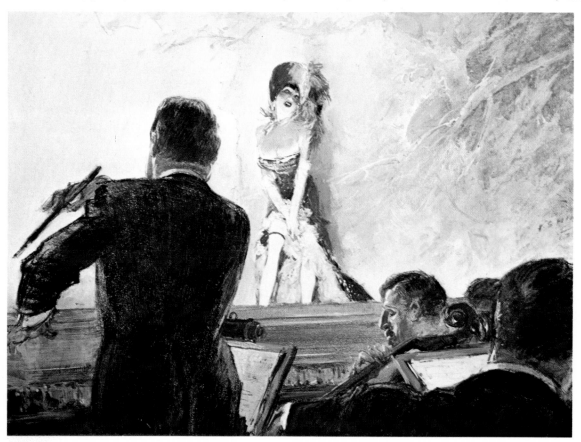

Ringling Brothers Circus, Winter Quarters, Sarasota, Florida, *1949.* COLLECTION MRS. WILLIAM BENDER, PHOTOGRAPH BY CHARLES UHT.

The Green Ballet, *oil on canvas, 1943*. THE WESTMORELAND COUNTY MUSEUM OF ART, GREENSBURG, PENNSYLVANIA.
WILLIAM A. COULTER PURCHASE FUND.

Portrait of Marion, *pastel, circa 1930*. COLLECTION GAIR CHASE. PHOTOGRAPH S. T. WHITNEY.

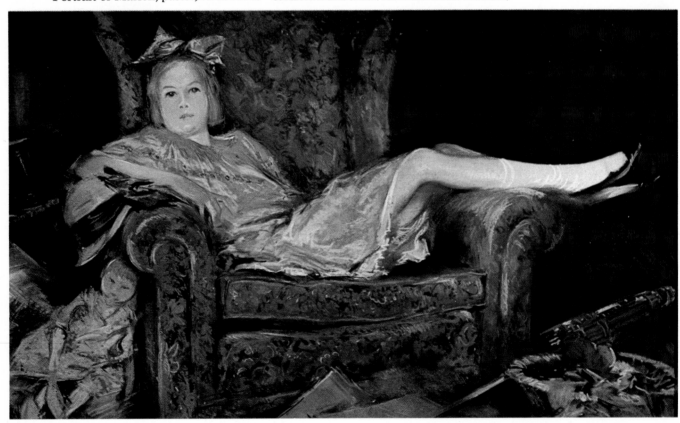

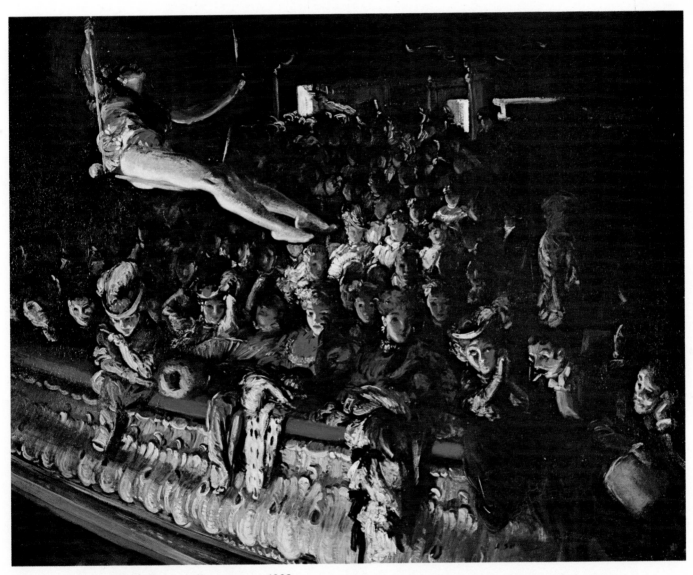

London Hippodrome, *oil on canvas, 1902.*

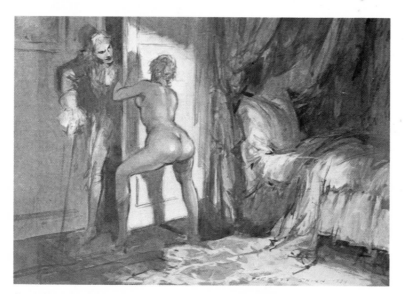

Interior with Two Figures, *red chalk, 1934.*

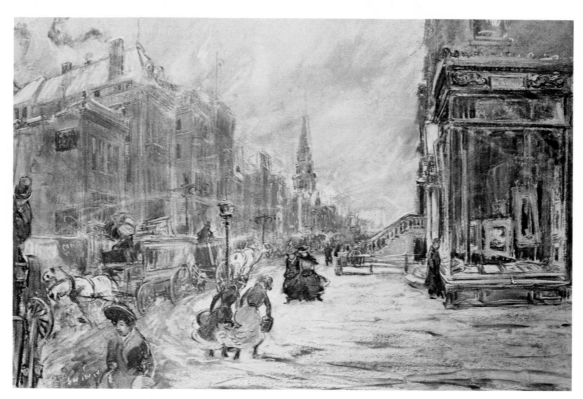

Fifth Avenue and Thirty-Fourth Street, *pastel, circa 1915.*

*James Preston and
Flossie Shinn in* The
Prune-Hater's Daughter.
SHINN PAPERS.

*William Glackens as
Fludgeon Smith and
James Preston as Boob
Jordan in* Hazel Weston
*or More Sinned Against
Than Usual.* SHINN PAPERS.

Everett Shinn and Ben Ali Haggin at wheel of automobile around 1918.
SHINN PAPERS.

Everett Shinn as Luke Prentice: "I won't have no blood of mine in the same room with a woman whose past won't stand huskin'." Act I, Hazel Weston or More Sinned Against Than Usual.

Angela Ogden as Hazel Weston.

In one passage, the villain of the piece, Flugeon Smith, has tried to acquire Hazel's affections by foul means. Not being able to accomplish this, he offers marriage, to which Hazel responds:

> *"You vampire in viper's form! Rather a thousand times would I*
> *be dead—with a snowdrift in my hair! That sir would be my bridal*
> *wreath!"*

The lines were supplied by Flossie as Everett seems to have run dry around this time, a temporary thing.

Jimmy Preston, an artist and writer, was always cast as the village idiot. Mrs. George Bellows regularly played "Hearts and Flowers" on the piano. There was even a house doctor in attendance.[7]

Some of Shinn's plays were eventually bought and incorporated into vaudeville acts. According to Ira Glackens, some of Shinn's early plays were even translated into foreign languages.

Whatever the literary quality of the plays, Shinn made beautiful stage sets for them. For one of his later plays, *The Dump*, Ira Glackens remembers seeing one set of a city dump that was a beautiful one.

Glackens remarks:

> *The plot involves derelicts and hoboes, and as the night descends*
> *and the distant lights of the city begin to twinkle, a lone lamppost*
> *beyond the dump is suddenly observed to have taken on the*
> *shape of the Cross. This religious allegory seemed very unlike*
> *Everett and his former plays. The play never saw Broadway, and*
> *I believe the producers felt, and not without reason, that a religious*
> *play laid entirely on a dump, however beautiful, tended to be*
> *depressing.*[8]

Shinn often professed to have a deep feeling about Christianity. However, none of his writings reflect anything but a superficial interest—almost a childlike one. He did some illustrations from the life of Christ that while sensitively drawn are really quite shallow.

His daughter, Janet Shinn Flemming, however, feels that his religious beliefs were not superficial, but rather nondenominational and unformed. His belief in God, she says, was definite, and in her words "God and only God got Everett's attention—not Jesus Christ, The Holy Ghost, or any of the Saints."

A late play by Shinn entitled *Mid Ocean* was supposedly produced on Broadway. No evidence, however, exists of this production. The play was written in the mid-twenties and the action took place on board a sinking ship. There were five characters: a young couple, a millionaire, a rabbi, and his son. There is much talk about God and death. The play is in one act and winds up with the wife and the rabbi's child being saved while the

husband, millionaire, and rabbi go under with much exclaiming about God, and so forth.[9]

The poor rabbi is made to speak some kind of Katzenjammer Kids German-English patois. The whole play is silly beyond belief with a great deal of adolescent searching going on throughout.

Whether Shinn's fascination with the theatre and its people was an effort on his part to escape from the realities of day-to-day living is hard to say. Probably escape had a great deal to do with his theatrical interests—it allowed the endless legitimate role playing essential to Shinn's psyche.

In any case, Shinn was never happy pursuing one line of endeavor. He was a man with far too many talents, and he became bored very quickly when pursuing one channel of creativity to the exclusion of others. He could have been a great set designer and costume designer, but he did neither with complete professionalism.

Chapter Five

DECORATION

IN 1899, EVERETT SHINN MADE THE ACQUAINTANCE OF CLYDE
Fitch, the playwright, He was introduced to Fitch by Julia Marlowe, who
was a famous actress and Fitch's close friend. He also made the acquaintance
that year of a woman with whom he was to work for a number of years.
Her name was Elsie de Wolfe, and she was a fascinating person, a decorator
and bon vivant, a kind of 1900s jet setter.

Ludwig Bemelmans wrote a book entitled *To the One I Love the
Best* that is, in fact, a whimsical biography of Elsie de Wolfe. In this book,
Bemelmans quotes Sir Charles Mendel, Elsie's husband, who describes her
as follows:

> *She is a remarkable woman, utterly selfish and at the same time
> irresponsibly generous. She is incapable of adjustment to the life of
> our day. She is perhaps the incarnation of someone—I don't
> know, however, of whom, for no one like her has ever lived or shall
> come after her.*
>
> *Elsie claims she is psychic and that she can feel people. She says
> of people that they have an aura about them, or not. Those that
> have the aura become her immediate friends. . . .*

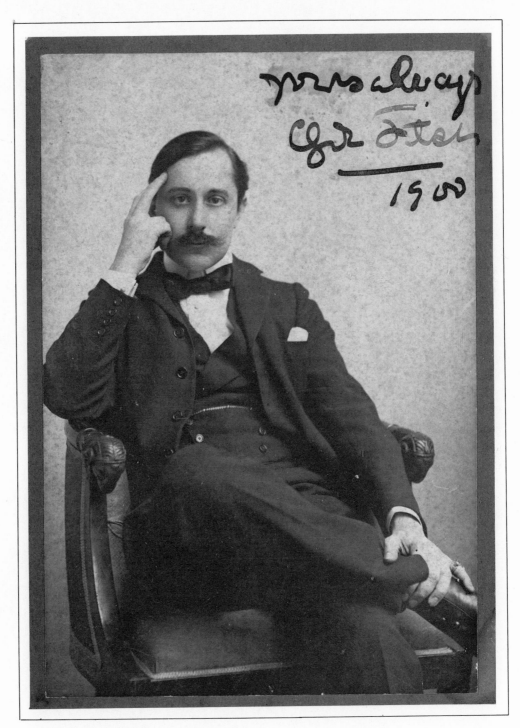

Clyde Fitch, 1900. SHINN PAPERS.

Julia Marlowe, circa 1903. SHINN PAPERS.

Elsie de Wolfe, 1903. SHINN PAPERS.

Elsie de Wolfe, *by Romaine Brooks, oil on canvas, circa 1908.* MUSÉE MODERNE
À PARIS.

Everett Shinn apparently had "the aura," for he and Elsie de Wolfe became fast friends. And she began to bring work Everett's way in the decoration of houses under her auspices.

Through Fitch and de Wolfe, Shinn met two other men who were to be most important to him. These men, David Belasco and Stanford White, were to use Shinn's services often in creating murals and decorations in their own homes and places of business and were to recommend him to many of their acquaintances.

In January of 1900, Everett Shinn's notebooks show that he sent three paintings to Clyde Fitch, presumably for his inspection with an eye to buying them. One was a portrait of Fitch. As early as November 1899, there is an entry in his journal: "At Miss de Wolfe's, 122 East 17th Street, November 7 to 17." Presumably this notation referred to a small, private exhibition at her house, in which five pictures were on display. One of these Shinn sold to Clyde Fitch.

Shinn did a portrait sketch of Elsie de Wolfe on November 18, 1899, and one of Julia Marlowe on January 15, 1900. Three portraits of Miss Marlowe, one of Mr. Fitch, and one of Miss de Wolfe were in his first large exhibition at Boussod, Valadon, from February to April of 1900.

It seems Shinn carried on a voluminous correspondence with Elsie de Wolfe. There are some restrictions in discussing these letters since we have only her letters to him and none of his answers at hand. Almost all her letters to him concern business dealings. Mostly they exhort him to finish whatever project she has asked him to do for a prospective client.[1]

Shinn appears to have developed friendships with Fitch, de Wolfe, and White, along with the professional relationships.[2]

Stanford White was the most distinguished architect of his time. He designed architectural settings for Augustus St. Gaudens's sculptures and among his major works are the Monument to the Founder in Llewellyn Park, New Jersey (1880), the H. B. Auchincloss residence in Orange, New Jersey (1884), and various other buildings in and around New York, notably the Century Club and the first Madison Square Garden. He was a tall man with bristling red hair and moustache; he was strong, enthusiastic, vigorous, and versatile, according to Charles Baldwin, his biographer.

Everett Shinn speaks of him as follows:

> Belasco knew that Stanford White had been my friend and that by my proximity to his unerring taste I must have gleaned something of selectiveness. It assured him of guidance toward those objects that would advertise still further his reputation for impeccable taste. He knew too that in White's house only rarities would be assembled, just as he knew of the dependability of Tiffany's.

Shinn said of White, "White picked me out of all the other dogs in the pound and took me home. Maybe I wiggled an ear at the right time."[3]

David Belasco, circa 1900. SHINN PAPERS.

Typical example of Shinn's rococo revivalism mural treatment, circa 1907.
SHINN PAPERS.

White's biographer, Baldwin, says of him: "... whether a genius or not, [he] was a great artist. He was in many ways like the men of the Italian Renaissance; animated with a passion for the beautiful in all forms."

Shinn did a number of murals for houses built by Stanford White and for many houses and apartments decorated by Elsie de Wolfe. He continued to decorate houses in the Louis XVI manner—a style often referred to as "rococo revivalism"—long after the shooting of Stanford White by Harry K. Thaw in 1906. In fact, his decorating career started just before White's death and he went on working with Miss de Wolfe for some time afterward.

As for Clyde Fitch, he was extremely well known in the 1890s and early 1900s as a playwright and a prolific one. Fitch actually produced over forty plays, and he was considered by at least one other authority on drama to have been the one writer who might have written "the great American drama" had he not died at such a young age.[4] Fitch once had seven plays running in one season on Broadway and at the same time had three more openings in New York and five on the road. Among his most notable plays were: *Nathan Hale* (1898), *Captain Jinks* (1901), and *The City* (1909).

Shinn decorated Fitch's ceilings as well as some pianos and sideboards in the manner of Louis XVI, and sold him some paintings, which served as good advertisement.[5]

Design for ceiling in Stanford White house, chalk, circa 1906.
CHARLES T. HENRY GIFT TO EMILY HELEN ALTSCHUL, 1966.

Piano similar to one decorated by Shinn for Clyde Fitch. SHINN PAPERS.

Girl Looking in Mirror, *red chalk, circa 1901.* ARTHUR G. ALTSCHUL COLLECTION.

Nude, Back View, *red chalk, 1907.* ARTHUR G. ALTSCHUL COLLECTION.

Sketch for Belasco's Stuyvesant Theatre, watercolor, 1907.
NEW JERSEY STATE MUSEUM. GIFT OF MR. EARLE W. NEWTON.

In payment for part of the work Shinn did for Fitch (the playwright was always broke or thought he was), the artist received gold chairs and a mahogany table.

Through Fitch, Shinn became acquainted with David Belasco, the impresario, in the early 1900s. Shinn reminisced about Belasco:

> The Belasco around whom so much tradition and reputation was built was actually a colossal faker—Belasco was short, heavy-set and of Portuguese descent, coming to America by way of California. Everything about Belasco was an affectation: his clothes, his mannerisms, his habits. He dressed always in black, but in the black of a minister of the Gospel with a clerical collar that made his short neck appear as though it might withdraw still further into the circle of immaculate linen and draw the head in after it. He had squarish, sensitive features and a great shock of iron gray hair that grew rather long in a high, unruly pompadour. An actor during every waking minute, his short and dumpy figure could assume the tireless energy of a Napoleon or the listlessness of a dying man.[6]

Shinn's contribution to Belasco's Stuyvesant Theatre was enormous, involving eighteen panels of murals. The general decorative scheme of the Stuyvesant Theatre was by Wilfred Buckland. The work was finished in 1907 and the theatre opened to great praise. In the catalog of the opening night there is a reproduction of a fine drawing by Shinn of the theatre exterior and also two Shinn portraits of Belasco.

94

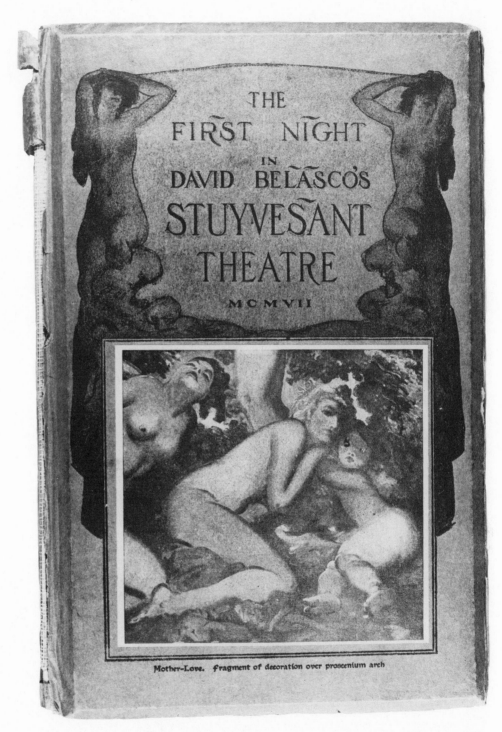

Mother-Love. fragment of decoration over proscenium arch

Cover of catalog of opening night at Belasco's Stuyvesant Theatre, 1907.
SHINN PAPERS. PHOTO NICK HENKY.

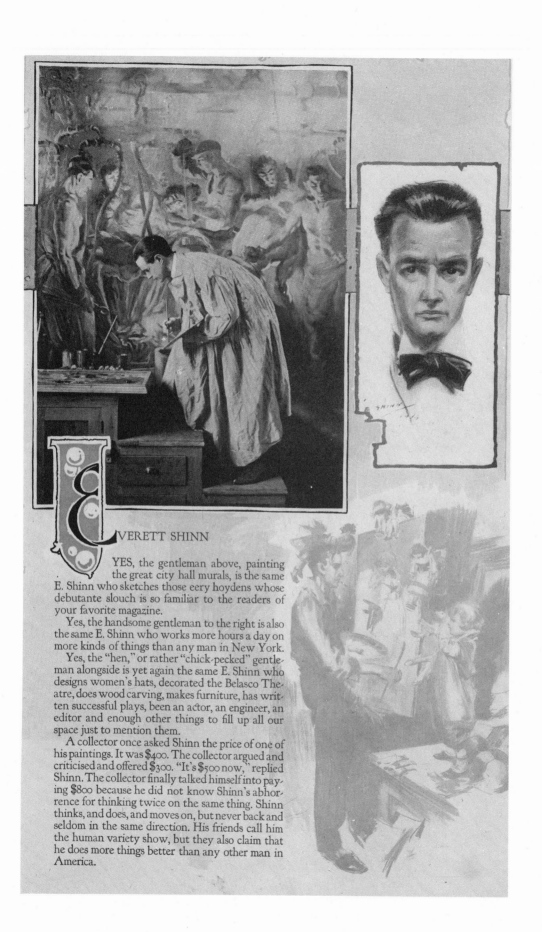

EVERETT SHINN

YES, the gentleman above, painting the great city hall murals, is the same E. Shinn who sketches those eery hoydens whose debutante slouch is so familiar to the readers of your favorite magazine.

Yes, the handsome gentleman to the right is also the same E. Shinn who works more hours a day on more kinds of things than any man in New York.

Yes, the "hen," or rather "chick-pecked" gentleman alongside is yet again the same E. Shinn who designs women's hats, decorated the Belasco Theatre, does wood carving, makes furniture, has written successful plays, been an actor, an engineer, an editor and enough other things to fill up all our space just to mention them.

A collector once asked Shinn the price of one of his paintings. It was $400. The collector argued and criticised and offered $300. "It's $500 now," replied Shinn. The collector finally talked himself into paying $800 because he did not know Shinn's abhorrence for thinking twice on the same thing. Shinn thinks, and does, and moves on, but never back and seldom in the same direction. His friends call him the human variety show, but they also claim that he does more things better than any other man in America.

Shinn's paintings were described in the catalog:

... Briefly, Mr. Shinn's palette suggests that of a Rembrandt rather than those of the run of our decorators, whose pastel schemes less often create than dispel the harmony of interiors.

In Shinn's murals for the Stuyvesant, the original colors were ambers and golden browns, faded green blues and dusty oranges. In the catalog, Shinn's figures are described as having a certain "luxurious heaviness in the pose and modeling."

In 1911, Everett Shinn was commissioned to do murals for the Council Chamber in the City Hall in Trenton, New Jersey. His rococo revivalism style was obviously unsuited to these murals and he made them very realistic.

The two large murals he did for the Council Chamber are representative of Trenton's two great industries. One mural is taken from the Roebling steel mills and the other from a large Trenton pottery works.

According to a long anonymous article on the murals in *The Craftsman* of January 1912, Shinn's preparations for painting these murals were very "long and arduous." Shinn spent six months in Trenton before doing any work on the huge panels, and, according to *The Craftsman*, he "lived alternately" between the Roebling Steel Mills and Harry Mattock's pottery kilns.

He used three men from the Roebling Steel Mills as models of whom the most famous is Willie Clegg whose face appears a number of times in the two panels. Clegg "taught Shinn how to wipe a joint and bantered with him because he had put a leather apron on the wrong mechanic." According to the same writer, "there is not a faulty detail in the work, thanks to Willie Clegg's advice. The machinery represented is exact, the proper workmen do their proper tasks."

Shinn said of these murals: "What the Council Chamber should laud in an American City Hall and should commemorate is not past glories but present ones. The towns that look ever toward their pasts are lost towns."

Shinn spent another six months in studying lighting and placement in the Commission Council room. The murals are, indeed, very interesting although not quite the major contributions to art history that the *Craftsman* writer may have thought.

Professor Milton W. Brown in his book *American Painting from the Armory Show to the Depression* has this to say about them:

They are not world-shaking. They did not, unfortunately, inaugurate an era of mural painting. That had to wait until the thirties, for Thomas Hart Benton and the Mexicans Rivera and

Mural Decoration, Council Chambers, City Hall, Trenton, New Jersey, oil, 1911.
NEW JERSEY STATE MUSEUM.

Orozco. The murals were important, however, in that they treated a contemporary industrial subject rather than an historical or allegorical scene. In the realm of American mural decoration, Shinn's Trenton murals are among the first instances of the use of contemporary subject painted in a realistic manner and as such they should have been a milestone in American art. . . . However, Shinn's murals never received much attention. Either Trenton was too far from New York or Shinn was not a recognized member of the mural painters' clique.

The panels themselves exhibited the limitations of Ash Can realism as used by Shinn. . . . The attempt of Shinn to enlarge the scene to heroic proportions merely laid bare his deficiencies in composition and form. What in a small picture might have been a spirited brush stroke became in a mural painting a large, empty and meaningless area. Then the composition itself was a little too ambitious for Shinn's ability. The figures never entirely found themselves in relation to each other nor the whole. There are even unhappy passages of clumsy drawing.

On a limited basis, Shinn continued to do mural painting after 1912. In 1924, he used his rococo revivalism technique to decorate the home of Mrs. William Coe on Long Island with murals. He also did them for Mrs. Edwin S. Boyer of New York City.

Other murals by Shinn were done for the home of Warren M. Salisbury in Pittsfield, Massachusetts, and the home of George H. Townsend in Greenwich, Connecticut, in the early twenties.

In *Arts and Decoration*, November 1924, Giles Edgerton (Mary Fanton Roberts) states:

Of all painters in this country Mr. Everett Shinn stands alone as one who has seemed to relive in his mind the spirit of Watteau and of Boucher—who seems able to visualize in graphic terms, the gardens, the fetes, the animated life of that brief and wholly vanished phase of French history.

The well-known critic A. E. Gallatin once said that Shinn had schooled himself well in the traditions of this enchanted epoch.

In the 1940s, Shinn returned to his realistic style to do the famous murals in the Plaza Hotel men's bar. These depict scenes outside the famous hotel—especially the hansom cabs. The drawings for these murals are very beautiful and have become collector's items.

Study for decoration, 1911. CHARLES T. HENRY, ST. PETERSBURG, FLORIDA.

La Chambre, *red chalk, 1910.* EVERETT SHINN ESTATE, JAMES GRAHAM & SONS.

One of the murals from the Plaza Hotel men's bar, New York, depicting a rainy night in New York and showing the Plaza at right and the former Cornelius Vanderbilt mansion in background (now the site of Bergdorf Goodman), 1944.
COURTESY PLAZA HOTEL.

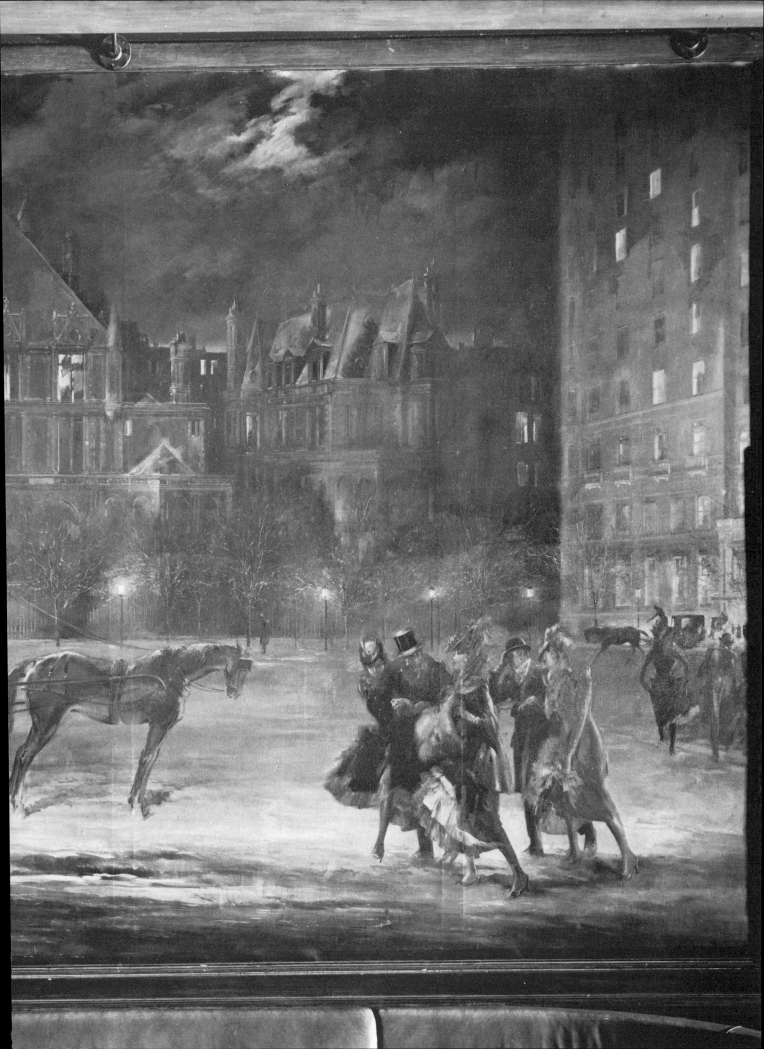

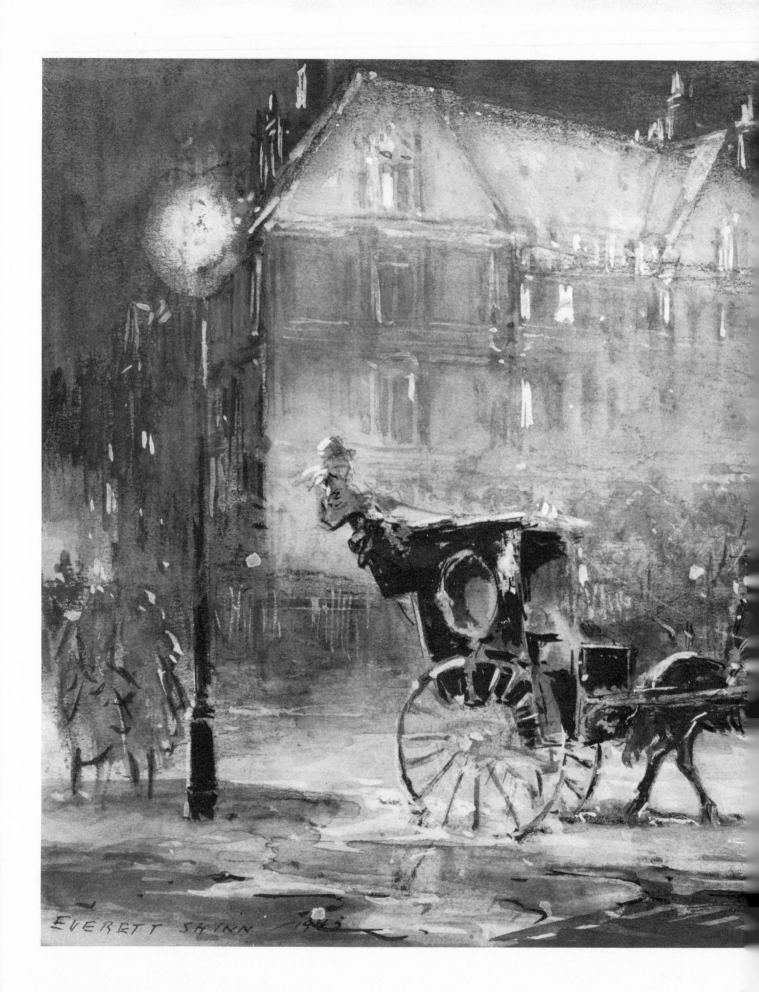

EVERETT SHINN 1905

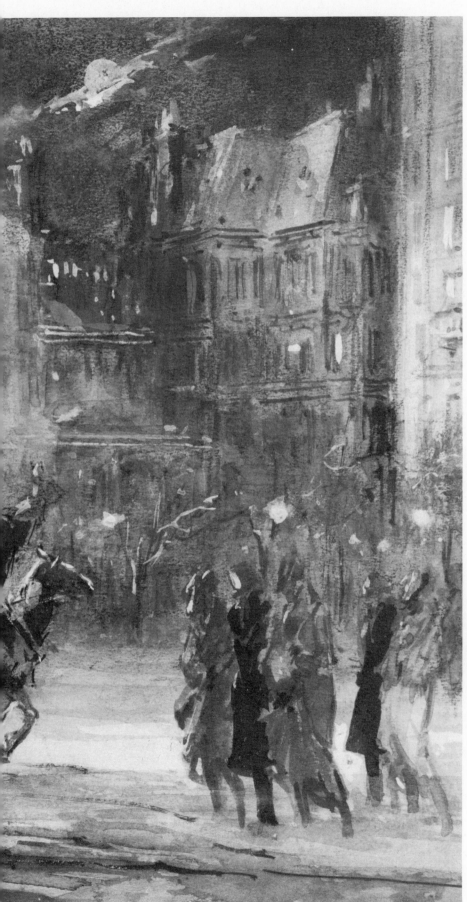

Horse and Carriage at Plaza
Square, *watercolor, 1945.*
COLLECTION MR. AND MRS.
ROBERT C. GRAHAM.

→

*Mural from the Plaza Hotel
men's bar, showing a frosty night
in Central Park at the turn of
the century, 1944.*
COURTESY PLAZA HOTEL.

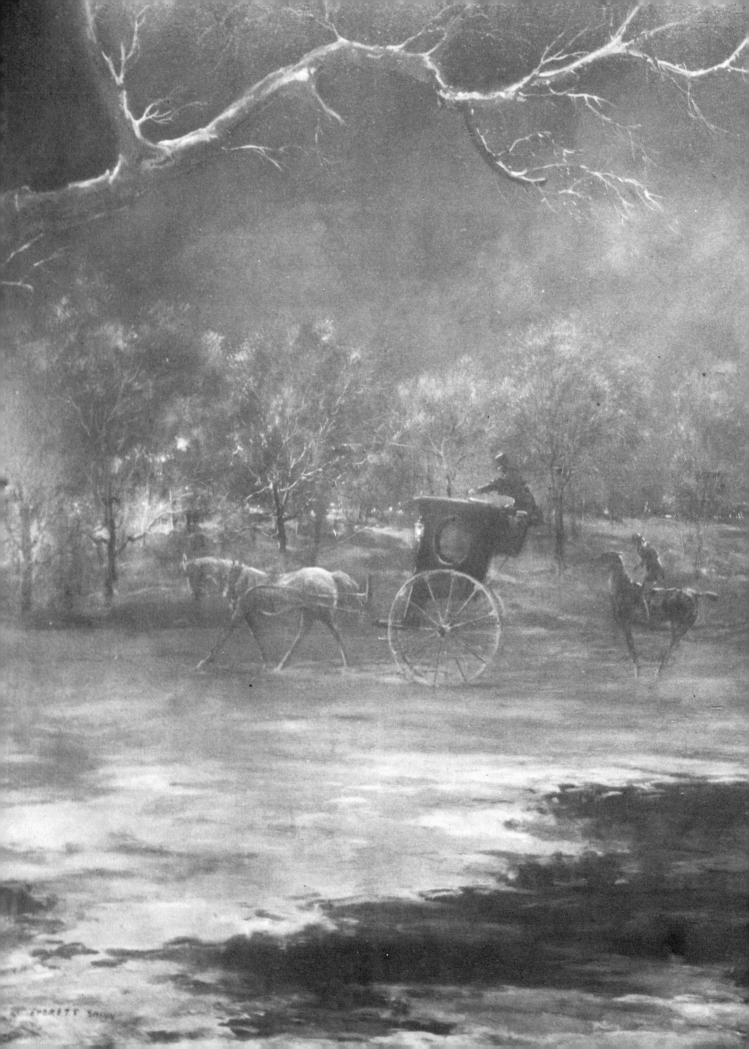

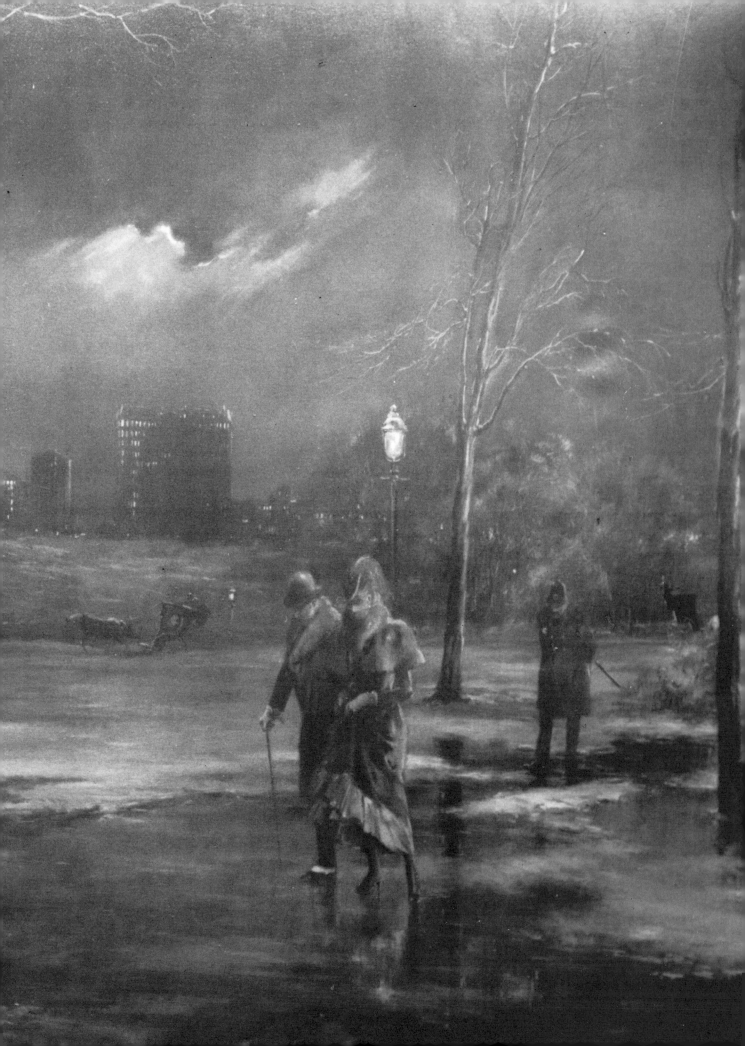

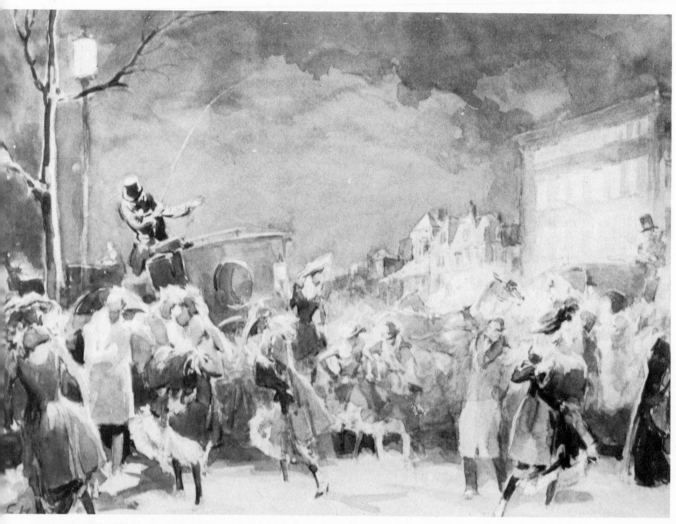

The Plaza Looking North from 59th Street, *watercolor, circa 1900.*
STUDIES FOR PLAZA MURAL. COLLECTION MR. BERNARD BLACK.

Painting that hangs over the Oak Bar in the Plaza Hotel, New York, showing the "Fountain of Abundance" in the square in front of the Plaza, willed to the city by Joseph Pulitzer, 1944.
COURTESY PLAZA HOTEL.

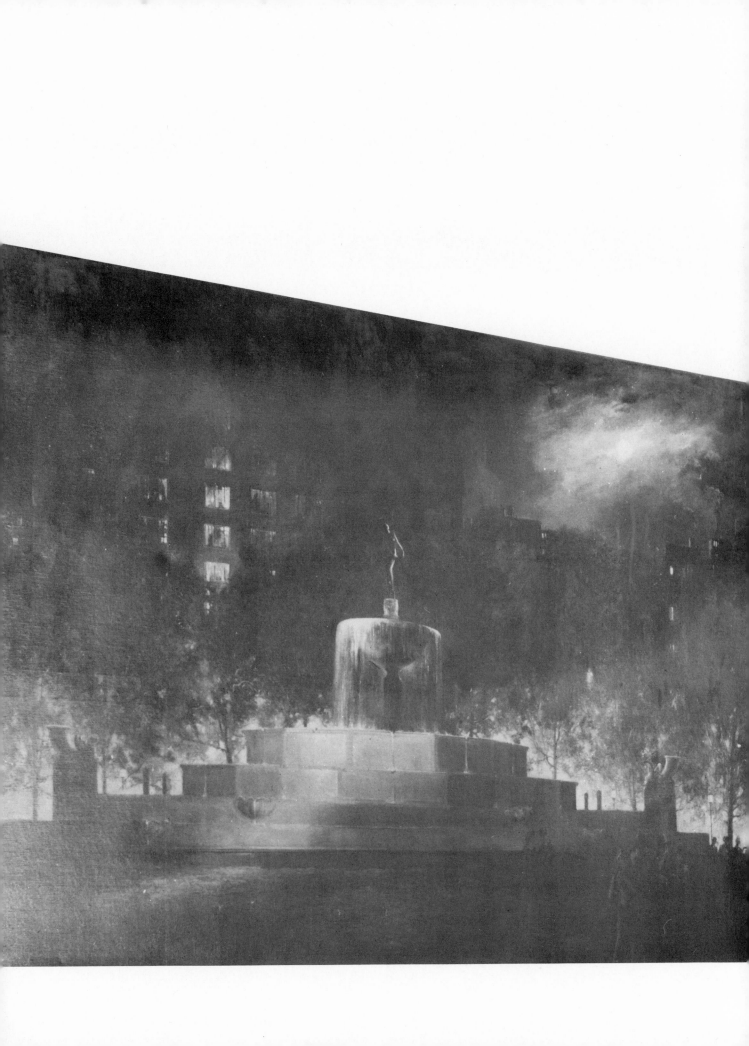

Model set from Polly of the Circus, *1917, patterned after Woodstown, New Jersey.* SHINN PAPERS.

Chapter Six

MOVIES

THE MOTION PICTURE INDUSTRY WAS A NATURAL FOR Everett Shinn. As a decorator it offered to him a new field in which to exercise his talents, at the same time it catered to his fascination with play-acting and the theatre. He entered this business in 1917 when he was hired by Goldwyn Pictures as art director, being engaged to supervise and direct the art work at a studio which was based in New York at that time. His contract was signed by himself and one Samuel Goldfish, that being the real name of the famous Sam Goldwyn.

In that same year, Shinn did the art direction for Goldwyn's movie *Polly of the Circus*. His working script is extant and with it some of his small preliminary drawings for sets as well as some larger ones. The latter are of a small, colonial house which was undoubtedly patterned after 68 North Main Street, Woodstown, New Jersey, a late-seventeenth-century building in which one of the artist's ancestors had lived.

Mae Marsh was featured in this production, and a whole village was constructed for the movie, of which the replica of the Woodstown house was a part. *Vanity Fair* in October 1917 praised the hiring of an artist to

Interior set from Polly of the Circus, *1917, based on 68 N. Main Street, Woodstown.* SHINN PAPERS.

Set workers, Polly of the Circus, *1917.*
SHINN PAPERS.

Scene from Polly of the Circus, *1917.*
SHINN PAPERS.

Set design for The Dump.
SHINN PAPERS.

consult with the moving picture industry by saying: "Now at last we are beginning to see a little light. Here is the Goldwyn Company employing Everett Shinn, the painter, to design their backgrounds."

Polly of the Circus was quite a successful movie and, in 1920, Shinn's reputation was such that Inspiration Pictures offered him a contract as art director. He left Goldwyn and went to Inspiration to work on a movie based on the Joseph Hergesheimer novel *The Bright Shawl*. This movie was a big success, being the story of political intrigue during the Cuban revolt of 1870. The cast included Richard Barthelmess, Dorothy Gish, and Mary Astor.

From Inspiration, Shinn transferred to Cosmopolitan Pictures in 1923. This move was made because Shinn had caught the eye of William Randolph Hearst, and Mr. Hearst hired Shinn for the express purpose of doing art direction on the film *Janice Meredith*. This movie was very important to Mr. Hearst because it was to star his famous mistress, Marion Davies. Shinn has the following to say about his meeting with Mr. Hearst and subsequent dealings with him and his movie company:

> The place of my meeting with Mr. Hearst was his temporary office in the Cosmopolitan Studios, a moving picture company of which he was president, owner, and producer. In this storage-loft-like room with its cluttered disarray of dusty props of chairs, pictures, mirrors, and ancient weapons our talk took place. He had asked me there to discuss "Janice Meredith."
>
> We had finished the preliminaries when Mr. Hearst was called on his private wire. This pause gave me more time to contemplate the picture's possibilities, particularly the need to keep fresh in the minds of our youth those events which had brought about our freedom. I saw ragged farmers holding the narrow bridge at Concord, the sudden erupting of bloody violence on the common at Lexington. I saw Bunker Hill and empty powder horns, Patrick Henry in the House of Burgesses. "Give me liberty or give me death." I heard the sound of gentle taps on the edge of a silver bowl that amplified into pounding hoof beats on Paul Revere's ride while far off tiny lanterns glow in a church belfry. I saw bales of tea hurtling over ships rails in Boston harbor and the black waters and heaving ice floes of the Delaware River and the rigid figurehead of independence, General George Washington, inflexible, as if carved in oak at the prow of his barge, the leader determined against George III's Hessian mercenaries.
>
> I was thrilled with the prospect of seeing it all come to life again until Mr. Hearst placed the telephone on its cradle and turned to me. In one sentence he sunk my hopes for the picture's success under the ponderous weight of his final order.
>
> "I wish to spend a million dollars," Mr. Hearst's thin voice was high pitched with desire. "Yes, Janice Meredith should make a very inspiring picture and I wish to spend a million dollars on it." How vastly different his mental picture must have been than mine. Where could a million dollars be spent? Mr. Hearst must not dare to gold plate the homely pewter.

I felt in this one extravagant utterance that the whole conception of the fight for liberty had been obscured in the mind of a man, who, from early youth had never known a slight restriction to his fabulous spending.

"Isn't that a lot of money to spend on a picture of that period?" I ventured. I was brushed aside with finality—"And I want it sumptuous."

Shinn went on to explain to W. R. H. that the sets for *The Bright Shawl* were all made in New York including the one for the Angleterre Hotel, which Hearst especially admired.

"Made here," I said. "It did have a look of blistering sun . . . but I wore a fur-lined overcoat while it was being built."

To which Heart said, "Splendid, you'll have more room in the Cosmopolitan Studios. 'The Bright Shawl' was a bit skimpy." With this Mr. Hearst's eyes indicated my way of dismissal by their withdrawal from the door to my hat . . . as I picked it up he said, "You now know what I want . . . Mr. Le Baron's office is on the floor below . . . see him about your salary."

I finally saw Mr. Le Baron with no need to talk of my salary for he had named a sum far above my most avaricious dreams, an amount I never would have dared utter even if I were talking in my sleep. However, I left his office with the first evidence of his sumptuousness in my pocket and in writing.

Shinn discusses at some length the actual filming of *Janice Meredith*, something of a travesty from beginning to end.

For the battle of Lexington, a long line of lumber laden trucks and a weaving trail of motor cars filled with carpenters, masons, mechanics, and their helpers from the Cosmopolitan Studios in New York drew in on a thousand acres of pastureland in Mount Kisco and deployed to dump their cargoes of building material at designated positions for houses that had been checked from a ground plan taken from ancient maps and old prints of the little hamlet of Lexington, Massachusetts.

With the same precision that would mark the efficiency of a corps of Army engineers or the gangs that pitch a tented circus city there was to come out of their labor a mirroring duplicate of that historic spot on a stage in a Manhattan suburb, ready to echo again the surge of violence and the blast of guns which had wedged apart the colonies from their mother country.

And he goes on to describe what happened to the movie even with all the accuracy of staging upon which Shinn insisted.

Being unable to endure the hash that was being made of the picture I gave myself an honorable discharge and a citation for heroic endeavor and went home. I never saw the towering spire of the church reared against the sky. Judging from the fate of most of the scenes, the spire, the

lantern, and all these would be superfluous if Janice Meredith was not there in her prettiest gown to ring the bell.

One other important scene was yet to be recorded, General Washington in his floating deep freeze crossing the Delaware River. This scene was filmed at Lake George as no snow was scheduled to fall about any waterway near New York. Mr. Hearst's millions held no lure for the custodians of cosmic forces. It was old stuff. Everybody had seen the Currier and Ives lithographs of the event. Everyone had seen the original or post cards of the world wide famous great dimensional painting hanging in the Congressional Library at Washington. Why fill the screen with such bleakness.

The scene was admittedly historical but why repeat it when refreshing interest waited in the person of Janice Meredith on the opposite shore impatient to greet Washington with the news that the whole damned British army was soused and the General would have a pushover with them when he and his men entered the Inn.

The snow problem had to be solved. One of Mr. Hearst's "gofers" speaks as follows:

"How about it, chief. I beat it back to New York and order four freight cars filled with confetti. I put up wind machines on each side of the camera. George goes aboard his scow. The scow shoves off and the wind machines . . . wowie . . . zowie . . . a crew of men shovel the confetti in front of the wind machines."

"Get going, young man . . . make it six carloads," Mr. Hearst looked over every word in his chain of newspapers not realizing that if every newspaper had been clipped into tiny pieces by the idle company he would have all the paper snow he would need for the scene's rugged reality.

A day later a train pulled in behind the cars and confetti was sluiced in a trough from the freight cars to the edge of the lake. The paraffin ice floes were chained to rocks in readiness to jam the scow. Then the propitious moment dawned. Washington walked down the rocky slant with his bundled up soldiers and boatmen. Men, poised, tense in readiness with shovelfuls of confetti waiting the order to feed it to the wind machines' cyclonic blast.

Suddenly it is noticed by another bright young man that the confetti unlike snow did not melt when it struck the water and that with the first blast of confetti Lake George had become one vast white table cloth. The close ups showed George Washington blinking in a blizzard of perfect saucers.

However, the scene was of little importance anyway as history makes no mention of Janice Meredith as a figurehead on Washington's scow.

The ultimate effect of the lavishment of a million dollars on the filming of the picture seemed to take on an intention of a personal

crusade for the ravishment of art and history. One million dollars, and it would have taken an overload of snuff in the royal palm of George III to incite a sneeze at a million dollars. That just isn't hay or excelsior in a thin exchecquer. For that sum the Crown would have let the rebels off scot free and thrown in Canada with perpetual rights to its salmon fishing.

Some of the million dollars was left to lavish on General Lord Howe's headquarters where Janice Meredith reaped another American victory in the devastating casualties of British broken hearts thus proving that had Janice met the right people at the beginning of the story there would have been no occasion for friction between England and her wayward colonies.

Although Everett Shinn was a very competent art director and knew technically how to handle the problems of set design, he knew his own mind and for once in his artistic career refused to compromise in regard to what he considered good taste—even for Mr. Hearst. After the making of *Janice Meredith*, there is no evidence that Shinn continued his career in the motion picture industry, although he may have been called to California once again to consult on the designs for a movie.

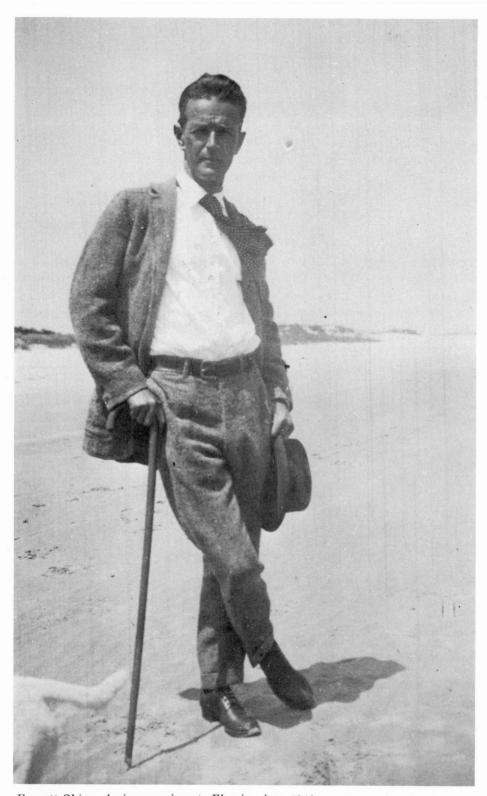

Everett Shinn, during marriage to Flossie, circa 1910. SHINN PAPERS.

Chapter Seven

ROMANCE, MARRIAGE, AND CHILDREN

IN HIS RELATIONSHIPS WITH WOMEN, EVERETT SHINN HAD A somewhat unusual, if not checkered, career.

He first began to discuss women at age twelve in his autobiographical reminiscences. He tells of his erotic fascination with odors emanating from an eleven-year-old girl with whom he had a conversation at the drugstore soda fountain. So, even at a young age, he was interested in the opposite sex, and this interest continued throughout his life. He was still fascinated by and fascinating to women at the time of his last illness at the age of eighty.

Flossie Scovel and Everett Shinn were married in January 1898 in Philadelphia and were divorced in August 1912. Flossie was extremely popular with the group of artists involved in The Eight's show and was a witty and talented woman.

From interviews with close friends of Shinn and with parties who knew both Flossie and Everett, reasons come forth for the dissolution of this marriage. Florence was very much afraid to bear children. This, of course, caused her to have some revulsion to the sexual act. So it stands to reason, in view of this situation, that the marriage could not last.[1]

Flossie's house, after 1910.
SHINN PAPERS.

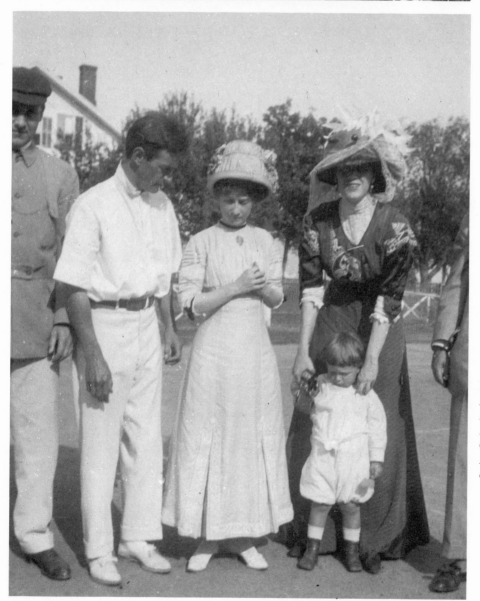

Left to right: *Daniel H. Morgan, Everett Shinn, Flossie Shinn, Grace Dwight Morgan, and Ira Glackens. Wickford, Rhode Island, 1909.*
COURTESY IRA GLACKENS.

On August 23, 1912, the story of Everett Shinn's marital troubles broke in the newspapers. Mrs. Shinn had sued him for divorce charging him with "breaking the commandment three times" according to the *Cincinnati Commercial Tribune*, in a special dispatch. They further state: "The complaint contains three causes of action, alleging misconduct with women unnamed." One occasion was on July 19 at the Hotel Belmont in West Forty-fifth Street; another at the Cadillac on July 24; and the last at the Cadillac on August 14.

Robert L. Luce, the referee in the divorce, ordered Shinn to pay $4,800 in alimony to Flossie and ordered the divorce to be granted to her.[2]

Throughout his life, Shinn always mentioned his fondness for his first wife. He regretted deeply that this marriage had not been a success, and he continually visited her during his lifetime, even bringing his succeeding wives to her for inspection.[3] There is a New Year's letter from Flossie among Shinn's papers, addressed to Everett and Paula, his fourth wife, and wishing them "miracles and wonders for 1939."

Everett's divorce from Florence affected his friendships with the other artists in the Ashcan Group, especially Edith and William Glackens, because Flossie had been and still was a particular favorite of theirs. There was coolness in his relations with this couple for some time. Possibly Shinn's relationship with John Sloan, tenuous at best, was adversely affected by his first divorce.

Shinn's second wife was Corinne Baldwin. Shinn married her in March 1913. Corinne, who was from upstate New York, visited in Bellport, Long Island, during the early 1900s, and this resort was frequented by the Glackenses and consequently by Everett and Flossie who visited, like everyone else, with the group.[4] So Everett had known Corinne for some time.

At one time, in fact, Shinn put on *Hazel Weston* in Mrs. Edie's playhouse at Bellport (according to Ira Glackens, Mrs. Edie was a grand dame and head of the Girl Scouts. She had a little theatre on her property). This production was a revival with the original cast consisting of the Shinns, Glackenses, and Jimmy Preston.[5]

Nancy (*Mrs. Ira*) Glackens's aunt Cornelia tried to dissuade Corinne from her interest in Everett Shinn. "He has a nice wife" was her ploy in trying to effect this maneuver.

Corinne was to bear Everett his only two children: Janet (now Mrs. John Flemming), born in 1915, and David, born the following year. Corinne and Everett originally lived on Twelfth Street in New York City before moving to Rhinebeck, New York, where they lived with their children. Everett eventually built an enormous house in Palenville, in the mountains back of Catskill. The house was never really finished, because at least twice a week Shinn would change the plans. This, according to Janet Shinn Flemming, drove the builders "to the bottle." She says this was completely understandable on the builders' part.

According to Janet Shinn Flemming, Corinne Baldwin Shinn was a

Corinne Baldwin, 1933. Everett Shinn's second wife. SHINN PAPERS.

Everett Shinn, circa 1920. SHINN PAPERS. →

Portrait of Janet Shinn, pastel, 1916. COLLECTION JANET SHINN FLEMMING.

Portrait of Janet Shinn, pastel, August 1916. COLLECTION JANET SHINN FLEMMING.

Janet Shinn, age three or four. SHINN PAPERS.

Janet and David Shinn, probably four and three years old, with Michael, the dog.
SHINN PAPERS.

Everett Shinn and the dog Gyp, 1918. SHINN PAPERS.

129

Everett Shinn, circa 1918.

good mother and had a very strong personality—she was tough on her children and believed strongly in rules and regulations. She had some very strange ideas about food. For instance, one of her sayings was that orange juice is gold in the morning, silver at noon, and lead at night. She never let the children have milk with meat, did not allow them to eat meat at night, and believed that bologna was pure poison. During the winter, she believed in large spoonfuls of cod liver oil and went the whole route with milk of magnesia every Friday night. She was great fun and was very attractive, although not beautiful. She taught her children that they were to the "manner born" and believed in good manners at all times.

One of the problems in this marriage was that Everett Shinn was one of the most meticulous men who ever lived while Corinne was anything but neat. She couldn't (according to her daughter) sew her way out of a

130

Bailiwick, Everett and Corinne Shinn's house near Catskill, New York, circa 1920.
SHINN PAPERS.

paper bag. She made a skirt and wore it for a year with a safety pin holding up the hem . . . the hem had come out within two weeks of being put in.

Corinne was no housekeeper. This drove Everett mad. But Corinne was very relaxed about the whole thing; she had a wonderful sense of humor and so did Everett. But his was not wonderful enough when it came to sloppy housekeeping.

The house that Everett Shinn decided to build in the Catskills was a remarkable thing. The family did live there for a time, but the plumbing was sketchy as was the heat. Everett loved beauty, but practicalities escaped him when planning houses.

The house was called Bailiwick. It was a house which would have taken an income of a million a year for upkeep alone. It had enormous heating pipes that did not function well at all. It also had enormous fire-

131

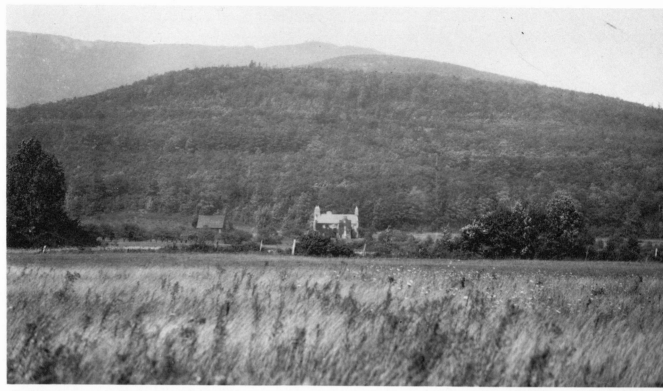

Bailiwick, from a distance. SHINN PAPERS.

Detail of doorway at Bailiwick. SHINN PAPERS.

places and its own reservoir. It was built of solid fieldstone and the interior was hand-paneled in chestnut. The attic ran the full length of the house yet contained nothing.

There was a thirty-five by twenty-five kitchen (above which were maids' quarters), and a big butler's pantry and huge dining room with fireplace as well. Many pieces of massive Italian furniture, garnished with cupids, were spotted about the place. The bathrooms were never quite finished. When Shinn and Corinne were divorced, he acted in a way that he followed consistently in his separations—she got the house, the mortgage, and the children.[6]

Shinn's attitude toward his divorces was that they were not his fault. That was his feeling. He said he had remained faithful to all his wives, with the exception of Flossie, as long as they were faithful to him. He was very annoyed at Corinne, but the fact is that he was probably impossible to live with. At the time of his divorce from her, there was much talk about property and there are many sheets in his personal files dealing with the disposition of such things as pepper and coffee mills. He clearly states in an agreement that Corinne may keep "all the French wicker chairs in the

132

house except two that mate." This document was duly signed on June 18, 1921, by Everett, Corinne, and a witness, one Audrey McEvers.

Shinn's divorce from Corinne was quiet and not attended by the usual lurid headlines and fanfare.

Shinn first met Gertrude Chase, his third wife, when he was working in the motion picture industry. She was working for John Robertson at Inspiration Pictures, and it was probably sometime in 1921 or 1922 when they met. Gertrude was an actress who had worked with Minnie Madern Fiske in *Mis' Nelly of N'Orleans* and also with Judith Anderson in *As You Desire Me.*

They were married in March 1924. Gertrude was very charming and well-bred and got along very well with Everett's children, who visited from time to time. However, Janet and David did not get along very well with Gäir and Marion Chase, Gertrude's children by a previous marriage.

Gertrude Chase, Everett Shinn's third wife, circa 1923. SHINN PAPERS.

Gertrude Chase with son Gair and daughter Marion, circa 1923. SHINN PAPERS.

Gair and Marion Chase, circa 1923. SHINN PAPERS.

Everett Shinn during marriage to Gertrude, circa 1923–24. SHINN PAPERS.

Gertrude Chase in costume, circa 1921. SHINN PAPERS.

Gertrude enjoyed a very active social life, which Everett abhorred as he thought many people were a total waste of time. According to a number of sources, there was not a high level of constancy on either side of this marriage. They stayed married until 1930, after a number of separations. At that time, Gertrude became very annoyed with Everett, or at least acted as though she was, for the purpose of divorcing him.

In any case, on March 13, 1932, and for a number of days thereafter, lurid accounts of their divorce proceedings appeared in Connecticut papers, especially in Westport, where they lived, and in Bridgeport. The gist of the divorce proceedings was that Gertrude Chase didn't mind posing for Shinn in the nude, but that she had serious objections to being photographed that way. Actually, Everett had photographed her in the nude any number of times. She was probably protesting to extremes, but her protests made for a good cruelty case.

Everett had borrowed heavily to fix up the house in which they lived in Westport. This money had come from Mrs. McManus, Gertrude's mother. He used part of it to buy a very snappy Auburn car which was to figure in his courtship of his next wife, Paula Downing.

Gertrude left the marriage with the children, the house, and the mortgage. As usual, there is a long paper in the files stating what was Everett's property and what was not. In this case, the paper is unsigned, which seems to indicate that Gertrude refused to go along with the negotiations.

In April 1933, the Connecticut newspapers again covered their front pages with suggestive headlines about the erotic painter in their midst. Everett Shinn had taken yet another wife, this time a twenty-one-year-old girl named Paula Downing. One headline read PAULA DOWNING MARRIES WESTPORT NUDE PAINTER IN PENNSYLVANIA TOWN.

Paula Downing Shinn, Everett Shinn's fourth wife, circa 1937.

These papers say that he is fifty-seven. One article (from the *Bridge-port Herald*) states that Mrs. Downing was prostrated by the news of her daughter's marriage.

In connection with his courtship of Paula, Shinn had endeavored to teach her to drive in the Auburn for which he had borrowed the funds from Mrs. McManus. She had an accident with the car, hitting her head against the steering wheel. This seems in some strange way to have endeared them to one another.

Janet, who was in the car at the time, recounts the incident: "I was with Everett and Paula when she plowed into that tree in Westport. I hit my head on the dashboard and so affected a slight concussion to keep me out of that damned boarding school for another week. Paula hit her head on the steering wheel and came up with a fractured skull. She was in the hospital for several weeks, and Everett was in what shall be called a 'state.'"

Paula, according to acquaintances, really wanted to marry Shinn. He was very fond of her but probably was worried about the difference in their ages.

And, because of this difference, Shinn could not really help but hold Paula back socially. He did not like parties, because people always drank too much, according to him. He liked to be the center of attention, and drunks had a tendency to divert attention he considered rightfully his. Shinn was exceedingly jealous of Paula, which made their marriage very difficult. For a while she thought it something of a compliment, but it became a great irritation as the marriage went on.

Paula Shinn states that Shinn had a brilliant mind and her marriage to him was a great learning process for her. He taught her to understand painting. Going to no end of pains, he would point out works of art in the galleries on Fifty-seventh Street. He would see a work in a second-story window and ask her to identify either the painter or the period. Then they would go up to the gallery and see if she was correct. Often she would get them right and was very pleased.

Shinn and Paula were very poor at times, as their marriage took place during the Depression and paintings did not sell very well at a time when necessities were hard to come by. Shinn had a solid gold watch which his father had given him for not taking a drink until he was twenty-one. Every once in a while he would pawn this watch and they would eat and eat well. Then he would retrieve it after he sold a painting or illustration.

During their marriage, Paula and Everett often visited at the Glackenses', where she became acquainted with many artists. She remembers some of the artists of The Eight and their contemporaries as "marvelously warm." They were very good to Paula, teaching her a great deal about the world of culture and art.

According to Paula, Shinn was absolutely fastidious. He had an in-born distaste for drinking, as mentioned before, and in Paula's opinion his love of possessions was something he inherited from his grandmother Shinn.

Paula, circa 1938–40.
SHINN PAPERS.

136

The Westport house of
Gertrude and Everett
Shinn.

Everett Shinn, during his
marriage to Paula, circa
1933–35. SHINN PAPERS.

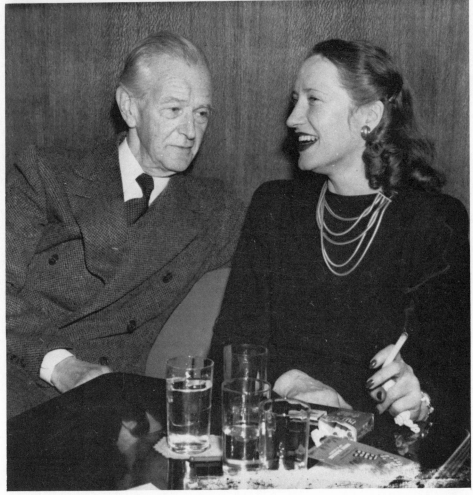

Paula and Everett, circa
1933–35. SHINN PAPERS.

Shinn used to say that his grandmother took the candlesticks to her room each night, returning them to the mantelpiece in the morning.

Everett and Paula lived for a while in a two-bedroom apartment on Fifty-seventh Street. The place was immaculate, as Everett had Paula and Janet Shinn, who was living with them at the time, go over it thoroughly every morning right after breakfast. Being madly in love and not a little bit in awe of Everett, Paula reacted to all this with a great deal of patience. She tried hard to please him in all ways.

At the time they were living on Fifty-seventh Street, Lou Fairchild, who had married Corinne after her divorce from Everett, came to visit them. Because of the notoriety surrounding their marriage, there were a number of reporters in the hallway when Lou entered. One of the reporters stopped him and he explained, in jest, that he (Lou) was just the father of Everett's children.

Paula Downing struggled alongside Shinn during the Depression, working to help support their menage. For a time they got along quite well. She was a charming, lovely girl. Five feet eight inches tall, she towered over Everett. All his friends were extremely fond of her, and she was a fine home-maker—a wonderful cook and hostess. She made a smock for Everett, every stitch by hand. It was made out of yards and yards of blue cloth with French smocking at least a foot deep all the way around. The garment was volumi-nous, and when Everett tried it on, he vanished.

It was probably inevitable, however, that Paula would eventually be attracted to a younger man, and that is exactly what happened. She left Shinn and eventually married Horace Carpenter, whom she had known as a neighbor during the time she and Everett lived in Roxbury, Connecticut.

According to Paula, she and Everett were divorced in 1942. In August of 1950, a series of letters were exchanged. A bit delayed, these were the usual letters following one of Shinn's marital separations covering items which he felt were his, but which, he thought, the wife had somehow made off with. Paula states she has "a few Wear-Ever pots and pans, absolutely nothing else." As long after as 1950, Shinn is still talking about his raincoat and leather jacket being missing, as well as a large pink rug.

Shinn always stayed on friendly terms with ex-wives and when he died, according to information obtained from family and friends, they all came to his funeral.

In talking about matrimony in his autobiographical sketches, Shinn has the following to say:

> In risking the precarious hazards on the slack wire of matrimony one needs the intrepidity of a Blondel who teetered out standing in a bucket over the roar and suctional pull of Niagara Falls. Four times above the whirlpools that were set in violent motion by so slight a stir I have had an imbecilic confidence in my success. Having, since a small child, a predi-lection for acrobatics, I have on each successive disaster followed the

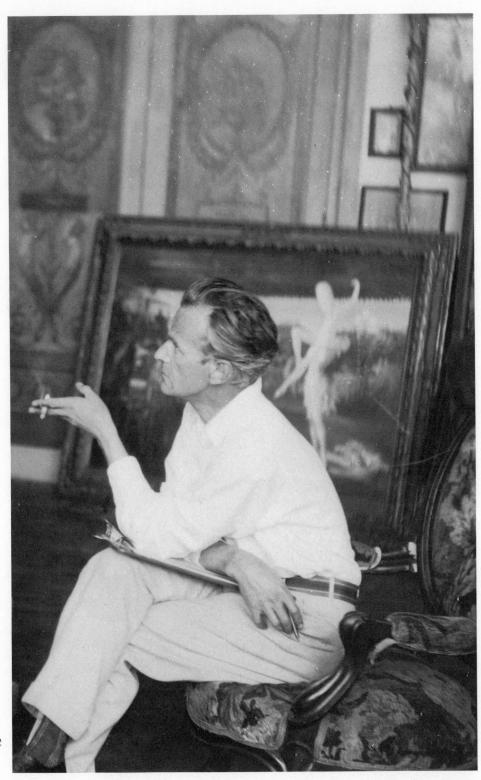

Shinn at his Westport
studio, circa 1938.
SHINN PAPERS.

Squire Carpenter house in Roxbury, Connecticut, 1940. SHINN PAPERS.

Everett Shinn in Roxbury, Connecticut, 1940.
SHINN PAPERS.

Everett Shinn, circa 1943.
SHINN PAPERS.

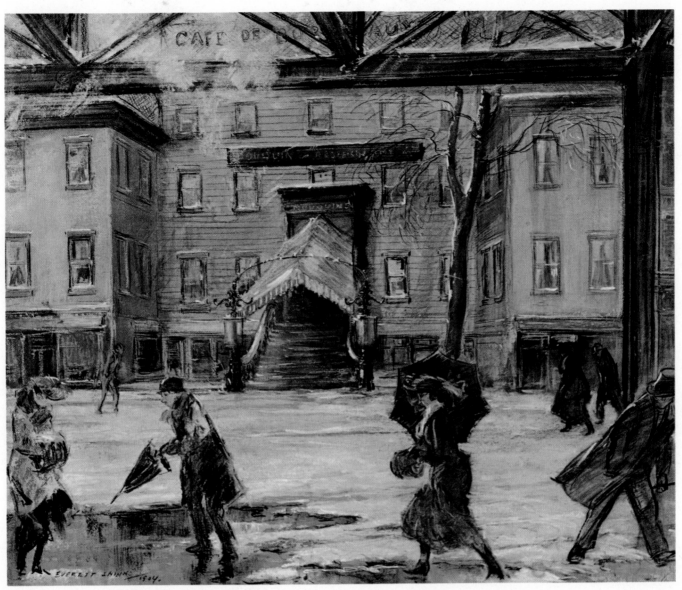

Mouquin's, *pastel, 1904.* NEWARK MUSEUM, EGNER MEMORIAL FUND, PURCHASE 1949.

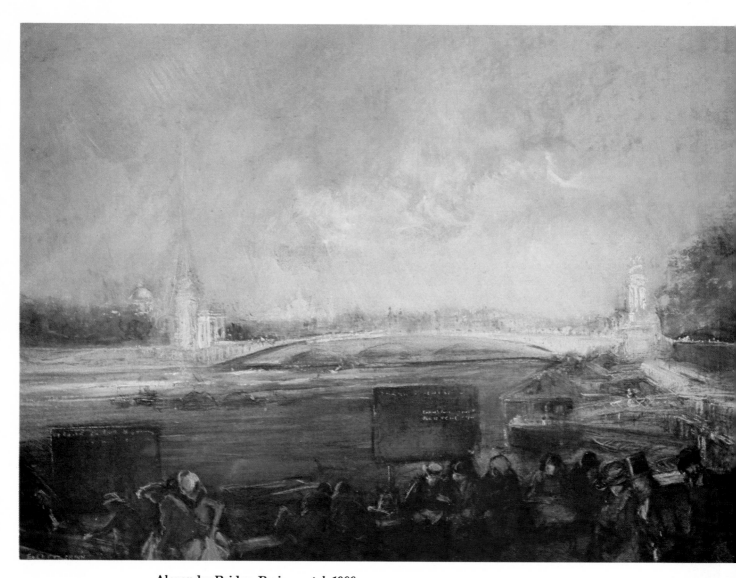

Alexander Bridge, Paris, *pastel, 1900.* BOSTON MUSEUM OF FINE ARTS, KAROLIK COLLECTION.

Portrait of Janet Shinn, *oil on canvas, 1916.* COLLECTION JANET SHINN FLEMMING.

Rue de l'Ecole de Médecine, *pastel, 1903.*

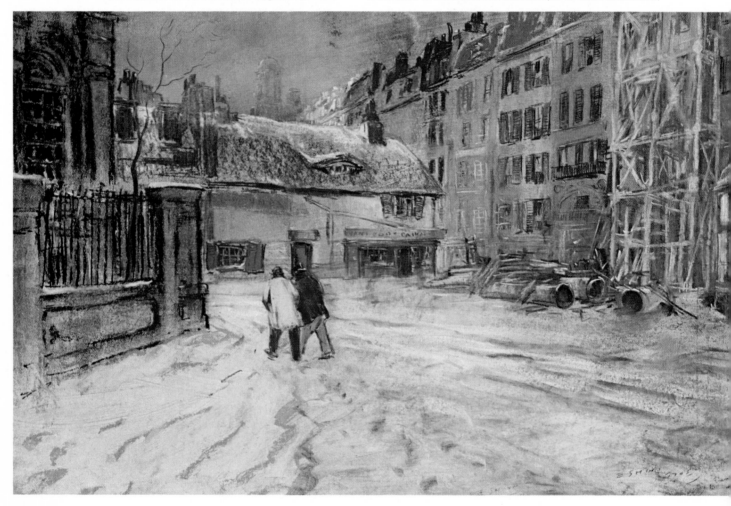

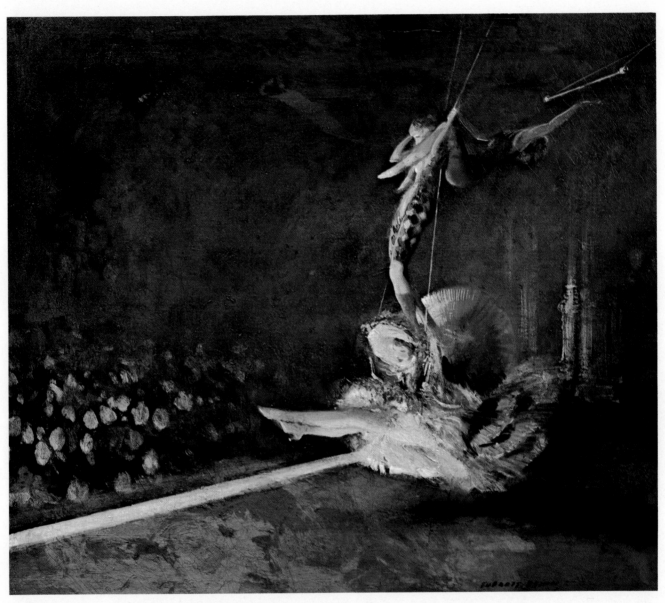

Trapeze, Winter Garden, New York, *oil, 1903.* COLLECTION ARTHUR G. ALTSCHUL.

Matinee, Outdoor Stage, Paris, *pastel on paper, 1902.*

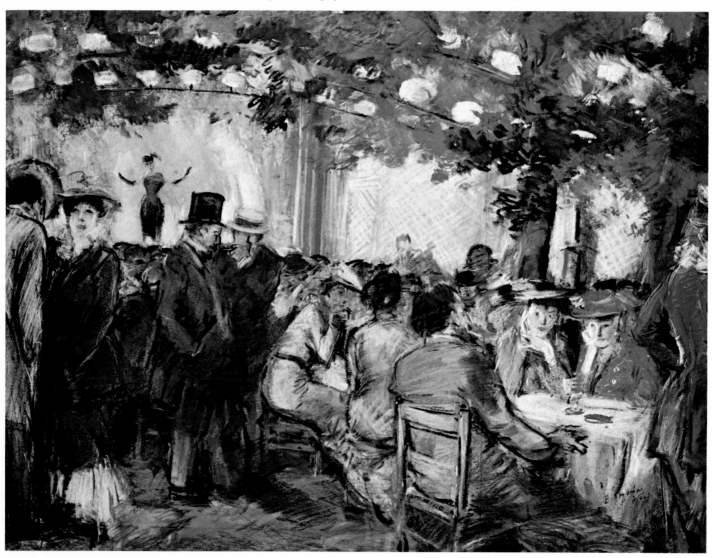

The Laundress, *pastel, 1903.* COLLECTION ARTHUR G. ALTSCHUL.

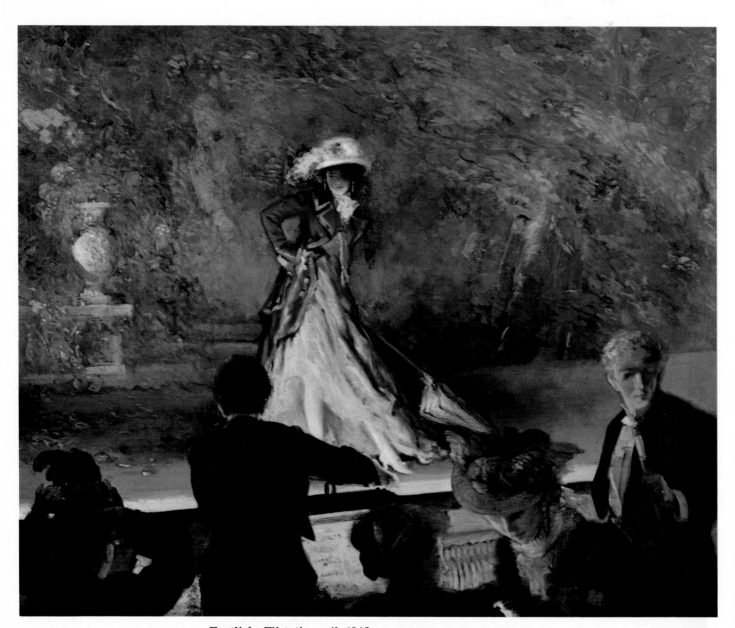

Footlight Flirtation, *oil, 1912.* COLLECTION ARTHUR G. ALTSCHUL.

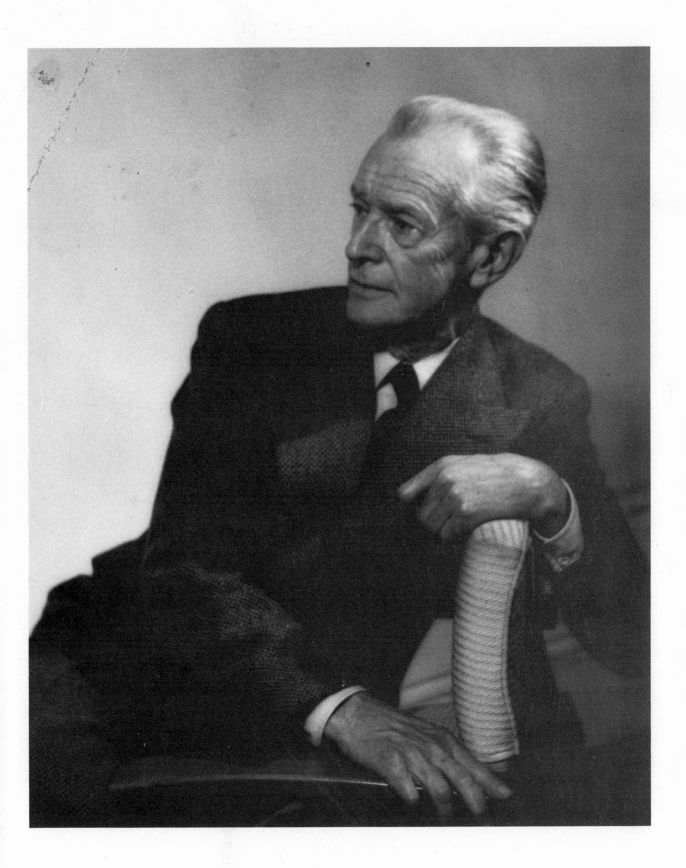

patterned coercion of a circus boss, who, having witnessed the precipitous drop of an aerial performer, demands, "Get back up there while your leg is broken and try again . . . never mind your fractured wrist . . . get up there *now* understand *now—not tomorrow . . . now, now, now or you're fired.* The voice of the boss was the voice of experience for he knew that had the trapeze artist nursed his broken bones and convalesced with the mounting thought of the dangers in his act he would never perform again. Once you've lost your nerve, you're through.

So bruised as I was I went up again. I looped and pinwheeled and hanging from my toes I believed, as always, that I was giving my best performance. Look, no hands. I was even cheered by the doubters who had shown no faith in my ability to stick. I swung higher. Still no hands. I just couldn't fall. Then both wires on the trapeze snapped and shot up to the top of the tent like released watch springs and I spun to earth. Ah, as usual, some woman had removed the net.

Bruised again and in the same manner of warding off fright I allowed no time to gather timidity between my flops in matrimony. Because of desire that bolsters confidence and I had desire enough to be irked at being grounded, I tried again. A casual check on the apparatus and I was again swinging from my toes . . . de . . . da . . . de . . . da . . . airy as a bird . . . swinging from my toes . . . up . . . down . . . up . . . down . . . no hands . . . de . . . da . . . de . . . da . . . but fate had dipped the trapeze bar in a biting corrosive acid . . . snap . . . and as I fell I saw a cobweb substituted for the net . . . held at each end by two lawyers dressed as clowns.

What kind of father was this man, Everett Shinn? Was he really the libertine he appears to be in his escapades with women?

His daughter, Janet, remembers that Everett's moods were like quicksilver. He would be enraged about a piece of underdone bacon and then be serene and joking in the space of a few seconds. For years he had a love affair with oatmeal and orange juice until one memorable breakfast he flew apart, blaming the orange juice for a headache he had had the night before. No orange juice would ever grace his table again, he stated, and it didn't— Everett was not a petty man, in his daughter's view, but he did have a knack for homing in on the idiotic. He was a profane man, and hells and damns flew around, but he most definitely was not vulgar. "Bathroom language," as he called it, was not allowed in his presence. He was, however, extremely earthy. He once lectured Janet and Paula about sex until the small hours of the morning, getting his message across quite well without a single vulgar word or graphic description.

According to his daughter, Everett was a charming father but not terribly devoted. The truth was that he was too taken up with himself, too intensely interested in his own pursuits to be really devoted to children. His stepson, Gäir Chase, says that Everett always said the children were "in the road." In any case, the two Chase children, Gäir and Marion, were both packed off to school shortly after his marriage to their mother.

He painted pictures of Janet and David and Marion which were

142

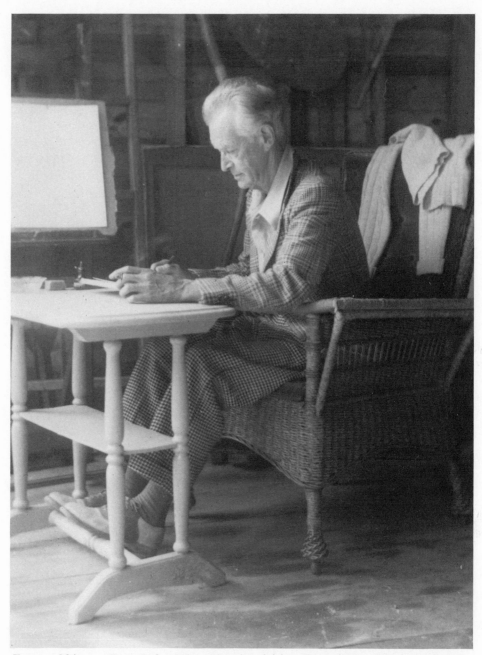

Everett Shinn at Bear Lake, Pennsylvania, visiting Dr. and Mrs. Henry A. Carr, July 1948.

charming and sensitive, and certainly warm. Toward the end of his life, from information received from various sources, it seems that he became very friendly with his son, David, and developed an interest in and liking for David's children.

Shinn was very courtly and did not mind spending a great deal of money to show a lady friend a good time, although he was extremely penurious about most things, including art supplies and especially taxis.

There is little doubt that he had numerous affairs before, during, and after his marriages. He appears to have been, in some way, irresistible to the opposite sex. When he was almost eighty he still commanded the love and attention of women. His interest in them began in his childhood in Woodstown, New Jersey, and never waned.

Shinn's enormous interest in women, although it manifested itself early in life, probably had less to do with the singular environment of his native Woodstown than with the permissiveness of his mother and the sepulcherlike gloom generated by his grandmother Shinn. He seemed to be constantly searching throughout life for the perfect partner and never successfully finding peace and companionship for any sustained period of time.

For all his flamboyance, Everett Shinn was a rather simple man in many ways. He adored rice pudding, for instance, and always had it in restaurants when it was on the menu. He felt cheated if there were no raisins. He insisted on bread and butter at every meal and loved jelly and gravies.

He was not really a collector except of watch fobs. He had a fine collection of these—antiques, especially, and pieces from all over Europe.

Chapter Eight

DREISER'S THE GENIUS

IN 1911 THEODORE DREISER WROTE A BOOK ENTITLED *The Genius*, which was published in 1915 and was based on the life of Everett Shinn. Dreiser was considered the great American novelist of his time, but if one were to judge Dreiser by *The Genius*, it would be hard to understand how he ever deserved the title.

The gossip of the time was that Dreiser had used Sloan's paintings and Shinn's studio as background for a book about himself. Indeed, one of his biographers, Ellen Moers, has written: "*The Genius* is a rather smug account of the troubles of the artist from the vantage point of a man who has conquered them, and half the book reflects in detail the 1905–10 period of Dreiser's life."

Dreiser came to have an acquaintance with the Ashcan painters because he was editor of several magazines in which their illustrations were published. There is, however, no evidence of close friendship with any of them except Shinn, and Shinn himself called it an "office friendship."

Joseph H. Kwiat, a student of Dreiser, asked Shinn to comment on the book and in 1952 Kwiat published a monograph entitled "Dreiser's *The*

Genius and Everett Shinn, the Ash Can Painter," in the *Modern Language Association Bulletin* for March.

In answering Kwiat's request for information Shinn states:

> I have carefully read Theodore Dreiser's book, *The Genius*, and have . . . made such marginal notes that touched on my art activities, incidents, and almost precise identification of some of my pictures that were fresh in the minds of Dreiser and in my own during a close office friendship where we both talked of our individual work. . . . We started at Ainslee's Magazine together.

> The art gallery that Dreiser overlays with another name is obviously that of Knoedler. One of my earliest exhibitions was held in that gallery when the gallery was at the corner of 34th and 5th. Pictures described in that gallery at one of my shows fit the things I made.

He states further on:

> Beyond the actual art expression I am in no way related to Witla the artist in Dreiser's book, *The Genius*. His emotional side is far and away from mine. That side of Witla's character is presumably the emotional unrest of Dreiser himself.

Eugene Witla, the hero of the novel, is a man of little emotional stability, especially as far as women are concerned. He rises to the top— which shows immediately how little Dreiser knew about artists and their goals, especially in the early twentieth century—and then falls. He loses wives and mistresses right and left, but always seems to find another young girl panting for him around the next doorway.

In connection with Witla, Shinn has this to say:

> This boob, Witla, has no reserve, no doubts of his genius. . . . Idiot. My picture bought from Knoedler's Art Gallery produced at the time a particular elation but I didn't entertain a belief that I was in any way as good as Winslow Homer that hung on the right of my picture and one by Whistler on the left.

However, Dreiser did describe Shinn's New York and Paris studios with much fidelity. In his description of paintings he uses some of Shinn's work (and also some of Sloan's paintings), describing it very accurately.

Dreiser also uses some of Shinn's artistic experiences. In portraying the fictional artist's brushes with the National Academy, for example, it seems that Witla in the early part of the book is impressed by the men who were N.A.s. Dreiser comments: "[He] little knew with what contempt this honor was received in some quarters, or he would not have attached so much significance to it." Shinn says, "All the 'Eight' hated the staff at the N.A." In truth, although Shinn felt contempt for the Academy, he did send pic-

146

tures to them periodically. And finally, late in life, he was admitted and could write "N.A." after his name.

Dreiser uses as an integral part of his book both his own and Shinn's interest in the city as a dramatic spectacle. Dreiser says: "It was all dramatic to him—the wagons in the streets, the tall buildings, the street lamps." Shinn says: "Certainly this was my intention—all dramatic."

The Genius is banal beyond belief. It is filled with unbelievable conversations, especially between Witla and his much-put-upon wife. She continually wails, "Oh, oh, you can't do this to me." People are constantly carrying on about their lots in life, especially the discarded females—wives and mistresses alike—who seem to strew the path before Eugene Witla like so many faded flowers. Shinn was extremely attractive and was attracted to women all his life, but there is no evidence of the almost total adolescence that characterizes Eugene Witla.

John Sloan says in his notes:

Dreiser who was supposed to be a realist, observer of life in the raw, wrote a most romantic and absurd book about an artist, The Genius. *The substance of that book is as inane as its style. I understand that the artist was based on Everett Shinn, Dreiser, and two unknowns, of whom, as a person, I am not one. Dreiser visited my studio in a loft building and saw at a glance that I was not leading the right kind of artist life for his purposes; no rich furnishings and none of the typical trappings like fishnets and spinning wheels that were the earmarks of the "studio."*

It aroused great notoriety when Comstock and Sumner's League for the Suppression of Vice discovered a passage describing a Caesarian operation and so suppressed the book. The rest of the book is so banal and sentimental and saccharine that one is surprised today to realize that he was considered the Hemingway of his time. I would never have paid any attention to this Dreiser failure if I had not learned that he described some of my paintings very accurately as works of his hero . . . who achieves great prestige and financial success as soon as he shows them, circa 1908. How untrue to life in America.

Then he has this artist who paints the life of the city, rise to the top of the advertising world and live like a millionaire. Meanwhile, all his life, he has had an obsession for young girls, and finally one of these adolescent affairs wrecks his career. But only temporarily for he returns to painting and is soon selling great pictures for eighteen thousand dollars a piece.

Now it may be true that Shinn has had a checkered career, working in the theater and Hollywood, making money, spending and

147

*losing it, but I don't think Dreiser borrowed much of Shinn's
character as an artist save for his love of studio trappings. This
artist-hero is based mostly on Dreiser's childish ideas, illusions,
and desires. There are artists, good ones, like Cellini who have been
Don Juans—and preserved their integrity as artists; but there
is a consistency about the character of such a man and the social
background must be sympathetic if he is going to make a success.*

This comment by John Sloan seems to sum up the worth of *The
Genius*. As a curiosity, it is interesting. As anything approaching a work of
art or a great novel, it is the worst kind of nonsense, written, however, with
Dreiser's strong peasantlike prose and with great professional attention to
background detail.

STYLE

EVERETT SHINN PASSED THROUGH A SERIES OF DIFFERENT styles during his long and prolific career as an artist. One should always remember that he was a newspaper reporter–artist long before he became a fine artist. He worked at this profession for a good many years, and throughout his career brought a certain element of reportage, mixed generously with the dramatic, to all his work.

He had a phenomenal memory. This is clearly shown by his drawings of the buildings in Paris, done many years after his one trip to that city. Not only are the structural elements accurate, but there's a certain indefinable feeling—a typical French ambience—that shows Shinn not only retained a great deal of visual detail but could call actual moods of places to mind at will.

In his early days as a fine artist (1900–15), Shinn painted in what has come to be known as the "American Impressionistic" style. His palette was dark and limited. He loved night scenes and looked for dramatic ways of producing scenes with intense light glowing in the darkness of the city.

His early work during his Ashcan period has been compared to

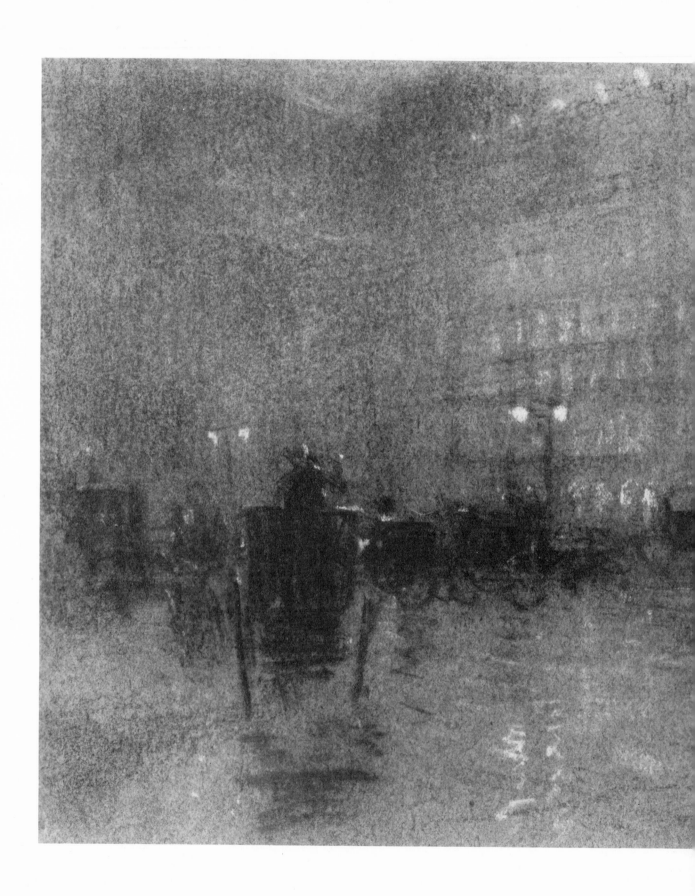

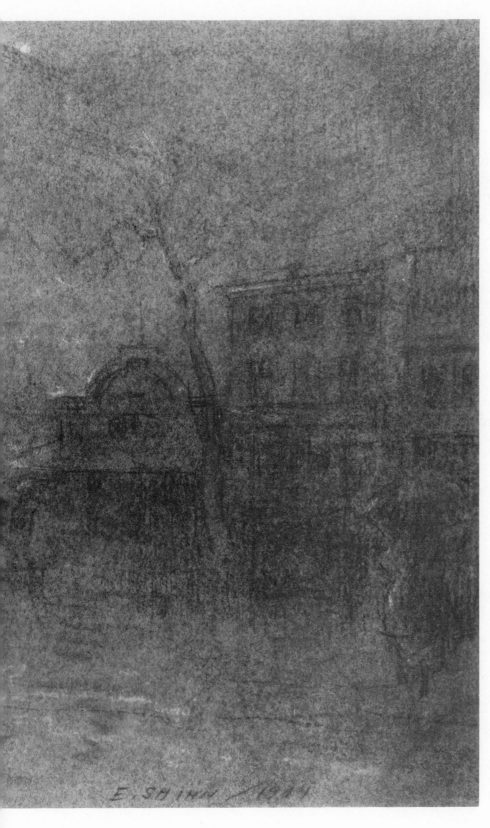

Delmonico's Fifth Avenue,
charcoal, 1904. Early night
scene, impressionistic style.

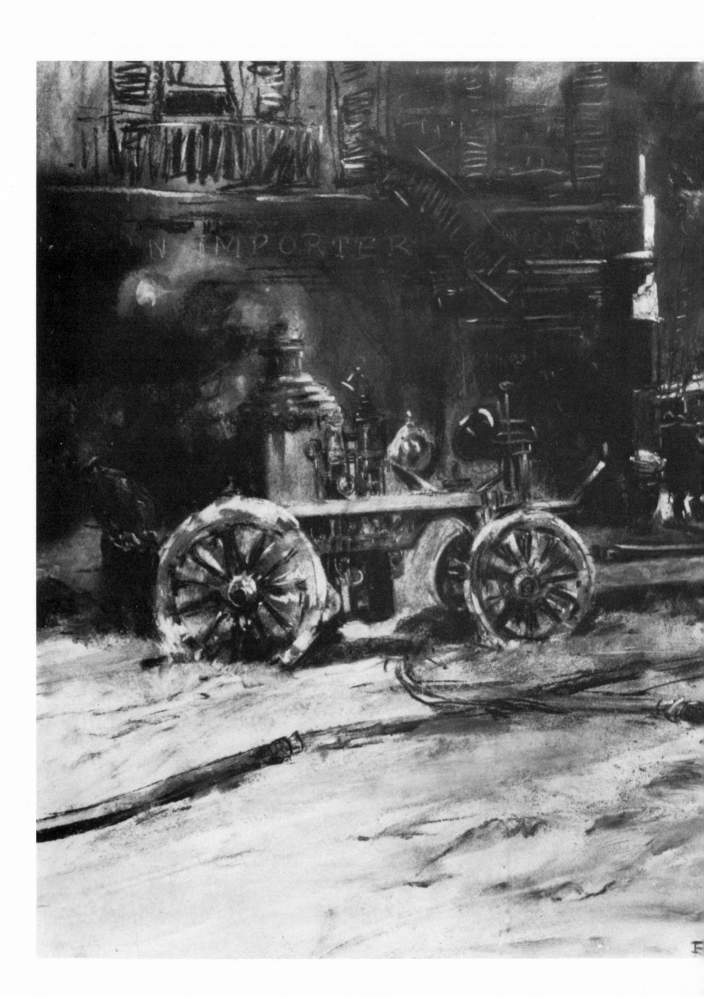

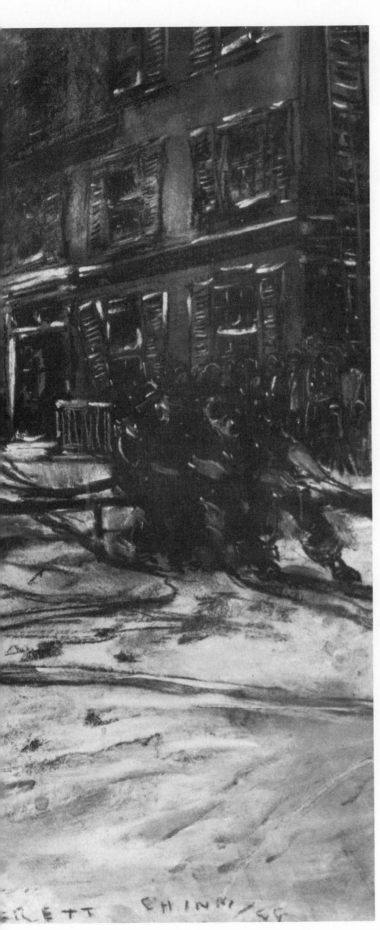

Fire Scene, *pastel on paper, 1909(?).*
Impressionistic style. ARTHUR G. ALTSCHUL
COLLECTION.

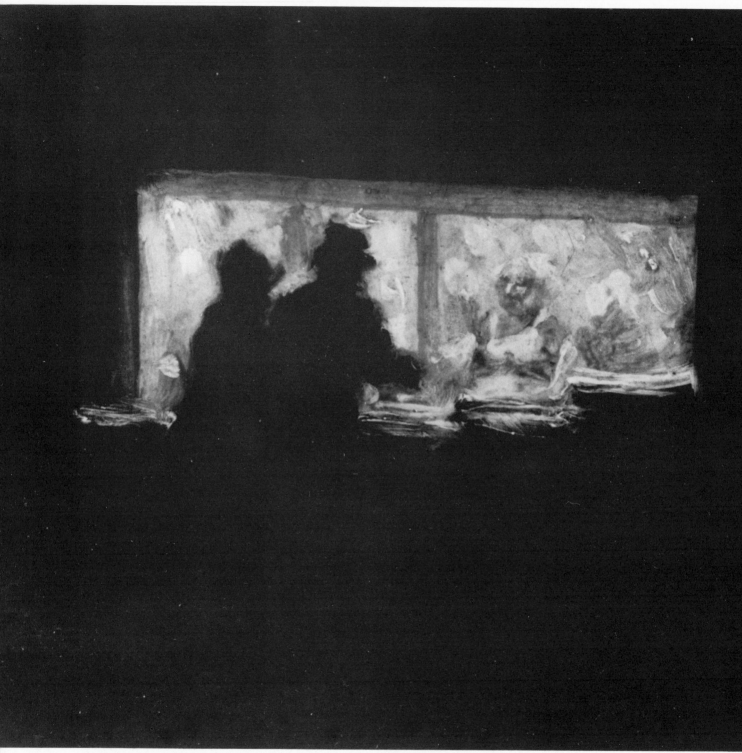

Newspaper Stand, *oil on wood panel, n.d. Impressionistic style.*
ARTHUR G. ALTSCHUL COLLECTION.

Degas, Daumier, and Lautrec. It may certainly be possible that Shinn was influenced by both Daumier and Lautrec. In many ways, his work shows such influence. Like Daumier, he used the cartoon character in his painting many times, especially during Ashcan days, and he was, of course, interested in the theatre and world of make-believe just as Lautrec was. However, Shinn never mentioned any interest in either of these artists— or any other artist for that matter. The only artist for whom he ever expressed admiration, as far as anyone knows, was William Glackens. Later on in his career the comparisons were to Fragonard and Boucher and once in a while to Watteau, but these comparisons were not made until his decorative period, referred to facetiously as "rococo revivalism," the style he used in mural decoration.

To compare Shinn to Degas is surely unfair to the fabulous Frenchman. While Shinn did indeed do paintings of the ballet and other subjects also used by the famous Impressionist, Degas was a meticulous draftsman, going over and over his work hundreds of times until his standard of perfection was achieved. Shinn was a fast worker and once he had a painting— especially a pastel or watercolor—fairly close to his conception he usually did not try the subject again for some time, even years.

Shinn was extremely facile. From his earliest days, he used the pencil and pen with great ease and the conté crayon as well. Unfortunately, his natural facility and the ease with which he drew were probably his undoing, in the sense that he never examined anything in great depth.

To compare Shinn to Lautrec is even more ridiculous. It would show a callous misunderstanding of Lautrec's sensitivity to line and the subtlety of his satire. Again, the genre quality of the paintings seems to be all they have in common. Shinn may have been many things—facile, dashing, even dramatic—but he was not subtle.

No, if we must compare, let us compare him to Walter Sickert, the man who occupied a place in British art similar to Shinn's in America. Sickert was an English Impressionist, and the two men thought a bit alike. In an article in *International Studio* in December 1923, Mrs. Gordon Stables says of Sickert:

> . . . *One detects his condemnation of the prevailing ideas on*
> *loveliness as being too often false and ephemeral. His penetration*
> *is too keen, his wit too biting—the artist has a witty brush as well*
> *as a humorous tongue—for compromise, nor will he consent to*
> *the glorification of either his models or their setting. He is at his*
> *best in dealing with what might be described as the tragedy*
> *of the commonplace.*

And in *Modern English Painters*, Sir John Rothenstein quotes Sickert as saying: "The more our art is serious the more will it tend to avoid the drawing room and stick to the kitchen."

Yes, it would seem that Mr. Sickert and Mr. Shinn have a great deal more in common than Mr. Shinn and the other prestigious gentlemen mentioned above.

Shinn comes closest to showing a great artist's real emotional involvement with surroundings in his early New York pictures. Here the people on the docks and in the streets, in restaurants and taking part in events around the city, are depicted with some sympathy and understanding. This feeling of empathy with and sympathy for subject decreases as Shinn continues in his career. In pictures from the thirties and forties in which he goes back to his original New York themes as an Ashcan painter, there is absolutely none of it apparent.

It is interesting to note that when Shinn was a very old man, just before his death, he seemed once again to have some feeling for subject. In the paintings he did of the Ringling Brothers' winter quarters in Sarasota just prior to his last illness in 1953, and in drawings he did in New York Hospital during his terminal illness, there is a return of stamina and heart not noticed for many years.

After Shinn's trip to Paris in 1900 and dating probably to his associations with Elsie de Wolfe and Stanford White, he began to paint murals for the Stanford White house. After Fitch's friends saw these decorations, Shinn was inundated with orders to paint murals in the homes of New York's nouveaux riches.

For his murals, Shinn did preliminary studies in red chalk on architectural detail paper. Red chalk was a favorite medium. He made large preliminary sketches and then plotted them on final panels. He also executed many of the final works in red chalk that ranged from dark red brown to light red.

The Trenton murals, which came after Shinn's first associations with White, were a departure from the Watteau-Fragonard-Cupid-Lover routine. In these Shinn reverted somewhat to the realist-dramatic style of his early paintings.

In his later magazine illustrations (1917 on), he drew highly stylized figures—women with very long legs, bodies generally exaggerated, not to the point of John Held, Jr., or Petty, but exaggerated—because this is what the editors preferred. This lengthening of legs became such a habit with Shinn that he continued it for the rest of his life, making it rather easy to distinguish Shinn's later work from his earlier endeavors.

Dating Shinn's work, however, is tricky at best. Shinn is known to have signed fairly late work with early dates because he knew the earlier work brought higher prices.

For a time, probably around 1915, Shinn had a short period of what could be referred to as his "Guy Pène du Bois" period. Du Bois painted in a very flat style—much different from any of his contemporaries—with well-defined planes. Everything had a rounded, molded look. His palette was somewhat lighter than Shinn's, but Shinn did not vary his own palette when

156

he endeavored to imitate the roundness and light planes of Du Bois's contours. This period lasted a relatively short period of time.

According to Norman Kent, Shinn always used a limited palette for his work, regardless of the medium. He always toned the canvas or paper before painting. He used only a few pure pigments applied in thin washes and used turpentine *only for density*. Finally, he would apply heavy opaque color in highlighted areas for accent. His favorite color was Prussian blue and he used it wherever possible.

Shinn was a master with pastels. He used them in much the same way Europeans did, with some innovations. His masterful use of this medium could be a major reason for his being compared to Degas. Shinn, moreover, probably did copy the style of this great Frenchman somewhat.

For pastels, Shinn developed a very important innovation, which is most difficult to use. He took paper mounted on a heavy backing board and soaked it completely in a tub of water, removing excess water with his hand or a sponge. Then, with the final color composition completely in his mind, he began laying on patches of color. When these colors struck the wet ground, they turned immediately to a dark tone, losing their original coloration. Shinn worked swiftly and continued to build up his design until he had covered the whole surface. As the picture dried, the original color would return, but unlike the usual quality of pastel with its delicate, dustlike surface, evaporation of the water caused the pigment to dry hard, producing brilliant color with a temperalike quality.

In explaining his technique to Mr. Kent, Shinn said: "Don't blame me if it doesn't turn out for I'm warning you—an awful lot that's unexpected can happen when you're puddling around on that wet ground with color that you can't see a few seconds after you've put it down."

Although Shinn publicly abhorred the use of photography, there is strong evidence from his files that in later years he used it extensively.

The realism of Shinn and his fellow painters at the beginning of the century was called ugly, disgusting. The group were referred to in the press as "Apostles of Ugliness" among other things. It is hard for us to understand this today because of the real ugliness surrounding us. Their work, in the words of Harvey Dinnerstein and Burt Silverman writing about The Eight in *Art News*, February 1958, had a "humorous detachment" from subject matter. Perhaps this was more true of Shinn than the rest of them.

Shinn, meticulous in everything, was, of course, a meticulous painter as well. He never made a mess and would paint in a small corner of a room which always remained immaculate. He loved to organize things and had small drawers built into all his desks for clips, rubber bands, pen points, and whatnot. He never lost this fastidiousness.

Shinn, himself, abhorred all modern art. He thought Alexander Calder's work a joke; hated Picasso and thought him a complete charlatan; and, as for the other avant-garde Frenchmen of the Armory Show period (1913), Everett had nothing but bad words to say about them.

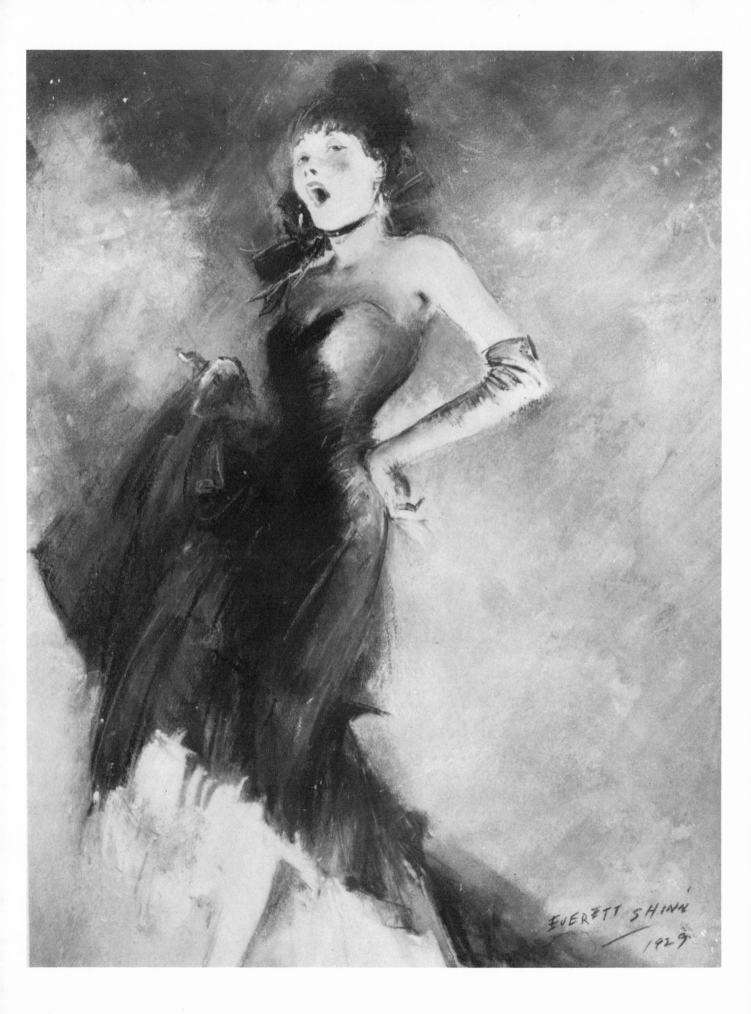

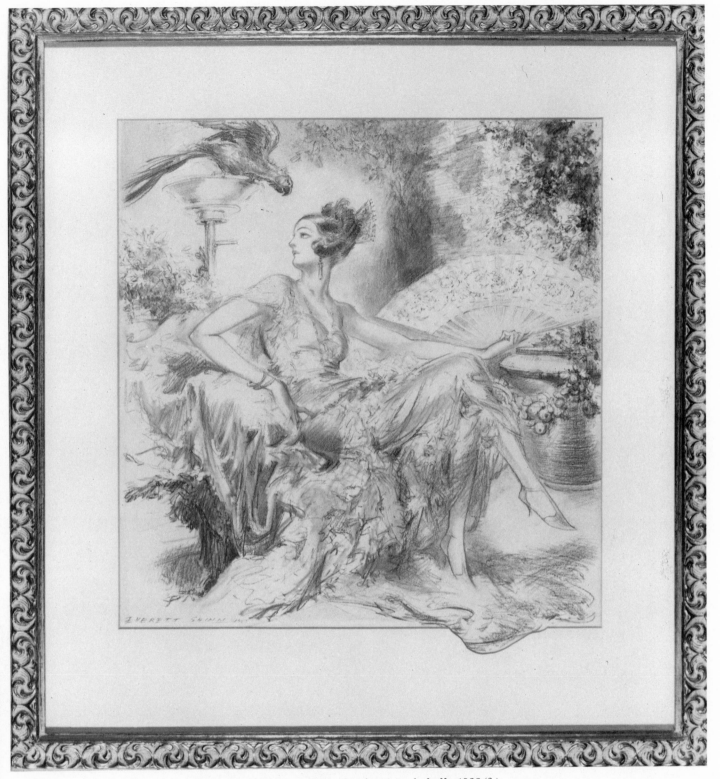

Mrs. John Thomas *(Shinn's niece), red chalk, 1923(?)*.

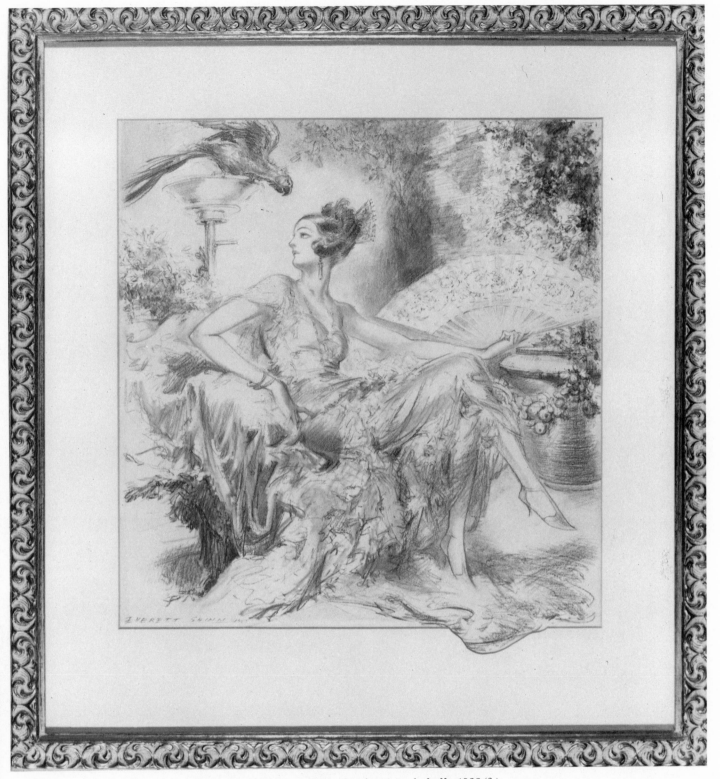

The Singer, *pastel, 1929. Shows propensity toward elongation of*
trunk and limbs. ARTHUR G. ALTSCHUL COLLECTION.

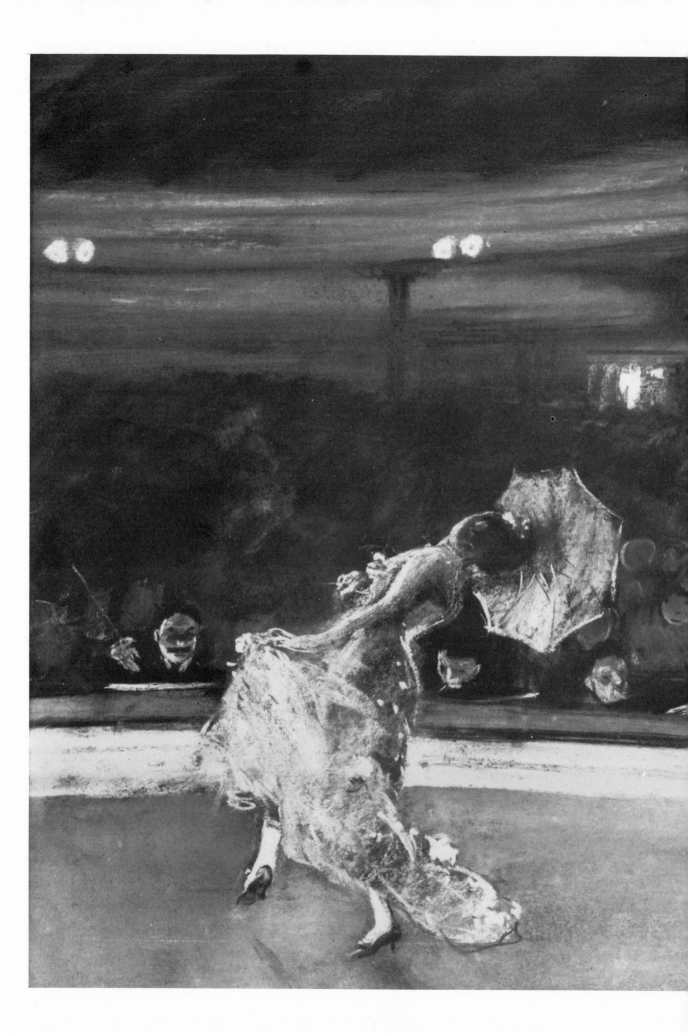

Dancer on Stage, View into
Audience, *oil, circa 1913. Guy
Pène du Bois style.*

Dolly Sisters in Red, *oil, circa 1916. Guy Pène du Bois style.*

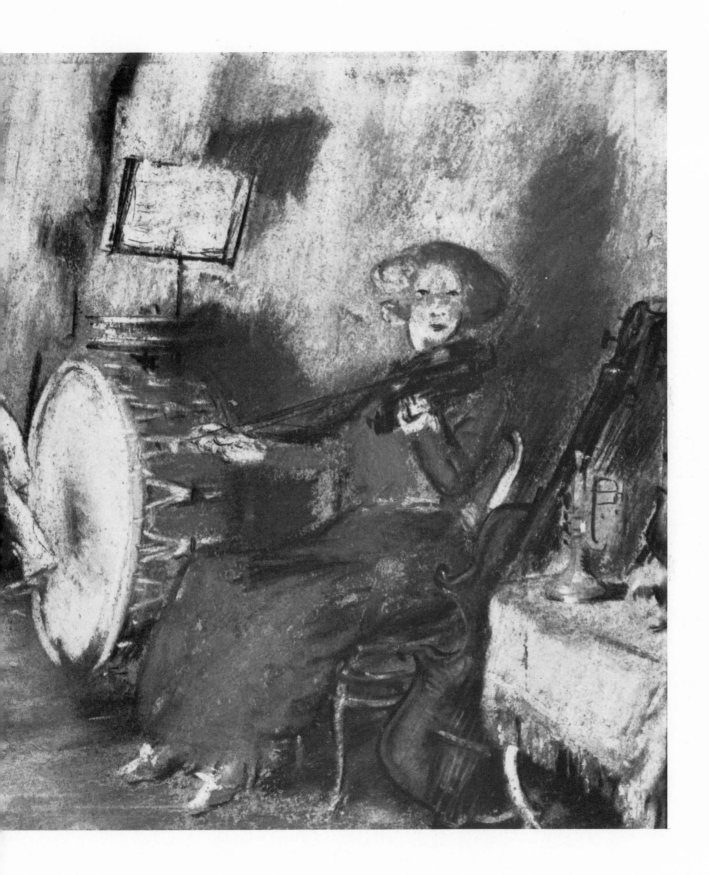

Reclining Nude, *pastel, 1925.* ARTHUR G. ALTSCHUL COLLECTION.

In an interview, Robert Graham, proprietor of James Graham and Sons on Madison Avenue, New York, recalled meeting Shinn in 1945 while he was living on Gramercy Park in New York.

As Mr. Graham remembers it, Shinn was a little less than friendly to him on their first meeting. Shinn stated that he had an ardent dislike for collectors, critics, and dealers in that order. At this time of his life, he was bitter about his treatment in the press, especially when critics accused him of "prostituting" his art with his clown paintings and so on.

He disliked collectors because they were always coming down to his studio and trying to buy his work for nothing. Even during the Depression, Shinn had an aversion to selling his work for too little and resented the intrusion of these bargain hunters.

Graham, who had dinner with Shinn many times after their first meeting, got to know the artist very well and they became friends.

Even though the Graham Gallery gave Shinn several shows in his late years, Shinn needed money desperately. According to Robert Graham, his gallery and a number of others got together and subsidized the artist in the last year of his life, allowing him to make a trip to Florida.

Shinn's associations with the other members of the Ashcan Group were, to say the very least, detached. Many of them did not consider him a serious fellow in any way, feeling that he had prostituted himself to commercialism and had little true dedication as a fine artist. In John Sloan's notes, referring to a period in the late thirties and the forties, he states:

> Shinn is now doing a very sad and cheap thing. After being satisfied
> to do commercial work for years he is now trying to echo the
> old self that painted city life, around the turn of the century—
> very thin echoes. He tells me there is a dealer in California who
> will take all the clowns he can make. What a paradox that we two
> should be the last of The Eight, Shinn who was in the group by
> accident, clinging on Glackens' shirttails—now catching up with
> the demand for pictures by the Eight who were rejected in their day.

Shinn's paintings however, were always arresting. Frank Jewett Mather, Jr., writing in *Arts and Decoration*, November 1916, said that "Sloan . . . and

Ventriloquist and Dummy, *pastel, 1938. Clown period.*
COLLECTION MR. AND MRS. ROBERT C. GRAHAM.

166

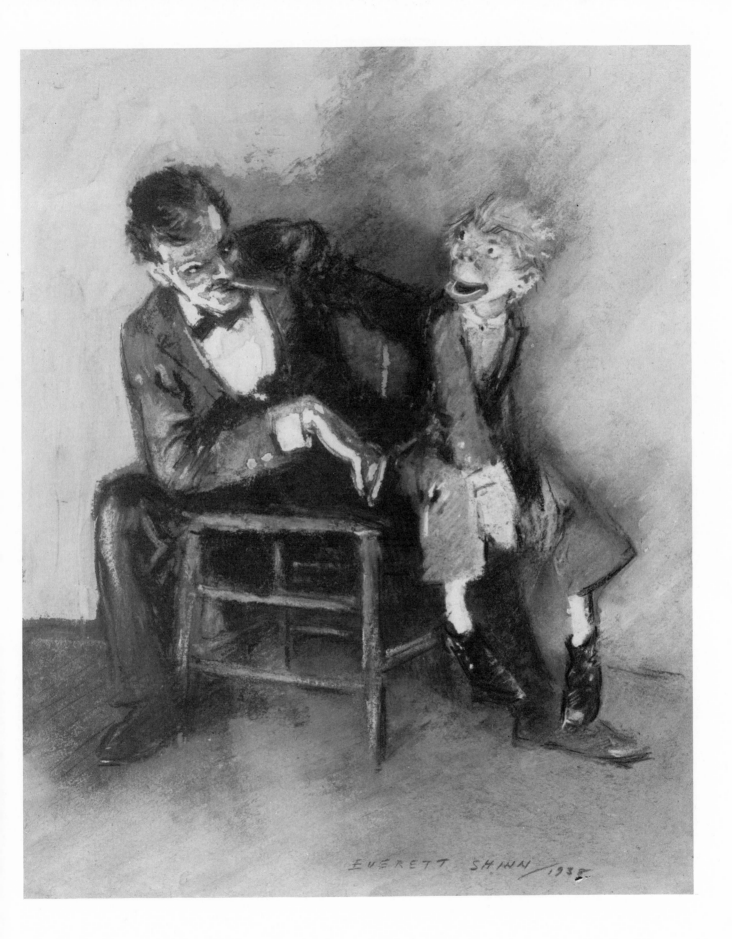

Seated Clown, *blue crayon and watercolor, circa 1940.* PRIVATE COLLECTION.

Shinn . . . tampered a bit more than the rest of their contemporaries. They don't let things alone."

Shinn never seemed to be able to.

It seems important to relate Everett Shinn to the American Realists of which he was a part—if only fleetingly. Shinn, with his confreres of The Eight, certainly can be compared with men like George Bellows, and, to some extent, even Hopper and others of his group in the American Realistic School.

But he was also different in one way, and it was such an important way that it must not pass unnoticed. These men were all dedicated to painting, and, to a large extent, refused to paint to a market. Shinn differed widely from some of his contemporaries in this regard. He always painted pictures with the idea of selling them because making money was an enormous moving force in his life. He liked the good life much too well to support "art for art's sake."

No, Shinn was both after his time and before his time in this view. He was a "mini-Renaissance" man in some ways. The collectors were his patrons—not the Church. Shinn was known to dash into his studio and turn out three pastels if he knew an important collector was coming. He painted clowns when they were "selling." He believed in the marketplace and geared himself accordingly.

And it is certainly true that he never saw anything wrong with this attitude. In his mind, to think this approach was wrong, one would have had to criticize Peter Paul Rubens, Michelangelo, and Veronese. Artists have been painting for their *padrones* for centuries. It is not hard to imagine the chief caveman directing his artists as to which animals to paint on the walls at Lascaux. Indeed, it was a time-honored tradition, and the very modern of the moderns have gone back to it.

In attitude, Everett Shinn would have fit in well with either group— but these commercial attitudes were frowned upon in his own time.

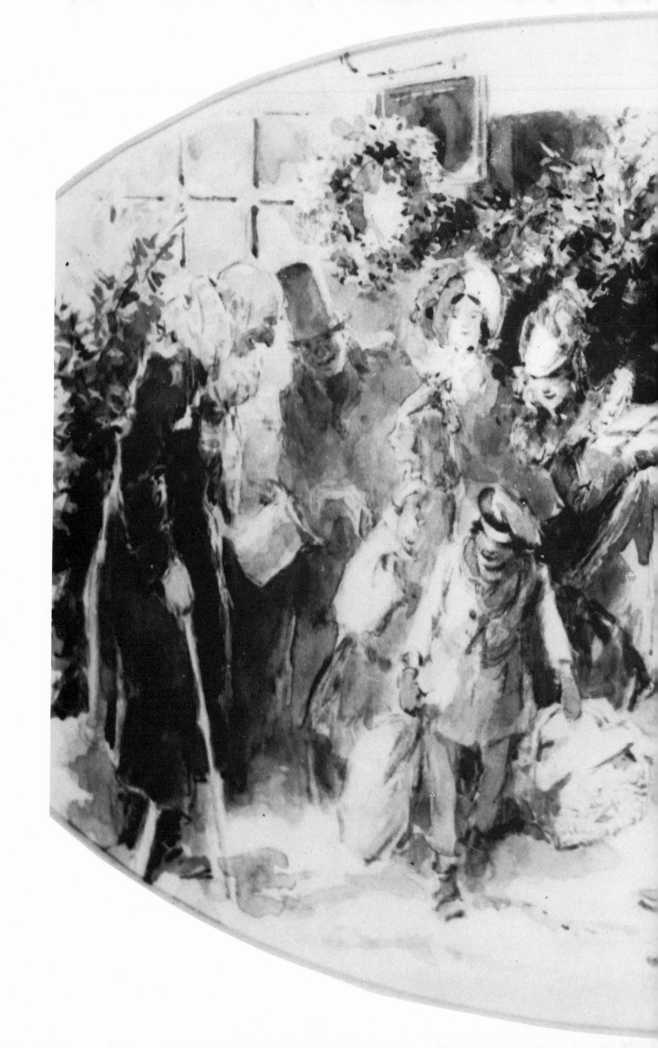

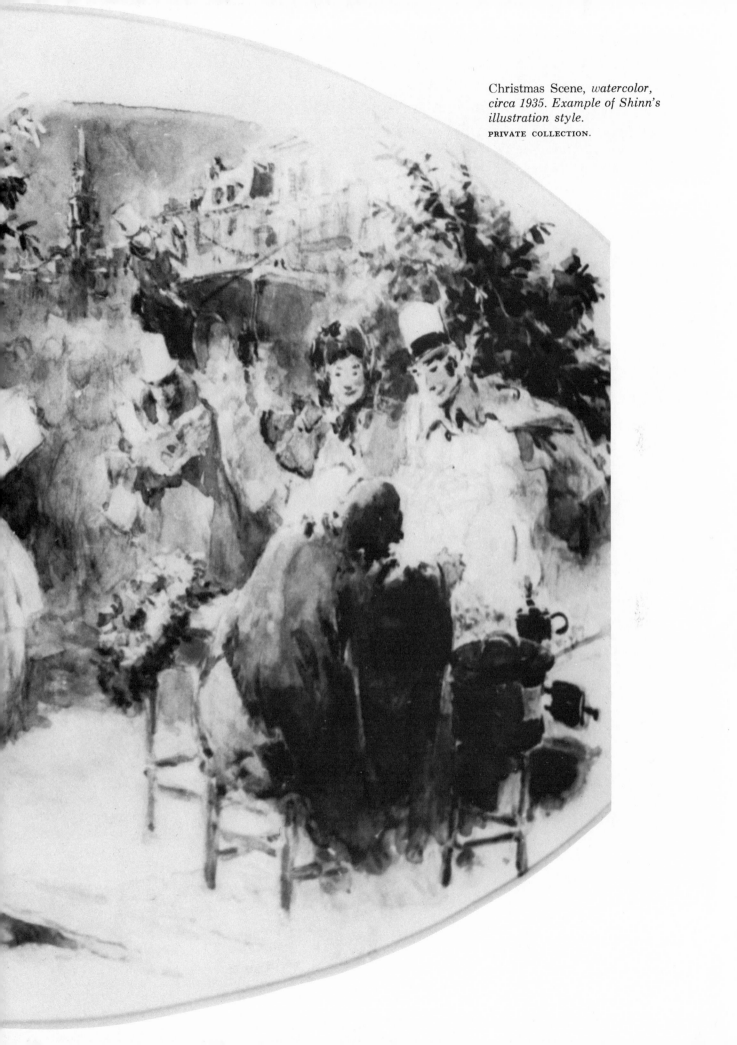

Christmas Scene, *watercolor,
circa 1935. Example of Shinn's
illustration style.*
PRIVATE COLLECTION.

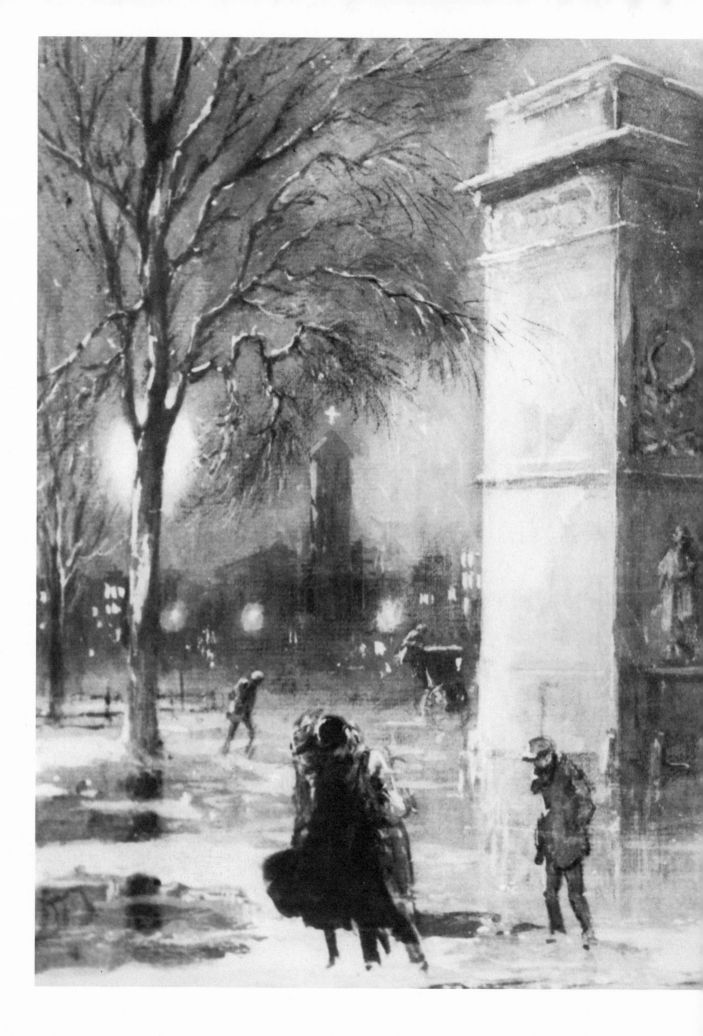

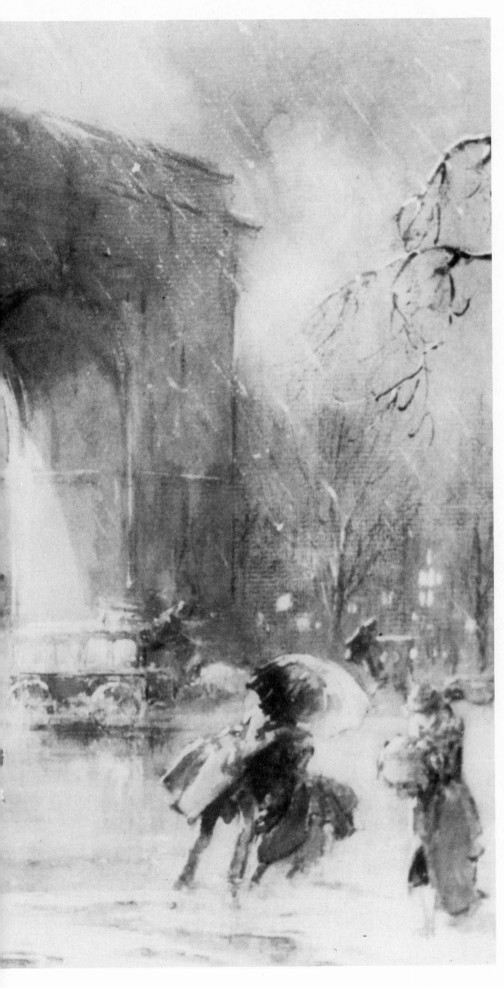

Washington Square,
Stormy Night, *pastel
and watercolor, 1951.
Shinn's late New York
style.*
UNION CLUB, NEW YORK.

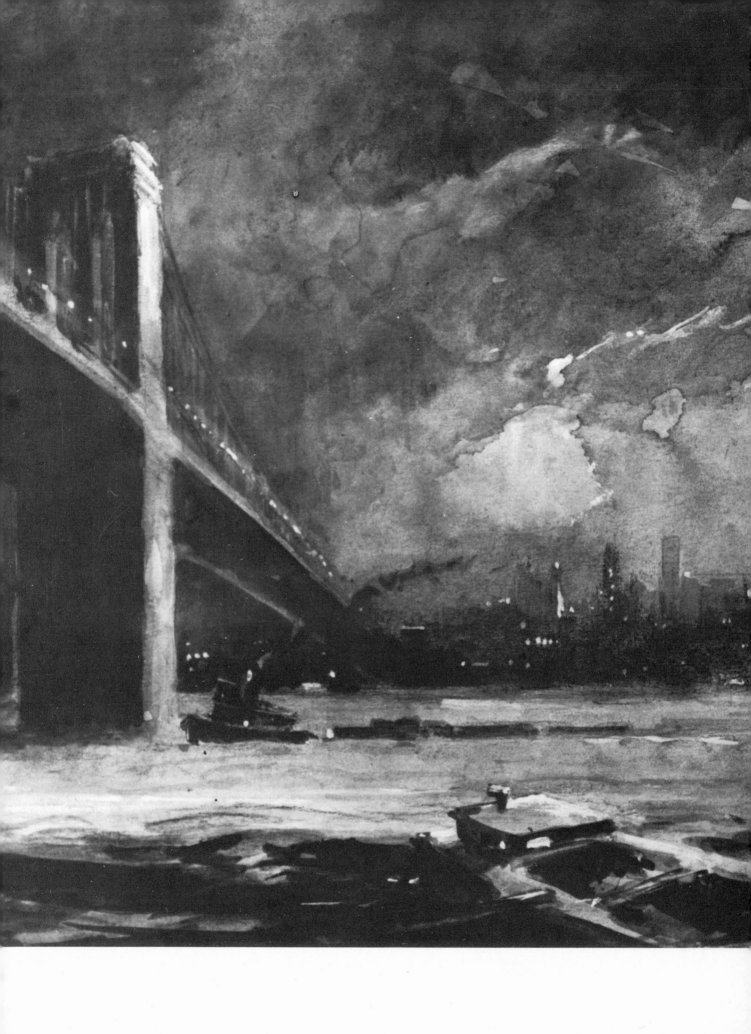

East River Bridge, *watercolor, 1940. Shows return to original style.* ARTHUR G. ALTSCHUL COLLECTION.

Chapter Ten

FRIENDS

EVERETT SHINN WAS NOT A MAN WHO MADE A GREAT MANY friends. He was much too busy with his own ideas, his writings, his paintings, and his other various harebrained projects to make a lot of money fast.

But he did have some friends, and they were fairly close ones. A few continued their friendship with him throughout their life-span and his.

Actually, of the painters with whom he was associated in the early New York days, only William Glackens remained a lifelong friend. Both Edith and William Glackens were very fond of Eve, as they called him. There was a cool period in the friendship after Shinn and Florence were divorced, but eventually they became friendly again. The truth of the matter was that Edith Glackens was not fond of his second wife, Corinne, but apparently did like both Gertrude and Paula, who followed. After Glackens's death, Shinn tried to provide as much help to Edith as he was able, and proved to be a good and loyal friend.[1]

One close friend from his early New York days was Ben Ali Haggin, the artist and actor. This man had a partially Turkish background. He was a rake, raconteur, and playboy, and he and Everett were a lively pair.[2]

176

Rudolph Valentino, 1924.

It is a shame that so little information has come to light on Shinn's friendship with Ben Ali Haggin. He was a most interesting and fascinating personality, and it is probable that he and Everett shared many a lurid escapade.

Janet Shinn Flemming remembers him well. She stated in an interview: "The only thing I can remember about Ben Ali Haggin is Everett did the oval oil of me at his place and I was sitting on Rudolph Valentino's lap. R. V. gave me the red toy I'm holding. I know Everett thought a lot of Haggin and his wife Bonnie. Everett referred to him as 'that mad man' in an affectionate way." Rudolph Valentino also visited often at the Catskill house.

Shinn was also a fairly close friend of Elsie de Wolfe, Stanford White, and Clyde Fitch, although how much of these relationships was professional and how much personal is hard to say. Shinn greatly admired that triumvirate, especially White. He knew David Belasco as well, but the evidence is that they were not particularly friendly and that he had very little actual admiration for Belasco.[3]

Bernard Baruch was another of Shinn's close friends, according to the family. Janet Shinn Flemming says that Baruch bought her first pair of roller skates. Other friendships that endured were those between Everett and Charles (Chic) Sale and between him and Wilfred Buckland ("Doc Allen"). Both the friendship with Baruch and those with Sale and Buckland are obscure, there being no letters or evidence except photographs to substantiate them.

One of Shinn's most interesting friends was a man named Poultney Bigelow. Bigelow lived in Saugerties, New York, and his friendship with Shinn spanned a thirty-five-year period. He wore baggy pants and bellowed at the top of his lungs. He ran the magazine *Outing*, which was devoted to amateur sports, especially bicycling.[4]

Bigelow was a nut on health food and made all his guests eat this fare. In fact, Charles Henry, another friend, categorically states that he used to refuse to visit Bigelow because he just couldn't stand the food—especially Bigelow's special gruel in the morning.

Bigelow was a husky man and swam nude in the Hudson River almost every day, winter and summer. A flaming anti-Semite, Bigelow was very friendly with the German Kaiser. His father had been ambassador to Germany at one time. He gave David and Janet Shinn each a German army rifle with bayonet fixed when they were nine and ten, respectively. His house was crammed with magazines and books and one had to proceed through a series of small alleys between ceiling-high stacks of reading material and animal skins.[5]

Bigelow's anti-Semitism is a strange quality in relationship to his friendship with Shinn. In all the biographical and autobiographical material on Everett Shinn, there is not one word that would lead a biographer to believe that he had any racist feelings at all. It seems strange that he could have established such a close relationship with a man who circulated vicious

178

Charles (Chic) Sale.

pamphlets against the Jews. But possibly this was a facet of Bigelow's personality that Shinn chose to overlook. In any case, he never comments upon it.

When Bigelow was around eighty and Shinn sixty-eight or so, they exchanged letters in which Shinn expressed annoyance with Bigelow for taking a girl away from him. It seems that the girl had first come to Bigelow's house as Shinn's guest. And lo and behold, the next time Shinn dropped in, there was the girl.[6]

A close friend of Shinn's later years is a fascinating man named Charles T. Henry. Early in his career he became a lighting engineer and was the man who converted St. Patrick's Cathedral in New York from gaslight to electricity. Henry was an artist at lighting, and his services were sought for special lighting jobs all over the world, including at such New York galleries as Duveen and Wildenstein.

Henry and Shinn met in Westport, Connecticut, in the early thirties. Shinn was between his marriages to Gertrude and Paula—probably about fifty-nine and Henry somewhat younger.

Henry was on the beach at the Long Shore Club, and when he learned that Shinn was in the neighborhood, he made a point of meeting him because he had always admired his work very much.

At the time Henry met him, Shinn was suffering from a great lack of funds as it was in the depths of the Depression. When Henry dropped in on Shinn at Westport (bringing three friends), the cupboard was dry. So they all repaired to the Long Shore Club. To help Shinn over his financial embarrassment, Henry bought a picture out of the kitchen of Shinn's cottage.

This was the beginning of what was probably the deepest friendship of Shinn's life—a friendship that developed and continued from that time until Shinn's death in 1953.

Henry was very loyal to Everett, and after his death when the estate was being handled by Graham Gallery, he finally stepped in and bought it out. After moving to Florida, Charlie Henry opened a gallery and sold many of Shinn's paintings. In fact, some of the best collections of Shinn's works originated at Henry's Gallery in St. Petersburg Beach.[7]

Toward the end of his life Everett Shinn became extremely friendly with a charming couple from Manhattan, Dr. and Mrs. Henry Ashley Carr. The Carrs were amusing and attractive companions, and in the last eight years of his life Shinn spent a great deal of time at their summer home in the Poconos. While in residence, he designed a wing for their house, and the drawing for this addition is further evidence of his versatility.

He was very fond of the Carrs' young daughter, and he made a small and charming stage set for her. It shows a small house with a pool; the moon rises and sets; and the lights in the house go on—both upstairs and downstairs.

The Carrs added greatly to the enjoyment of Shinn's last years. They were vivacious, interesting companions for the artist, and he loved visiting them both in New York and the Poconos.

180

Wilfred Buckland, Hollywood, California, 1916.

Poultney Bigelow, 1950.

Charles T. Henry, Sarasota, 1949.

Chapter Eleven

LATER LIFE

EXCEPT FOR ONE EXHIBITION AT KNOEDLER'S IN 1920, Everett Shinn does not seem to have exhibited paintings between 1910 and 1937.

In 1937, Shinn was invited to exhibit at the New York Realists Exhibition held at the Whitney Museum in February. This was the one and only time Shinn was invited to exhibit at the Whitney, due to difficulties with Mrs. Juliana Force, the director. Mrs. Force was as strong as her name would imply, and rumor had it that she and Shinn engaged in some kind of shouting match at a cocktail party. After that episode, Mrs. Force would have nothing whatsoever to do with Shinn, and he responded in kind saying that he didn't much care if he ever darkened the Whitney's door again. To this day, no major exhibition of Shinn's work has ever been held at the Whitney, although the Museum owns several fine paintings of his through the generosity of Mr. Arthur Altschul of New York.[1]

The exhibition of New York Realists included the work of all The Eight except Arthur B. Davies and Maurice Prendergast, and also included the work of George Bellows, Glenn O. Coleman, and Guy Pène du Bois. Shinn exhibited ten of the best examples of his work, including *London Hippodrome* and *Theater Box*.

184

There followed in the thirties and forties any number of exhibitions at the Museum of the City of New York, the Art Institute of Chicago, the Carnegie Institute, and the famous Eight exhibition recap at the Brooklyn Museum in 1943.

In 1939 Shinn received the coveted Watson F. Blair Prize for watercolors at the Art Institute of Chicago. After this exhibition the museum purchased his painting *Early Morning, Paris* at a reduction in price from $1000 to $600, apparently because Shinn was willing to let it go for the amount of money represented in the purchase award.

During 1944, he exhibited at the Carnegie Institute in Pittsburgh show of "Painting in the U.S. 1944." He exhibited his well-known *Bastille Day*. Another interesting exhibition that took place the same year was at the Museum of Fine Arts in Boston. The exhibition was entitled "Sport in American Art." Shinn's contribution was *Hoboken Skaters*.

In 1935, Everett Shinn went to Boston and under contract to the *Boston Traveler* sketched a murder trial—the Millens/Faber trial—in nearby Dedham. His sketches for this trial indicate he had lost none of his facility as a newspaper reporter–artist even though he had not exercised the skill in years.

In the middle and late forties he exhibited in The Eight show that opened at the Museum of Modern Art and traveled to Cleveland and Columbus, at the Philadelphia Museum's "Painters of the Philadelphia Press," and at several exhibitions at the American British Art Center in New York as well as in Chicago's "Survey of American Painting," where *London Hippodrome* was shown.

From 1943 through 1948, Shinn was represented by the Feragil Galleries in New York. This gallery was run by a man named Frederick Newlin Price, well known on the New York art scene. He and Everett carried on a voluminous correspondence, mostly concerning who should pay for frames and why they were too expensive, in Shinn's view. One letter from Fred Price states, "You make me sick. With all good wishes and take care of yourself...."

A word about Shinn and money: where Shinn would spend untold amounts of money impressing women in whom he was interested, the artist was extremely cheap when it came not only to frames but to materials for painting. Several times Feragil complained that Shinn's paintings were "chipping off." Janet Shinn says that her father hated to buy canvas and would sometimes paint on anything available, including shirt cardboards.[2]

At the same time that Shinn was represented by Feragil in New York, he was represented by James Vigeveno in Los Angeles. For this gallery he did mostly clown paintings—Vigeveno could move a lot of them. One that comes to mind is owned by Joseph Cotten, the actor.

Back in New York, Fred Price had a way with words, especially in press releases. In a real flight of fancy, he states with admirable metaphoric virtuosity that Shinn is "Fragonard...Daumier...Degas American....

185

MESSRS. M. KNOEDLER AND COMPANY
ANNOUNCE AN EXHIBITION OF PAINTINGS
BY
EVERETT SHINN
AT THEIR GALLERIES 556-558 FIFTH AVENUE
NEAR FORTY-SIXTH STREET
FROM FEBRUARY 16th TO ~~FEBRUARY 28th~~ 1920
Mar - 13

UNDER THE DIRECTION OF
MRS. ALBERT STERNER

To be collected by U. S. Budworth
424. West 52d St.
tel - 120 - Columbus. New York City

PAINTINGS

— ✗ 1. Janet Shinn
— 2. London Music Hall - #1.200 to stay.
— ✗ 3. The white ballet
— ✗ 4. Ballet girl and Harlequin
— 5. The little ballet girl #1.200 - SOLD
— ✗ 6. Prima Donna
— ✗ 7. Out door stage, Ville D'Avery
— ✗ 8. The Opera ballet
— 9. The third number #3.500 - To stay.
— 10. The winter garden #4.000 - to stay.
— ✗ 11. La Premiere Danseuse
 ✗ 12. The end of the dance
 ✗ 13. Behind the drums
— ✗ 14. Nude
 ✗ 15. Nude

PASTELS

— ✗ 16. Davidson Shinn
 loaned 17. John Hilder Jr. - Returned
 ✗ 18. U. S. Recruiting Station and Cooper Union
 19. In the Orchestra
— ✗ 20. Old Fifth Avenue
— ✗ 21. Central Park
— ✗ 22. Cafe Concert

OK

— ✗ Hippodrome - from Paris.

The stability of art in America is assured as long as Shinn arrives in port on occasion under his own steam." The quotes here are Price's, but it is unclear who is being quoted—sounds a great deal like Shinn himself.

In 1949, Shinn was made an Academician, Painter Class, in the National Academy of Design, after first being elected to the Institute. This ceremony took place on October 3 of that year. He was then entitled to put "N.A." after his name, a title he had often pooh-poohed in his early days as a painter. He was initiated into the American Academy of Arts and Letters in 1951.

Immediately prior to his death in 1953, Shinn began to be represented by the James Graham and Sons Gallery in New York, which held two exhibitions for him—one in 1952 and one in 1953.

Everett Shinn had a tremor of the hand for about six years before his death. The doctors could find no cause for this and in any case it disappeared completely when he picked up a pencil or brush.

In 1953, after a trip to Sarasota, Florida, to visit the Ringling

glass in old frames.

23. Fifth Avenue *#400. SOLD*
× 24. Le Farceur, Gaité Montparnasse
× 25. Une Fiacre
× 26. In the park
× 27. La Chanteuse Jaune
28. Sur la Seine
× 29. L'Omnibus
× 30. L'ecole du Medicin
× 31. Une Rue de Montmarte
× 32. Backyards, New York
× 33. Les Galleries
× 34. Election banner, Madison Square
× 35. Follies Bergeres
× 36. Washington Square
× 37. Early morning, Paris
× 38. Sunset, North River
× 39. Evening, North River
× 40. La Velette
× 41. Chanson d'Amours
× 42. Slack wire
× 43. Le Lever du matin
× 44. Le Coucher
× 45. Les Affiches
× 46. The ballet chorus
× 47 *pastel-nude - girl in bed -*

× - *Winter Garden - Runway.*
× - *girl on trapeze - trscsmore*
× - ① *Bronze figure (Calder)*

Knoedler catalog for 1920 Shinn exhibition.

Brothers winter quarters for the circus and to catch the sun with Charles Henry, Shinn became quite ill with lung cancer. While he was getting cobalt treatments for this disease, his daughter says, he did not want to pay for a cab to and from the hospital and so he walked at least one way, a matter of some twenty blocks.

He painted up until the time of his death. In fact, he did a beautiful sketch from his hospital window, showing the East River and a tugboat, very shortly before he died on May 1, 1953, at the age of seventy-seven.

Shinn's contribution to the artistic history of the early part of this century is unchallenged. No one depicted New York with quite the verve and affection he displayed—not before his time, during, or after. He was eternally fascinated with the city and this shows—right up to the small painting of the river done during his final days in New York Hospital.

His was the mercurial personality—the artist mixed with practicality —the many-faceted man who was certainly "a figure in his time."

187

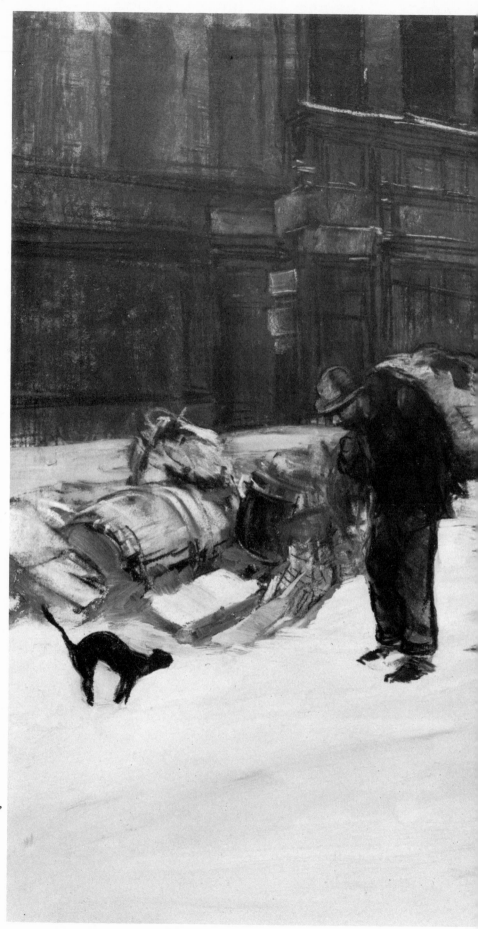

Early Morning, Paris, *watercolor,*
1901. Purchased by The Art
Institute of Chicago in 1939.

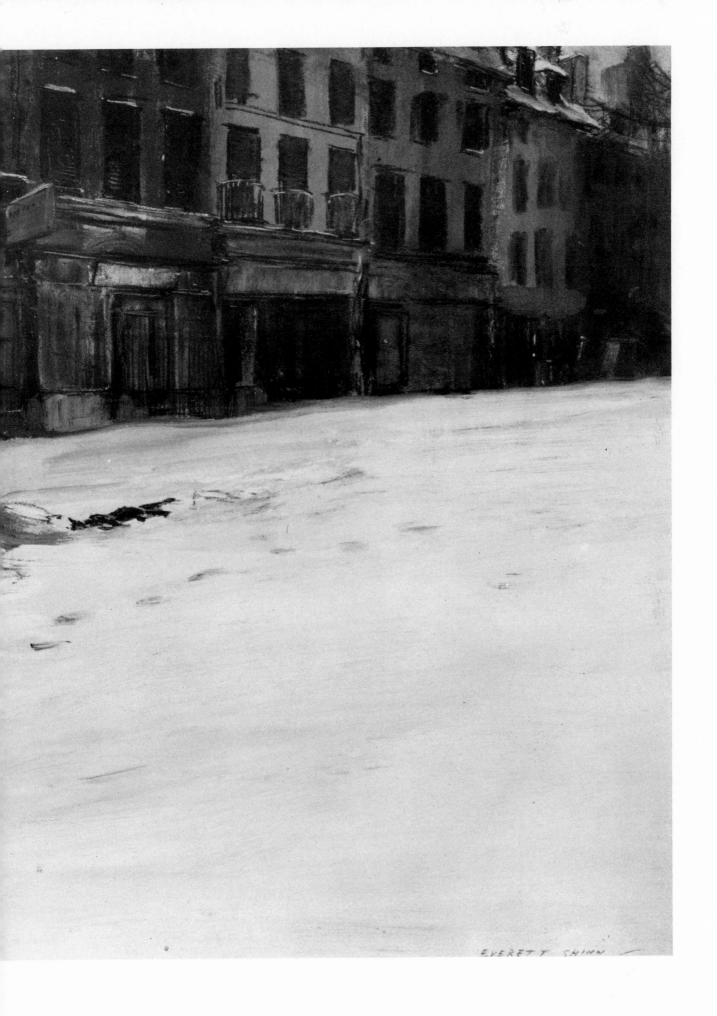

EVERETT SHINN

MONDAY, APRIL 16, 1934

IRVING MILLEN

Irving Millen as he appears to Everett Shinn of New York, famous illustrator who is sketching scenes at the Millen-Faber trial exlusively for the Traveler.

BOSTON TRAVELER

TRAVELER'S NOTED ARTIST

Everett Shinn, distinguished artist, whose sketches of Millens-Faber trial will appear exclusively in the Boston Traveler.

Photograph of Everett Shinn at the Millen/ Faber trial and three of the sketches that appeared in the Boston Traveler, *1934.*

MURTON MILLEN

Murton Millen, as sketched by Everett Shinn of New York, great illustrator who is attending the Millen-Faber trial exclusively for the Traveler.

Bullet Holes in Patrolman's Coat Identified

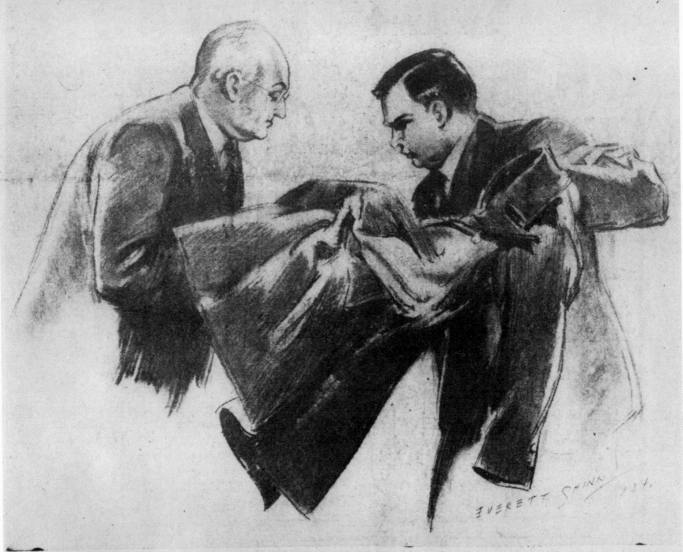

Everett Shinn, famous artist, caught a tense moment in Dedham court when Chief of Police Arthur P. Bliss (left) identified the uniform of the slain Patrolman McLeod and also the bullet holes in it about which he is being questioned by Dist.-Atty. Dewing. Artist Shinn's graphic sketches appear exclusively in the Boston Traveler.

191

View from New York Hospital,
1952, mixed media.
ARTHUR G. ALTSCHUL COLLECTION.

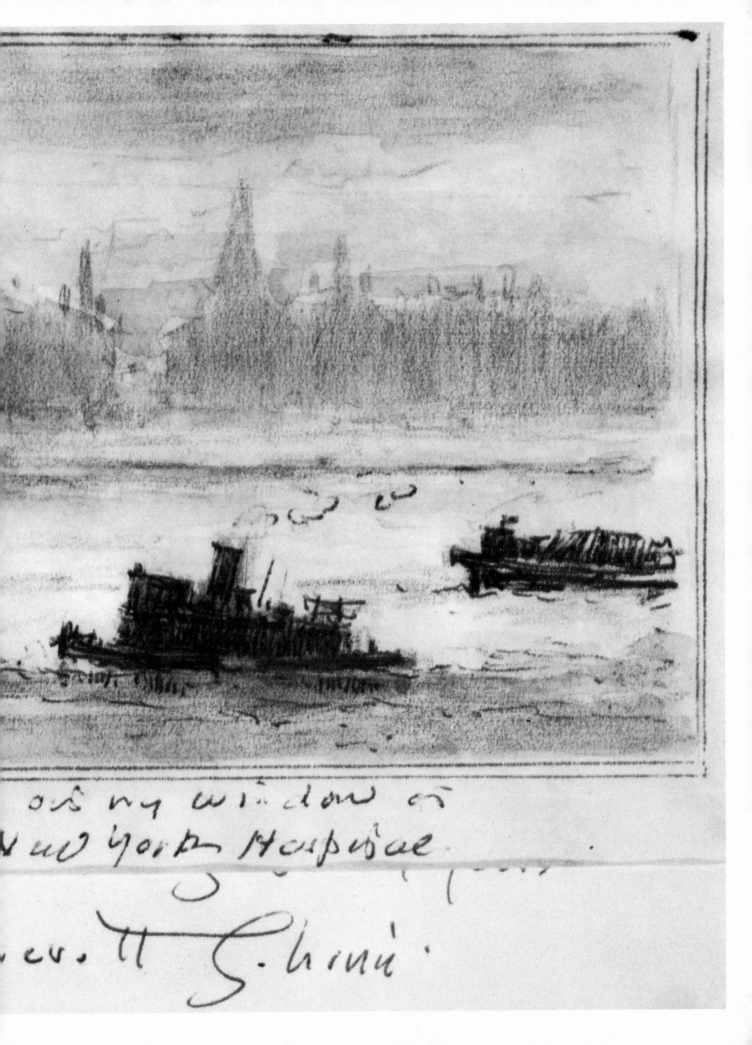

... of my window ot
New York Hospital.
ev. H. S. Hvin.

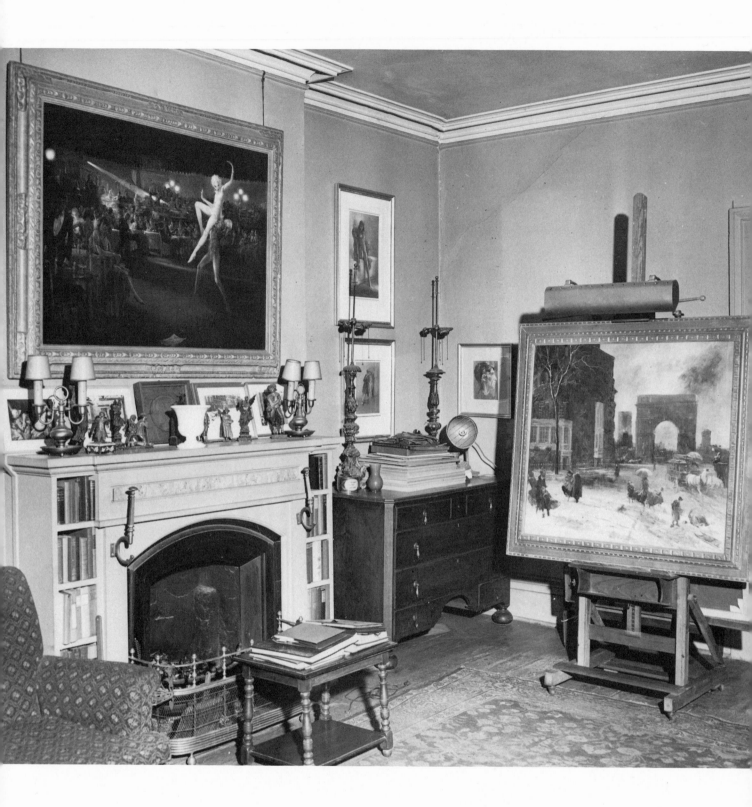

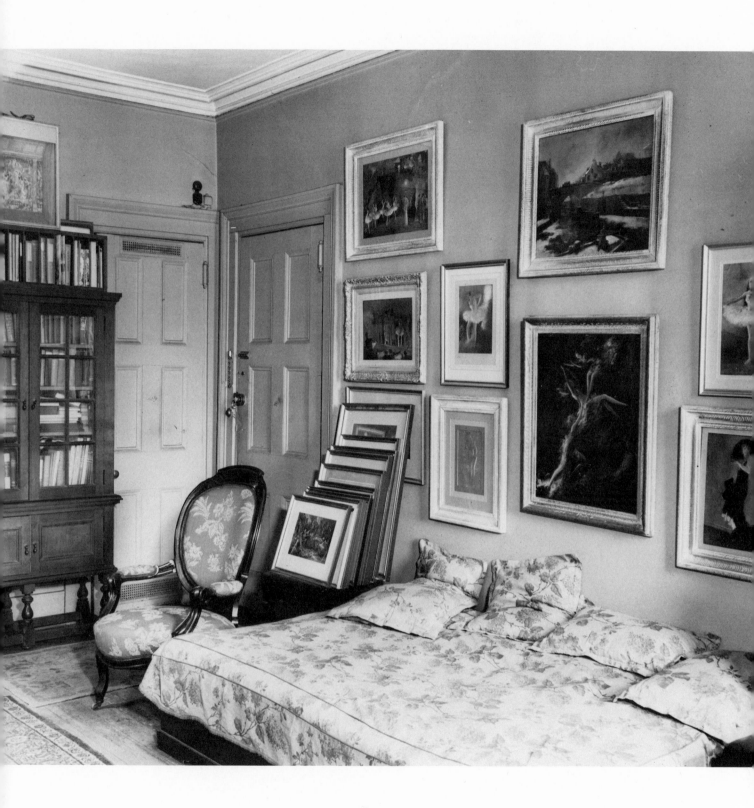

Everett Shinn's last studio, on Washington Square, circa 1948–49.

Appendix 1

Notes

CHAPTER ONE

1. Shinn Autobiographical Material on deposit, by Edith DeShazo, at the Delaware Art Museum, Wilmington, Delaware. (Hereinafter referred to as SAM.)

2. SAM Manuscripts.

3. Manuscript of Minutes Yearly Meeting Woodstown Town Meeting 1844, Woodstown Public Library, Woodstown, N.J.

4. SAM.

5. Shinn Papers. Interview with Mrs. Warren Shinn, Everett Shinn's sister-in-law.

6. SAM.

7. Shinn Papers. Interviews with Mrs. Warren Shinn and Joseph Andrews, Shinn's friend in Woodstown.

8. SAM.

9. SAM.

10. Shinn Papers. Interviews with Mrs. Warren Shinn and Joseph Andrews.

11. SAM.

12. SAM.

13. SAM.

14. SAM.

15. SAM.

CHAPTER TWO

1. Bennard Perlman, *The Immortal Eight*, p. 69.

2. SAM.

3. Perlman, *The Immortal Eight*, p. 69.

4. SAM.

5. Perlman, *The Immortal Eight*, p. 70.

6. SAM.

7. SAM.

8. Perlman, *The Immortal Eight*, p. 74.

9. SAM.

10. William Innes Homer, *Robert Henri and His Circle*. Also, Perlman, *The Immortal Eight*, p. 80.

11. Shinn Papers. Interview with Charles T. Henry.

12. Ira Glackens, *William Glackens and the Ashcan Group*, p. 19.

13. Perlman, *The Immortal Eight*, p. 77.

CHAPTER THREE

1. Glackens, *William Glackens*, p. 104.

2. Archives of American Art, National Collection of Fine Arts, Washington, D.C., Shinn Papers.

3. Perlman, *The Immortal Eight*, p. 108.

4. Archives of American Art, Shinn Papers.

5. *Ibid.*

6. *Ibid.*

7. *Ibid.*

8. Wilmington, Delaware, Delaware Art Museum, John Sloan's Notes.

9. Homer, *Robert Henri*, p. 76.

10. Brooklyn Museum, Catalog of "Eight Show," 1934.

11. Bruce St. John, *John Sloan's New York Scene*, p. 191.

12. Archives of American Art, Shinn Papers.

13. Perlman, *The Immortal Eight*, p. 131.

14. New Haven, Connecticut, Yale University Library, letters of John Sloan and Robert Henri.

15. Glackens, *William Glackens*, pp. 105–9.

16. Correspondence with Joseph S. Trovato (organizer of recap of Armory Show). Utica, New York, Munson-Williams-Proctor Institute.

17. SAM, Florence Shinn file.

18. Interview with Janet Shinn Flemming.

CHAPTER FOUR

1. Interview with Joseph Andrews.

2. Perlman, *The Immortal Eight*, p. 68.

3. Glackens, *William Glackens*, p. 140.

4. Glackens, *William Glackens*, p. 141; SAM.

5. Everett Shinn, *The Prune Hater's Daughter* (play).

6. SAM.

7. Interview with Ira Glackens.

8. Glackens, *William Glackens*, p. 144.

9. SAM, *Mid Ocean*.

CHAPTER FIVE

1. Shinn Papers, letters from Elsie de Wolfe.

2. SAM.

3. SAM.

4. Montrose J. Moses, *Concerning Clyde Fitch and the Local Scene*.

5. Perlman, *The Immortal Eight*, p. 112.

6. *Ibid.*

CHAPTER SIX

All material SAM except references cited in text.

CHAPTER SEVEN

1. Interviews with Ira Glackens and Janet Shinn Flemming.

2. SAM.

3. Interview with Janet Shinn Flemming.

4. *Ibid.*

5. Interview with Ira Glackens.

6. Interview with Janet Shinn Flemming.

7. Interview with Horace Gäir Chase.

8. Interview with Paula Downing Shinn Carpenter.

CHAPTER TEN

1. Interview with Ira Glackens.

2. SAM.

3. *Ibid.*

4. Interview with Janet Shinn Flemming.

5. *Ibid.*

6. SAM.

7. Interview with Charles T. Henry.

CHAPTER ELEVEN

1. Interview with Robert Graham.

2. Interview with Janet Shinn Flemming.

200

Appendix 2

Shinn Family History

On March 18, 1673, John Fenwick, Quaker, lawyer, Englishman, and fervent supporter of Oliver Cromwell, purchased for £1,000 the area known as West New Jersey.

He was granted amnesty by King Charles and he set sail from London aboard the ship *Griffin* bound for the Delaware River, where he "arrived in the said river the 23rd day of the Ninth Month at or neare New Salem in the year 1675. With him were a colony of persons including his three daughters and two sons-in-law and their thirteen servants."

And so started Fenwick's Colony which is now Salem County, New Jersey.[1]

In 1677, 230 Quakers left London for West New Jersey on the ship *Kent*. They were to be followed by many others between 1678 and 1680. In the general list of immigrants to this new colony will be found one John Shinn, who settled with his compatriots near Burlington, New Jersey.

John Shinn's signature appears in a letter from the Men's Monthly Meeting of Burlington to the "Friends and Bretheren of Ye Yearly Meeting of London," dated 1680.

John was the first Shinn to arrive on American shores. He was a freeholder and a Quaker. This man's sons and their issue were to spread over

1. Salem County Tercentenary Committee (ed.), *Fenwick's Colony*.

Southern and Western New Jersey, and some were to settle in Fenwick's Colony.

John Shinn's grandson, Isaiah, died in Greenwich, Cumberland County, in 1763. Although the records are vague, there is evidence that this man was the progenitor of Everett Shinn.[2]

2. Woodstown, N.J., Woodstown Public Library, Manuscripts.

Appendix 3

Chronology of Everett Shinn's Life

1876 Shinn is born in Woodstown, New Jersey, of Isaiah Shinn and Josephine Ransley Shinn.

1876–88 Woodstown Years.

1888–90 Studies engineering and industrial design at the Spring Garden Institute, Philadelphia.

1890–93 Works for Thackeray Gas Fixture Works, Philadelphia.

1893–1897 Studies at the Pennsylvania Academy of the Fine Arts. Also works for the *Philadelphia Press* as staff artist. Meets Luks, Glackens, Sloan, and Henri.

1895 Luks and Glackens join the staff of *Philadelphia Press*. Sloan joins later in the year.

1898 Shinn marries Florence Scovel, illustrator and member of Philadelphia's prestigious Biddle family.

1899	Meets Clyde Fitch, Elsie de Wolf, Stanford White, David Belasco. Begins decoration of houses.
	Holds first important one-man show at Boussod-Valadon Galleries, New York City.
1900	Has another large, all-media show at Boussod-Valadon. Travels to England and France. Has exhibition in Paris. Becomes well known as illustrator for *Harper's Weekly*.
1901	Has a number of exhibitions at Boussod-Valadon, Pennsylvania Academy, St. Louis Museum, etc.
1903	Large exhibition at M. Knoedler and Co., New York.
1904	Large one-man show Durand Ruel, New York.
1905	Large one-man show at E. Gimpel and Wildenstein, New York.
1906	Does illustrations for *Frédérique* by de Kock. Stanford White is shot by Harry K. Thaw.
1907	David Belasco's Stuyvesant Theatre opens in New York. Shinn decorated this theatre.
1908	February 3–18: Exhibition of The Eight at Macbeth Gallery, New York. Show travels to PAFA, Art Institute of Chicago, and Buffalo and Toledo Museums.
1910	Exhibition of Independent Artists, 29 W. 35th St., New York.
1911	Completes murals in Council Room, City Hall, Trenton, N.J.
1912	Shinn's first wife, Florence, divorces him amidst a great to-do in the press.
	Produces plays with his friends at his Waverly Street Studio.
1913	Receives invitation to exhibit in the famous Armory Show. Refuses invitation or ignores it.
	Marries Corinne Baldwin.
1915	Birth of Janet Shinn.
	Theodore Dreiser's book *The Genius* is published. Main character supposedly based on Shinn.
1916	Birth of David Shinn.

1917	Starts work for Sam Goldwyn at Goldwyn Pictures as art director.
1920	Leaves Goldwyn and works as art director for Inspiration Pictures. Meets Gertrude Chase. Has exhibition at Knoedler's.
1921	Divorced from Corinne, his second wife.
1923	Leaves Inspiration Pictures to work for William Randolph Hearst at Cosmopolitan Pictures as art director.
1924	Marries Gertrude Chase. Decorates several houses on Long Island with Rococo Revivalist murals.
1932	Divorced by Gertrude Chase. Again, lurid newspaper headlines. Meets Charles T. Henry, one of his closest friends for the rest of his life.
1933	Marries Paula Downing. Headlines again.
1935	Goes to Boston to do drawings of murder trial for the *Boston Traveler*.
1937	Exhibits at the Whitney Museum.
1939	Receives Watson F. Blair prize for watercolor at the 18th Annual Watercolor Exhibition, Chicago Art Institute.
1942	Divorced from Paula Downing Shinn.
1943–48	Represented by Feragil Galleries, New York. Exhibition of The Eight, Brooklyn Museum.
1944	Exhibits at the Museum of Fine Arts, Boston, and at Carnegie Institute, Pittsburgh.
1945	Exhibits at Philadelphia Museum of Art, "Painters of the *Philadelphia Press*."
1946–49	Exhibits in several shows at the American-British Art Center.
1949	Made Academician, Painter Class, of the National Academy of Design.
1950–51	Exhibits at Metropolitan Museum of Art, New York. Inducted into American Academy of Arts and Letters.

1952	James Graham & Sons, N.Y., begin to represent Shinn.
	Travels to Florida to visit Charles T. Henry. Does beautiful paintings of circus winter quarters in Sarasota.
1953	May 1: dies, in New York Hospital.
1955	Charles T. Henry acquires Shinn estate from Graham and family.
1959	One-man exhibition at the Henry Clay Frick Fine Arts Department, University of Pittsburgh.
1960	Delaware Art Center, show commemorating 50th Anniversary of Exhibition of Independent Artists.
1962	One-man exhibition J. Bernard Black Galleries, New York.
1965	Exhibition of his theatre and street scenes at Graham Galleries, New York.
1969	One-man exhibition at the Museum of Fine Arts, St. Petersburg, Florida.

Appendix 4

Important Paintings, by Location

Addison Gallery of American Art, Phillips Academy, Andover, Massachusetts
WASHINGTON SQUARE

Albright-Knox Art Gallery, Buffalo, New York
THEATER BOX

Mr. Arthur G. Altschul, private collection

SIXTH AVENUE ELEVATED AFTER MIDNIGHT

FIRE ON 24TH STREET, N.Y.C.

THE LAUNDRESS

LUNCH WAGON, MADISON SQUARE

NUDE, BACK VIEW

RECLINING NUDE

EAST RIVER BRIDGE

DRAWING FROM N.Y. HOSPITAL

NEWSPAPER STAND

THE ORCHESTRA PIT, OLD PROCTOR'S
FIFTH AVENUE THEATRE

TRAPEZE, WINTER GARDEN, N.Y.

Amherst College, Amherst, Massachusetts
WILLIAM GLACKENS

Bernard Black, private collection
GREEN PARK, LONDON

Boston Museum of Fine Arts
ALEXANDER BRIDGE, PARIS

Brooklyn Museum, Brooklyn, New York
KEITH'S UNION SQUARE

Cass Canfield, private collection
INTERIOR WITH TWO FIGURES

Dr. and Mrs. Henry A. Carr, private collection
EAST RIVER TUG BOAT

LAFITTE HOUSE, NEW ORLEANS

Horace G. Chase, private collection
LADIES IN THEATER BOX

MARIAN CHASE

UNTITLED

The Art Institute of Chicago
EARLY MORNING, PARIS

LONDON HIPPODROME

Columbus Gallery of Fine Arts, Columbus, Ohio
LUXEMBOURG GARDENS

Delaware Art Museum
BACKSTAGE SCENE

Mrs. Rondal E. DeShazo, private collection
WOMAN CLOSING DOOR

SKETCH FOR A PAINTING (THEATER BOX)

MUSEE DE CLUNY, PARIS

GREENWICH VILLAGE

VIEUX CARRE, NEW ORLEANS

Detroit Institute of Arts
BASTILLE DAY

Mrs. J. J. Flemming, private collection
JANET SHINN
PORTRAIT OF JANET SHINN

Fort Worth Art Association, Fort Worth, Texas
EVICTED

Ira and Nancy Glackens, private collection
CURTAIN CALL

Mr. and Mrs. Robert C. Graham, private collection
GIRL AND GARDEN

BRIDGE OVER SEINE, PARIS

MILLIONAIRE'S ROW

GIRL DRESSING

FLEISHMAN'S BREAD LINE

WINDOW SHOPPING

MODEL

ACCIDENT

PARK BENCH

CANFIELD GAMBLING HOUSE

Hirschl and Adler Galleries, New York, New York
WINTER WASHINGTON SQUARE

BAR AT McSORLEY'S

PARK, PARIS

Henry E. Huntington Library and Art Gallery, San Marino, California
THE SEINE, RIGHT BANK

Eugene Iglesias, private collection
BARGES IN THE EAST RIVER

M. Knoedler & Co., Inc., New York, New York
5TH AVENUE AND 34TH STREET

Munson-Williams-Proctor Institute, Rochester, New York
PARIS CABARET

THE DOCKS, N.Y.C.

National Academy of Design, New York, New York
PORTRAIT OF EVERETT SHINN (by Mel A. Phillips)

University of Nebraska, Lincoln, Nebraska
RUE DE L'ECOLE DE MEDECINE

Newark Museum, Newark, New Jersey
MOUQUIN'S

New Jersey State Museum, Trenton, New Jersey
STUDY FOR TRENTON MURAL

Mr. and Mrs. Meyer P. Potamkin, private collection
BOWLING THE BOWLER

ELIZABETHAN DANCERS

Santa Barbara Museum of Art, Santa Barbara, California
SIXTH AVENUE SHOPPERS

City Art Museum of St. Louis, Missouri
MADISON SQUARE (NEW YORK BY NIGHT)

Saint Louis Priory and School, St. Louis, Missouri
 THE BAND, WASHINGTON SQUARE

 MAN IN RAIN

 VARIETY SHOW

Westmoreland County Museum of Art, Greensburg, Pennsylvania
 THE GREEN BALLET

Whitney Museum of American Art, New York, New York
 SEINE EMBANKMENT

 UNDER THE ELEVATED

 GIRL DRESSING

EXHIBITION OF PASTELS BY EVERETT SHINN

HELD AT THE GALLERIES OF BOUSSOD, VALADON AND CO., SUCCESSORS TO GOUPIL AND CO., PARIS. 303 FIFTH AVENUE, NEW YORK.

Appendix 5

Exhibitions

One-man shows are starred

1899	January 16–February 25	Pennsylvania Academy of the Fine Arts, Philadelphia (PAFA in future ref.), pastels
	September 11–October 14	St. Louis Exposition
	November 17–December 15	*Boussod, Valadon & Co., New York
1900	February 26–April 4	*Boussod, Valadon, all media
	April 16–30	PAFA, pastels
	May 19–July 9	Cincinnati Museum Association
	July	*Goupil, Paris, pastels
1901	January 15–February 23	*Boussod, Valadon, New York
	January 14–February 23	PAFA
	April 1–20	PAFA
	May 18–July 8	Cincinnati Museum Association
	September 13–October 13	St. Louis Museum of Art
	November 11–31	*Boussod, Valadon, New York

1902	January 20–March 1	PAFA
1903	March 9–21	*M. Knoedler & Co., New York
	April 4–19	PAFA
	April 24–June 1	Chicago Art Institute
	March 23–July 6	Cincinnati Museum Association
1904	March 2–16	*Durand-Ruel, New York
	March 28–April 16	PAFA
	April 28–June 5	Chicago Art Institute
1905	February 20–March 6	*E. Gimpel and Wildenstein, New York
	April 3–29	PAFA
	November 16–20	PAFA
	May 9–June 10	Chicago Art Institute
	June 1–October 15	Lewis and Clark Centennial Exposition, Portland, Oregon
	November 20–January 1/06	Carnegie Institute, Pittsburgh
1906	March 17–April 22	Society of American Artists, New York
	May 3–June 10	Chicago Art Institute
	October 18–November 29	Chicago Art Institute
1907	January 21–February 2	Corcoran Gallery, Washington, D.C.
	February 8–March 9	McClees Gallery, Philadelphia
1908	February 3–18	Macbeth Galleries, New York Exhibition of The Eight
	March 7	"Eight" Exhibition travels to PAFA, Chicago, Buffalo, Toledo
	December 8–January 17/09	Corcoran Gallery, Washington, D.C.
1910	April 1–27	Exhibition of the Independents 29 West Thirty-Fifth Street, New York
	April 18	American Watercolor Society
	June	Worcester Art Museum
1911	January 17–31	Folsom Galleries, New York Columbus Museum, Columbus, Ohio

		International Exhibition, Rome, Italy
	April 11–30	*Union League Club, New York
	November 21–26	Colony Club, New York
1920	June–August	Knoedler's, New York
1937	February 9–March 5	Whitney Museum, New York, New York Realists
1938	April	Museum of the City of New York, Circus Exhibition
1939	March 23–May 14	Chicago Art Institute, 18th Annual Watercolor Exhibition
1940	November 14–January 5, 1941	Chicago Art Institute Survey American Painting They purchase *London Hippodrome*
1943	January 18–27	*Feragil Gallery, New York
	November 8–28	*Feragil Gallery, New York
	November 24–Jan. 6, 1944	Brooklyn Museum, Eight Show Recap
1944	Fall	Carnegie Institute, "Painting in the U.S. 1944" *Bastille Day* exhibited
	Fall	Museum of Fine Arts, Boston "Sport in American Art" *Hoboken Skaters* exhibited
1945	July	*James Vigeveno Galleries, Los Angeles
	October 14–November 18	Philadelphia Museum of Art, "Painters of the Philadelphia Press"
	February 13–March 3	*American British Art Center, New York
1946	November 19–December 7	* American British Art Center
1947	February 16–March 20	*James Vigeveno Galleries, Los Angeles

1948	September 19–October 14	*James Vigeveno Galleries, Los Angeles
	February 16–March 15	*Feragil Galleries, New York
1949	December 4–January 5/50	Illustrators Society Galleries *American British Art Center
1950	December 9–February 25/51	Metropolitan Museum, New York, "American Painting Today"
1952	November	*James Graham & Sons, New York
1958	February	*James Graham & Sons, New York
1959	February 25–March 28	Henry Clay Frick Fine Arts Department, *University of Pittsburgh
1960	January 9–February 21	Delaware Art Center, "50th Anniversary of the Exhibition of the Independents"
1962	[month unknown]	*Bernard Black Galleries, New York
1965	January 19–February 13	*James Graham and Sons, New York, "Theater and Street Scenes"
1969	January	*Museum of Fine Arts, St. Petersburg, Florida

Plays and Other Writings by Everett Shinn

1915–1920

American Review
Bring Home the Bacon
English Review
French Review
Gladimecha, A Short Travesty
Hazel Weston, or More Sinned Against Than Usual
The Bullet
The Stratavarious
The Span (movie scenario)
The Prune Hater's Daughter
Under The Tent
Vaudeville Sketches

1921–1930

A Bowl of Matches (novella)
Exterior Street
Flames

How Royalty Came to Bunny Ridge
I Wonder Who's Next
Lafitte
Ste. Agatha
The Clay Prophet
The Cowlick
The Crimson Mantel [sic] (movie scenario)
The Empty Sleeve
The Flat Irony of Fate (movie scenario)
The Last Cigarette
The Middle One (movie scenario)
The Ninth Exposure
Where There's Smoke
Your People (written with Carl Schmidt)

1931–1953

Caboose Cottage (novel)
Little by Little Elmer, A Travesty in Three Acts
The Dump (updated version of *Exterior Street*)

Appendix 7

Book and Magazine Illustrations by Everett Shinn

Prepared by Edgar John Bullard, III

Snyder, Charles McCloy. *Comic History of Greece*. Philadelphia: J. P. Lippincott Co., 1898. 2 illus.

de Kock, Charles Paul. *Frédérique*, Vol. 1. New York: Frederick J. Quinby Co., 1907. 4 illus.

de Kock, Charles Paul. *Frédérique*, Vol. 2. New York: Frederick J. Quinby Co., 1907. 4 illus.

Johnson, Owen McMahon. *The Salamander*. Indianapolis: Bobbs-Merrill Co., 1914. Illustrations reprinted from serialized version of story appearing in *McClure's*, August 1913–May 1914.

Dutton, Louise Elizabeth. *The Wishing Moon*. Garden City, N.Y.: Doubleday, Page and Co., 1916. 11 illus. Illustrations reprinted from serialized version appearing in *Metropolitan Magazine*, 1916.

Shaw, Bernard. *O'Flaherty, V.C.: an interlude in the great war of 1914*. New York: Hearst's, 1917.

Webster, Henry Kitchell. *Real Life, into which Miss Leda Swan of Hollywood Makes an Adventurous Excursion*. Indianapolis: The Bobbs-Merrill Co., c. 1921.

Dickens, Charles. *A Christmas Carol*. Philadelphia: John C. Winston Co., 1938.

Dickens, Charles. *The Life of Our Lord*. New York: Garden City Publishing Co., 1939.

Irving, Washington. *Rip van Winkle*. New York: Garden City Publishing Co., 1939.

Ferris, Elmer E. *Jerry at the Academy*. New York: Doubleday, Doran and Co., Inc., 1940.

Hale, Edward Everett. *The Man Without a Country*. New York, Random House, 1940.

Wilde, Oscar. *The Happy Prince and Other Tales*. Philadelphia: John C. Winston Co., c. 1940.

Dickens, Charles. *Christmas in Dickens*. Garden City, N.Y.: Garden City Publishing Co., 1941.

Dickens, Charles. *The Mystery of Edwin Drood*. New York: Heritage Press, 1941.

Ewert, Earl C. *The United States Army*. Boston: Little, Brown and Co., 1941.

Jones, Rufus M. *The Shepherd Who Missed the Manger*. Garden City, N.Y.: Doubleday, Doran and Co., Inc., 1941. 1 cover illus.

Wallace, James F. *The U.S. Army in Action!* Racine, Wisc.: Whitman Publishing Co., 1941.

Williams, Chester Sidney. *Religious Liberty*. Evanston, Ill.: Row, Peterson and Co., 1941.

Maurois, André. *Frédéric Chopin*. New York: Harper and Sons, 1942. French edition: Montreal: Les Editions Variétés. New York: Brentano's, 1942.

Moore, Clement Clarke, *The Night Before Christmas*. Philadelphia: John C. Winston Co., 1942.

The Christ Story. Philadelphia: John C. Winston Co., 1943.

Riley, James Whitcomb. *Poems of Childhood*. New York: Grosset and Dunlap (distributors), 1943. Designed and produced by Artists and Writers Guild, Inc.

Purdy, Claire Lee. *Victor Herbert*. New York: Julian Messner, Inc., 1945.

Kaler, James Otis. *Toby Tyler*. Philadelphia: John C. Winston Co., 1946.

The Sermon on the Mount. Philadelphia: John C. Winston Co., 1946.

Dickens, Charles. *David Copperfield*. Philadelphia: John C. Winston Co., 1948.

Rice, Alice Hegan. *Mrs. Wiggs of the Cabbage Patch*. New York: Grosset and Dunlap, 1950. 11 illus.

Ainslee's Magazine

Hancock, H. Irving. "What One Man Saw," II, 6 (January 1899), 668–75, 7 illus.

"An Outpost at Valley Forge," III, 1 (February 1899), cover.

Bullock, Shan F. "The Brothers," III, 1 (February 1899), 9–19, 7 illus.

Cover, III, 2 (March 1899).

Besant, Sir Walter. "The Short Way," III, 2 (March 1899), 136–42, 6 illus.

Cover, III, 3 (April 1899).

Jacobs, W. W. "Three at Table," III, 3 (April 1899), 294–98, 5 illus.

Henry, Arthur. "The Young Wife of Old Pierre Prevost," III, 4 (May 1899), 425–38, 10 illus.

Wood, Eugene. "The Lost Day," III, 4 (May 1899), 487–93, 6 illus.

Bonner, Hugh. "Modern Fire Fighting," III, 5 (June 1899), 520–30, 5 illus.

Stringer, Arthur J. "Unanointed Altars," III, 5 (June 1899), 536–37, 2 illus.

Roberts, Charles G. D. "The Blue Dwarf of Belle Mare," III, 5 (June 1899), 557–66, 7 illus.

Wood, Eugene. "The Coming of the Circus," III, 6 (July 1899), 661–72, 4 illus.

Stephenson, Nathaniel. "Sisera," III, 6 (July 1899), 730–38, 6 illus.

Stringer, Arthur J. "On an Old Battleground," IV, 1 (August 1899), 73, 1 illus.

The Bookman

Baury, Louis. "The Message of Bohemia," XXXIV, 3 (November 1911), 256–66 (several illustrators, one illustration by Shinn, p. 218).

Century Magazine

"Four Midwinter Scenes in New York," LXI, 4 (February 1901), 521–25, 4 illus.

Parker, Louis N. "A Minuet," LXXXIX, 3 (January 1915), 370–76, 1 illus.

Kelley, Ethel M. "Making Over Mary," LXXXIX, 3 (January 1915), 435–41, 3 illus.

Ernest, Joseph. "Zizi's Hat," LXXXIX, 6 (April 1915), 914–26, 6 illus.

Steele, Wilbur Daniel. "The Real Thing," XC, 1 (May 1915), 2–13, 3 illus.

Allen, Frederick Lewis. "Cart Before The Horse," XC, 6 (October 1915), 942–51, 3 illus.

Vorse, Mary Heaton. "The Highest Power," XCI, 1 (November 1915), 96–106, 1 illus.

Vorse, Mary Heaton. "The Get-away," XCI, 4 (February 1916), 529–38, 2 illus.

Gillmore, Inez Haynes. "Ladies," XCI, 5 (March 1916), 705–16, 2 illus.

Collier's Weekly

Ruhl, Arthur B. "Monsieur Gaspard: Villain," XXXIV, 17 (January 21, 1905), 22–27, 2 illus.

Adams, Samuel Hopkins. "Studies of a Strike," XXXV, 1 (April 1, 1905), 17–18, 6 illus.

The Critic

"Sir Henry Irving as Robespierre," XXXV, 870 (December 1899), frontispiece opposite p. 1069.

"Mark Twain," XXXVI, 3 (March 1900), frontispiece opposite p. 193.

Ellsworth, William W. "Behind the Scenes at 'Ben Hur,'" XXXVI, 3 (March 1900), 245–49, 3 illus.

Malone, Walter. "The City," XLI, 6 (December 1902), 526–29, 2 illus.
"Mark Twain at Sixty-Seven," XLII, 1 (January 1903), frontispiece, p. 2.
"Mr. Clyde Fitch in His Study," XLIII, 5 (November 1903), 400.

Everybody's Magazine

Mallon, George Barry. "The Hunt for Bohemia," XII, 2 (February 1905), 187–97, 18 illus.

Kenton, Edna. "The Incumbrance," XIII, 3 (September 1905), 320–28, 5 illus.

Osborne, William Hamilton. "The Alarm of Angelone," XIII, 4 (October 1905), 466–72, 8 illus.

"Some Players by Everett Shinn," XIII, 6 (December 1905), 801–8, 8 illus.

Burgess, Gelett. "Smith and the May Lee Association," XV, 1 (July 1906), 105–12, 6 illus.

Cover, XXXVI, 3 (March 1917).

Futrelle, Mrs. Jacques. "The Late Betsy Baker," XXXVI, 5 (May 1917), 561–71, 5 illus.

Cover, XXXVI, 6 (June 1917).

Steele, Alice Garland. "Mrs. Deering's Answer," XXXVII, 2 (August 1917), 145–60, 5 illus.

Adams, Samuel Hopkins. "Room 12A," XXXVII, 5 (November 1917), 19–23, 5 illus.

Hale, Louise Closser. "The Measure of a Man," XXXVII, 6 (December 1917), 18–22, 4 illus.

Gil Blas

Symonds, George Wolsey. "The Mummied Head," I, 1 (November 2, 1895), 1.

Hunt, Albert E. "A Story Told," I, 2 (November 9, 1895), 4.

"Only a Picture," I, 2 (November 9, 1895), 12.

Symonds, George Wolsey. "The Mummied Head," I, 3 (November 16, 1895), 4 (same drawing as in issue no. 1).

Harper's Magazine

"Revenge Enough": XCVII, 580 (September 1898), 661.

"A Winter's Night on Broadway," XLIV, 2252 (February 17, 1900), 154–55.

"City Hall on Election Night," XLIV, 2290 (November 10, 1900), 1062–63.

"Progress of the Work on the Underground Railroad," XLIV, 2291 (November 17, 1900), 1084, 2 illus.

Townsend, Edward W. "To and From McGrath's," XLIV, 2294 (December 8, 1900), 1167, 1 illus.

Danby, Frank. "The Battersea Flat Crime," LIX, 3006 (August 1, 1914), 114–18, 1 illus.
"To the Shore or Not?" LIX, 3007 (August 8, 1914), 132–33.

Metropolitan Magazine

Hughes, Rupert. "The Bitterness of Sweets," XL, 2 (June 1914), 7–9, 4 illus.
Harris, Corra. "The Biography of Mary According to Martha," XL, 4 (August 1914), 5–8, 4 illus.
Laughlin, Clara E. "Pawns of Nature," XL, 4 (August, 1914), 26–27, 1 illus.
Tarkington, Booth. "Harlequin and Columbine," pt. 1, XL, 5 (September 1914), 7–9, 3 illus; pt. 2, XL, 6 (October 1914), 19–21, 2 illus; pt. 3, XLI, 1 (November 1914), 34–36, 2 illus.
Reed, John. "The Approach to War," XLI, 1 (November 1914), 15–16, 1 illus.
Abbott, Eleanor H. "Tinsel-Toes," XLI, 2 (December 1914), 7–9, 2 illus.
Balmer, Edwin. "Over the Sheer," XLI, 6 (April 1915), 17–20, 3 illus.
Dawson, Coningsby. "She Wanted to Know," XLII, 2 (June 1915), 35–37, 2 illus.
Bennett, Arnold. "The Muscovy Ducks," XLII, 3 (July 1915), 23–25, 4 illus.
Webster, Henry Kitchell. "Transmutation," XLII, 4 (August 1915), 19–21, 2 illus.
Hurst, Fannie, "The Name and the Game," XLIII, 2 (December 1915), 24–28, 5 illus.
Dutton, Louise. "The Wishing Moon," pt. 1, XLIII, 3 (January 1916), 5–8, 3 illus.; pt. 2, XLIII, 4 (February 1916), 17–20, 3 illus.; pt. 3, XLIII, 5 (March 1916), 18–20, 3 illus.; pt. 4, XLIII, 6 (May 1916), 27–29, 3 illus.; pt. 5, XLIV, 1 (June 1916), 18–20, 2 illus.; pt. 6, XLIV, 2 (July 1916), 21–22, 2 illus.; pt. 7, XLIV, 3 (August 1916), 12–14, 2 illus.; pt. 8, XLIV, 4 (September 1916), 22–24, 2 illus.
Duffy, Alice. "The Dual Life of Ariana," XLIV, 5 (October 1916), 20–22, 2 illus.
Webster, Henry Kitchell. "The Second Rescue," XLV, 1 (December 1916), 9–11, 3 illus.
Morley, Christopher. "Kathleen," XLVIII, 1 (June 1918), 11–15, 6 illus.
Gurlitz, Amy Landon. "The Changeling of the Gods," XLVIII, 3 (August 1918), 23–25, 3 illus.
Ryerson, Florence. "Orpheus and the Amazing Valentine," XLIX, 1 (December 1918), 21–23, 3 illus.
Parmenter, Christine Whiting. "Uncle Jed," XLIX, 4 (March 1919), 36–38, 2 illus.
Akins, Zoë. "New York's a Small Place," L, 2 (July 1919), 37–39, 4 illus.
Dutton, Louise. "Cinderella's Eyes," L, 3 (August 1919), 38–40, 2 illus.
Crabb, Arthur. "The Kiss," L, 5 (October 1919), 21, 1 illus.
Masson, Thomas L. "Nibs," L, 5 (October 1919), 38–39, 2 illus.
Robbins, L. H. "The Christmas Card," LI, 1 (December 1919), 42–44, 2 illus.
Parmenter, Christine Whiting. "The Peach in Pink," LI, 2 (January 1920), 42–45, 2 illus.
Mackendrick, Marda. "Jean—in the Negative," LI, 4 (March 1920), 29–30, 2 illus.

Collins, Charles. "The Girl on the End," LI, 5 (April 1920), 24–26, 3 illus.

Ueland, Brenda. "The Good Natured Girl," LI, 6 (May 1920), 36–38, 2 illus.

Carmichael, Catherine. "The Fairy of the Fire-Place," LII, 1 (June 1920), 13–14, 2 illus.

Duganne, Phyllis. "The True Art," LII, 2 (August 1920), 20–22, 3 illus.

Ueland, Brenda. "The Hootch Hound," LII, 2 (September 1920), 23–24, 2 illus.

Wonderly, W. Carey. "Field-Lilies," LII, 6 (December 1920), 18–19, 2 illus.

Scribner's Magazine

Williams, Jesse Lynch. "The Cross Streets of New York," XXVIII, 5 (November 1900), 571–87, (several illustrators, 3 illustrations by Shinn, pp. 574, 578, 582).

Williams, Jesse Lynch. "Rural New York City," XXX, 2 (August 1901), 178–91, (several illustrators, one illustration by Shinn, p. 188).

"How Easter Comes in the City," XXXI, 4 (April 1902), 450–51, 2 illus.

Corbin, John. "Play-Going in London," XXXV, 4 (April 1904), 395–410, (several illustrators, one illustration by Shinn, p. 410).

Chapman, Arthur. "The Colyum Conductor," LX, 2 (August 1916), 210–23, 5 illus.

Truth

"I Beg Your Pardon . . . ," XVI, 510 (January 21, 1897), 7.

"After the Play," XVI, 511 (January 28, 1897), 4.

"Why Don't You Like the Stories . . . ," XVI, 525 (May 6, 1897), 4.

"Married Yet, Old Man?" XVII, 601 (October 26, 1898), 19.

"What Are You Going to Be, Willie . . . ?" XVII, 602 (November 2, 1898), 21.

Johnson, Stanley Edwards. "A Woman of Nerve," XVII, 603 (November 9, 1898), 3–5, 2 illus.

"What Will You Do When You Grow Up?" XVII, 603 (November 9, 1898), 12.

"They Say Music Stimulates the Growth of the Hair," XVII, 605 (November 23, 1898), 13.

"The Old Man Began Fumbling in the Wood Box," XVII, 606 (November 30, 1898), 19.

"Football Enthusiasm," XVII, 606 (November 30, 1898), 24.

"A Precaution," XVII, 608 (December 14, 1898), 11.

"Why I've Got a Spaniel at Home . . . ," XVIII, 1 (January 3, 1899), 22.

"No, Miss Jeanette, I Have Never Crossed the Ocean . . . ," XVII, 590 (August 10, 1898), 7.

"Why Did They Call the Spanish Fleet a Phantom Fleet?" XVII, 590 (August 10, 1898), 15.

"My Dolly Can Say 'Papa and Mama,' " XVII, 593 (August 31, 1898), 3.

"A Fool and His Money Are Soon Parted," XVII, 593 (August 31, 1898), 15.

"It Says Here That Croesus Was Worth About Twenty Million Dollars," XVII, 594 (September 7, 1898), 6.

"We Never See Young Noodletop . . . ," XVII, 594 (September 7, 1898), 17.

"She Tries to Make Herself Look Like a Man . . . ," XVII, 595 (September 14, 1898), 3.

"I Can't Pay My Subscription . . . ," XVII, 595 (September 14, 1898), 7.

"So You Are Off for a Holiday?" XVII, 596 (September 21, 1898), 5.

"Is That Chewing Gum in Your Mouth?" XVII, 596 (September 21, 1898), 32.

"Look, Mama, Look!" XVII, 597 (September 28, 1898), 5.

"Is She a Friend of Yours?" XVII, 597 (September 28, 1898), 10.

"Papa, Do They Get Salt Out of Salt Lake?" XVII, 597 (September 28, 1898), 19.

"Will You Marry Me When I'm Grown Up?" XVII, 598 (October 5, 1898), 6.

"I Do Love to Be Out in the Country . . . ," XVII, 598 (October 5, 1898), 11.

"What Did Yer Name de Kid?" XVII, 598 (October 5, 1898), 22.

"You Are Always Finding Fault," XVII, 598 (October 5, 1898), 32.

"Here's a Story of a Man Out West Who Traded His Wife Off for a Horse . . . ," XVII, 599 (October 12, 1898), 3.

"Man Is Born to Rule the World," XVII, 599 (October 12, 1898), 13.

"Oh, Freddy, We Have a New Little Baby up at Our House," XVII, 600 (October 19, 1898), 19.

"Were You in the War?" XVII, 600 (October 19, 1898), 21.

"The Lecture and the Lecturer," XVII, 601 (October 26, 1898), 12.

Bibliography

BOOKS

American Heritage, ed. *New York, N.Y.* New York: American Heritage, 1968.

American Heritage, ed. *The Nineties.* New York: American Heritage, 1967.

Art in America, ed. *The Artist in America.* New York: W. W. Norton & Co., 1967.

Atkinson, William, ed. *The Farm Journal Farm Directory of Salem County, New Jersey.* Philadelphia: Farm Journal, 1913.

Belasco, David. *The First Night in the Stuyvesant Theater.* Privately printed, 1907.

Bemelmans, Ludwig. *To the One I Love.* New York: Viking Press, 1955.

Berry-Hill, Henry and Sidney. *Ernest Lawson, American Impressionist.* Leigh-on-Sea, England: F. Lewis Publishers Ltd., 1968.

Brooks, Van Wyck. *John Sloan, A Painter's Life.* New York: E. P. Dutton & Co. Inc., 1955.

Brown, Milton W. *American Painting from the Armory Show to the Depression.* Princeton, N.J.: Princeton University Press, 1955.

Cushing, Thomas, and Sheppard, C. E. *Genealogical and Memorial History of the State of New Jersey.* Vol. II. Philadelphia, Pa: Lewis Historical Publishing Co., 1910.

Dreiser, Theodore. *The Genius*. Cleveland, Ohio: The World Publishing Co., 1946.

Eliot, Alexander. *Three Hundred Years of American Painting*. New York: Time, Inc., 1957.

Glackens, Ira. *William Glackens and the Ashcan Group*. New York: Crown Publishers, Inc., 1957.

Homer, William Innes. *Robert Henri and His Circle*. Ithaca, New York: Cornell University Press, 1969.

Kock, Charles Paul de. *Frédérique I*. New York: Frederic J. Quimby Co., 1907.

Larkin, Oliver, *Art & Life in America*. Holt, Rinehart & Winston, N.Y. 1949, 1960.

Loukes, Harold. *The Quaker Contribution*. New York: The Macmillan Co., 1965.

Marcuse, Maxwell F. *This Was New York*. New York: LIM Press, 1969.

Moses, Montrose J. *Concerning Clyde Fitch and the Local Scene*. Boston: Little, Brown & Co., 1925.

New Jersey Bell Telephone Company. *Salem County Telephone Directory 1971*. New York: Ruben Donnelly Corp., 1971.

Perlman, Bennard. *The Immortal Eight*. New York: Exposition Press, 1962.

Reed, Walt. *The Illustrator in America, 1900–1960*. New York: Reinhold Publishing Co., 1966.

St. John, Bruce. *John Sloan*. New York: Praeger Publishers, Inc., 1971.

St. John, Bruce. *John Sloan's New York Scene*. New York: Harper & Row, 1965.

Salem County Tercentenary Committee, ed. *Fenwick's Colony*. Salem, N.J.: Sunbeam Publishing Co., 1964.

Shinn, Josiah H. *The History of the Shinn Family in Europe and America*. Philadelphia: Genealogical & Historical Publishing Co., 1903.

Sloan, John. *Gist of Art*. New York: American Artist's Group, 1939.

Who's Who in American Art. 1948–49. Vol. 24. Shinn Biography.

PERIODICALS

Baury, Louis. "The Message of Manhattan." *The Bookman*, vol. 33, no. 6 (August 1911), p. 593.

"Bright Shawl" (movie review). *New York Evening Telegram*, August 31, 1924.

Brooks, Van Wyck. "The Eight's Battle for U.S. Art." *Art News*, vol. 53, no. 7 (November 1954).

Dinnerstein, Harvey, and Silverman, Burton. "New Look at Protest: The Eight Since 1908." *Art News*, vol, 56 no. 10 (February 1958), pp. 36–39.

Edgerton, Giles. (Mary Fanton Roberts) "Modern Murals Done in French Spirit of Decoration." *Arts and Decoration*, vol. 22 (November 1924).

"Everett Shinn's Paintings of Labor in the New City Hall at Trenton, N.J." *Craftsman*, January 1919.

First National Bank, Woodstown, N.J. Almanacs and Year Books 1864–1908.

Fitzsimmons, J. "Everett Shinn, Lone Survivor of the Ash Can School." *Art Digest*, vol. 27 (November 15, 1952), pp. 10–11.

Hunter, S. "The Eight—Insurgent Realists." *Art in America*, vol. 44 (Fall 1956), pp. 20–22.

Kent, Norman. "The Versatile Art of Everett Shinn." *American Artist*, October 1945, p. 8.

Kwiat, J. J. "*The Genius* and Everett Shinn, the Ashcan Painter." *Journal, Modern Language Association of America*, vol. 67 (March 1952), pp. 15–31.

"Prune Hater's Daughter (review). *New York Times*, March 21, 1912.

Watson, Forbes. "Realism Undefeated." *Parnassus*, vol. 9, no. 3 (March 1937), pp. 11–13.

"Yale Collectors." *Time* (Art Section), May 14, 1956, p. 98.

IMPORTANT EXHIBITION CATALOGS

"The Eight." Brooklyn Museum, Brooklyn, N.Y. November 24, 1943, through January 16, 1944.

"The Fiftieth Anniversary of the Exhibition of Independent Artists in 1910." Delaware Art Center (now Delaware Art Museum), Wilmington, Delaware. January 9 through February 21, 1960.

"Everett Shinn—An Exhibition of His Work." The Henry Clay Frick Fine Arts Department of the University of Pittsburgh. February 25 through March 28, 1959.

"150th Anniversary Exhibition." Pennsylvania Academy of the Fine Arts, Philadelphia. January 15 through March 13, 1955.

"Artists of the Philadelphia Press." Philadelphia Museum of Art. October 14 through November 18, 1945.

MANUSCRIPTS AND FILES

Washington, D.C. Archives of American Art, National Collection of Fine Arts. Everett Shinn memorabilia and correspondence.

Bullard, E. John III. "John Sloan and the Philadelphia Realists as Illustrators, 1890–1920." Master's thesis, University of California, Los Angeles, 1968.

Wilmington, Delaware. Delaware Art Museum. Collection of Edith Kind DeShazo. Everett Shinn papers (plays, sketches, autobiographical sketches, etc.).

Wilmington, Delaware. Delaware Art Museum. Collection of Helen Farr Sloan. John Sloan Notes.

New Haven, Connecticut. Yale University Library. Correspondence between John Sloan and Robert Henri.

Everett Shinn Papers (interviews, correspondence)

Author's Note: No attempt has been made to include reviews of art shows and exhibitions in this bibliography. Upwards of two hundred and fifty have come to this writer's attention in doing research for this book.

Index

Italic page numbers indicate illustrations.

231